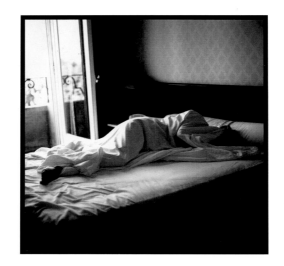

Women Before 10 a.m.

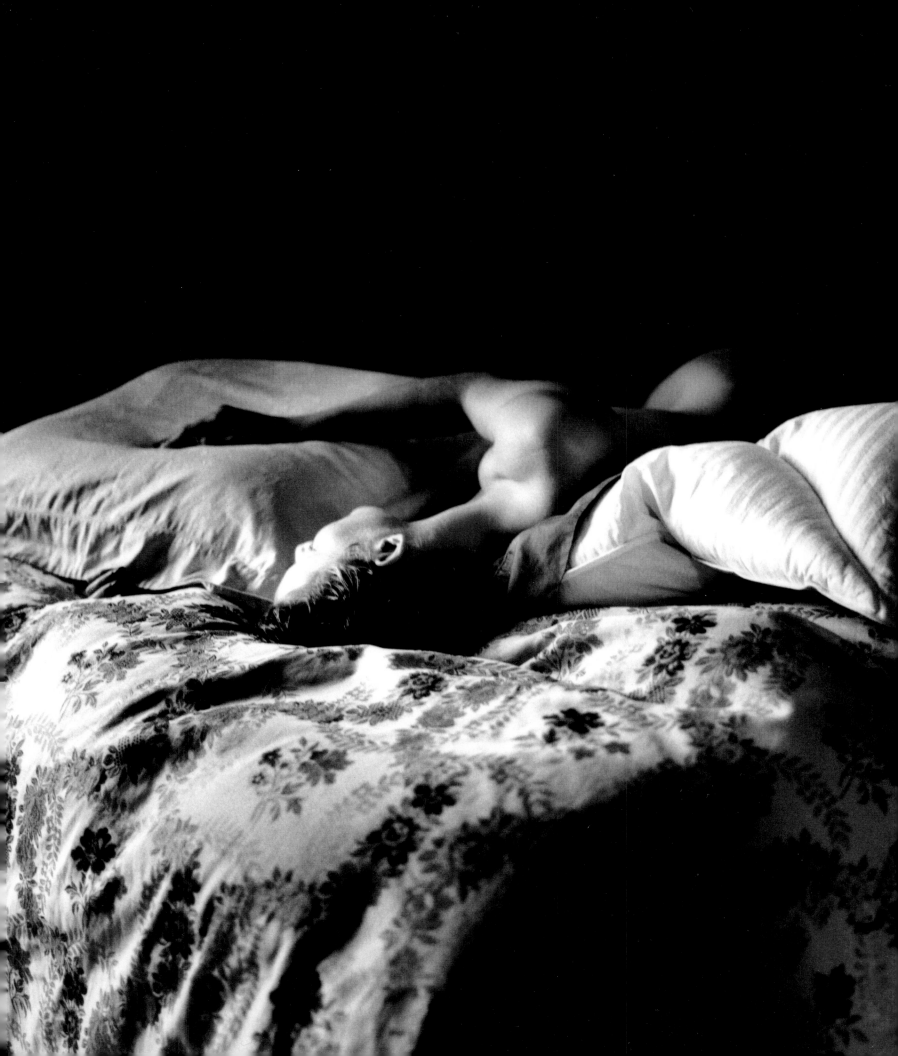

When I opened the door, she was still sleeping !!!
As I parted the curtains, she rose from the blanket
... like an angel ...

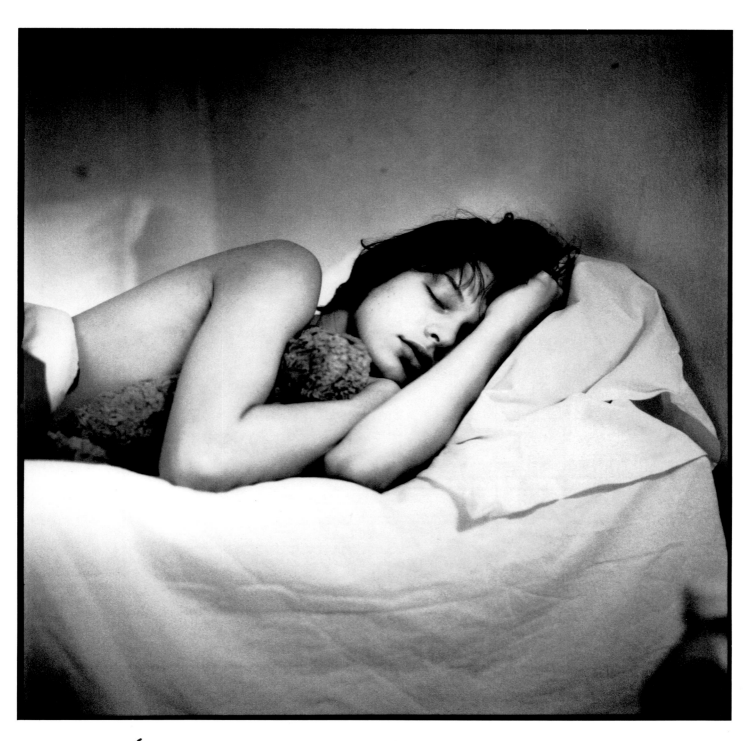

Milla Jovovich , 8.09 am

Women Before 10 a.m.

Photographs by Véronique Vial

Foreword by Sean Penn

powerHouse Books New York NY

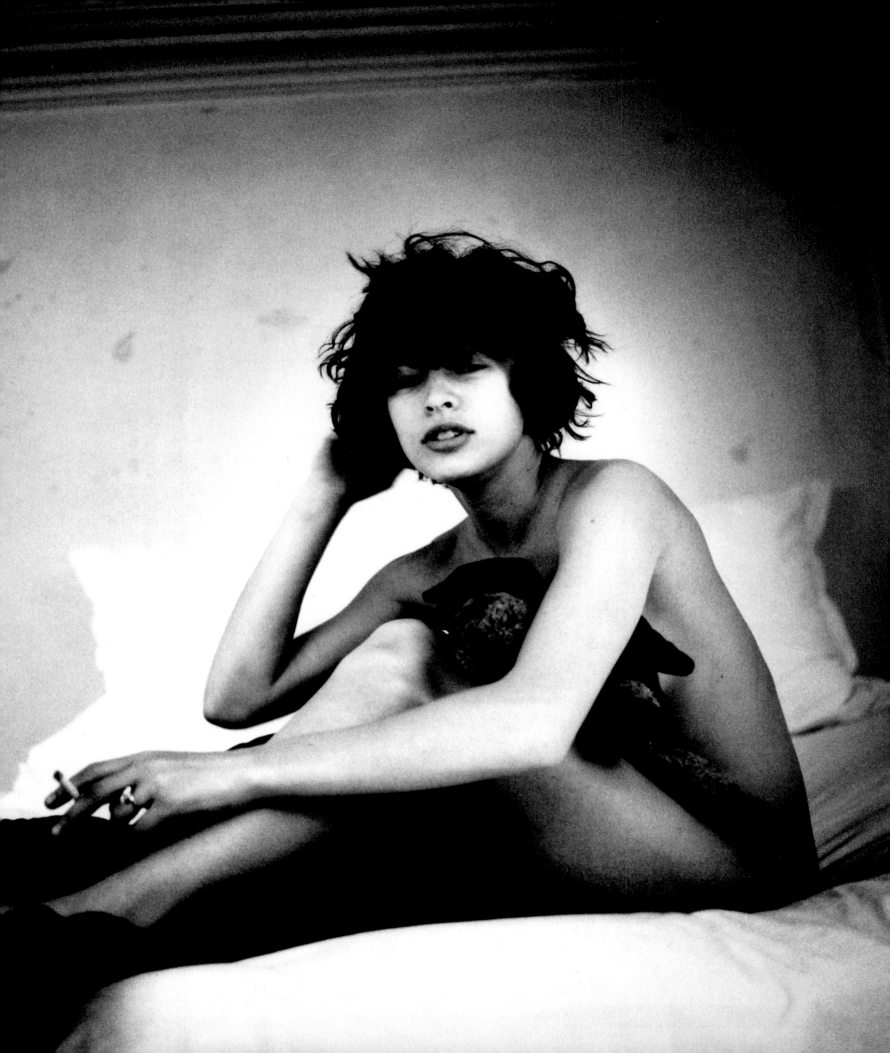

foreword

To see, really see, a woman, before 10 a.m....

I'd like to adjust the mound of duvet before my eyes with a flattening palm to glimpse her naked silhouette from behind where she stands facing morning light, soft through gentle window linens. Her hair flows between her shoulders to the small of her back—oh, the small of her back—to her buttock, a wisp of pubic hair kissing the air between her thighs. I'd like to adjust that mound of duvet to find that I haven't slept to the crack of noon and missed the whole dang thang, but, alas...in the words of my dear friend David Baerwald:

> "I wake up and you're not there
> But your clothes are in the closet
> And your scent's in the air
> If it ain't an answer
> I don't care
> Why was I born?
> Well I was born to love you..."

Sean Penn
San Francisco, June 1998

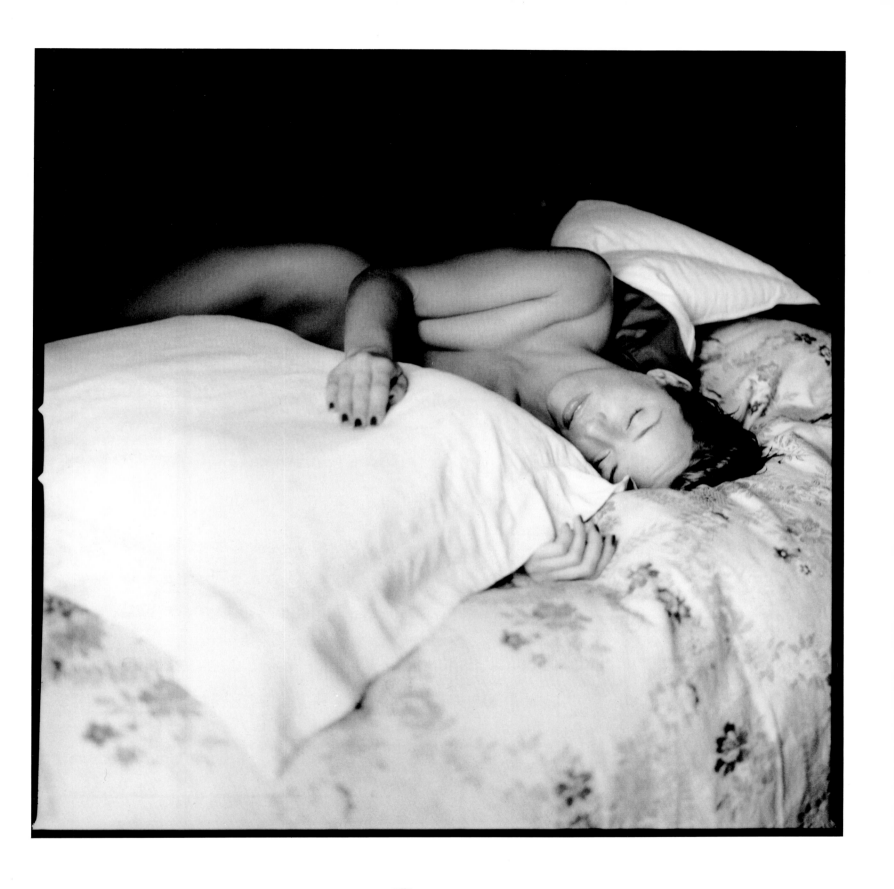

Diana Barton ,8.31am

Preface

After I had explored my favorite subject – men before 10 am – I decided to wake up women, despite the fear I might come across a lot of closed doors!

Unlike the men, who were fun and intensely sexy, photographing women early in the morning was more real, more soulful, more rewarding... and actually more interesting. I soon began to wake up early eager with enthusiasm for my next encounter. I promised myself not to orchestrate the shoot or use artificial light; that I would shoot two or three rolls maximum, and that I would want them raw, real, natural... no makeup, no posing, I wanted their souls!!!

Every morning, I learned a little more about life through the closeness shared with these wonderful women; the intimacy was a visual one, and it happened many times without words...

I photographed more than I should have; It became a nice way to start the day; I am grateful to all the women who let me in at sunrise, especially the ones who did not make it into the book... (Talk to Dan, my publisher!)

Thank you for sharing your homes and giving me a real reason to pick up my camera... and for getting up early!!!

Veronique Vial Venice Ca July 1998

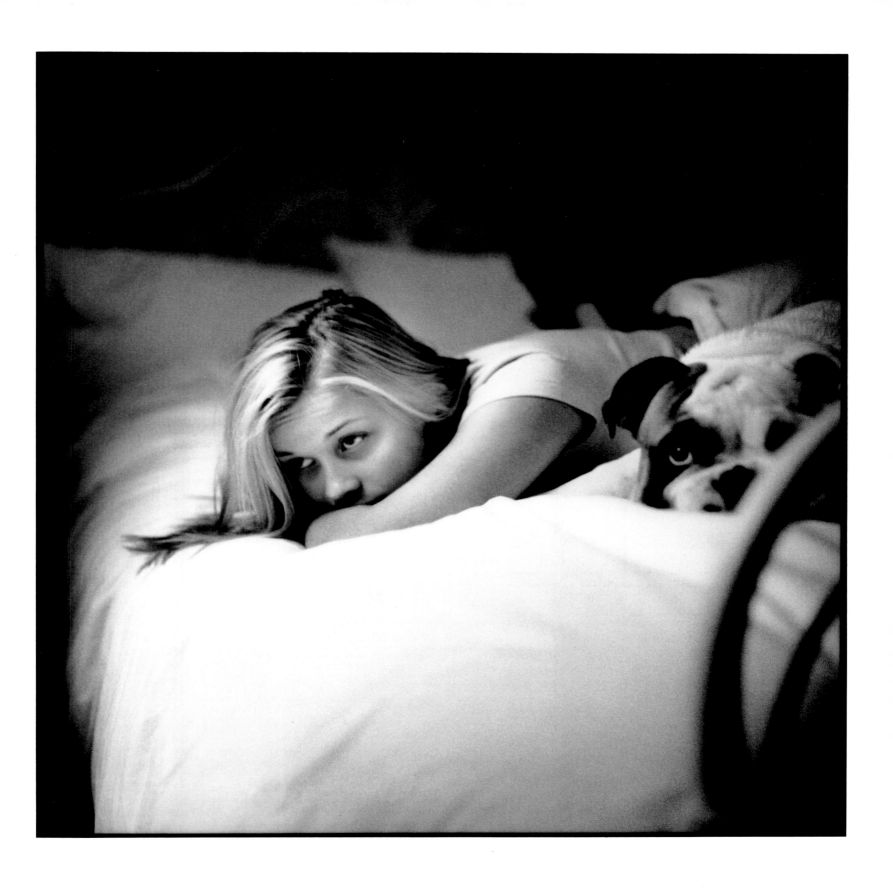

Reese Witherspoon, 7.57 am

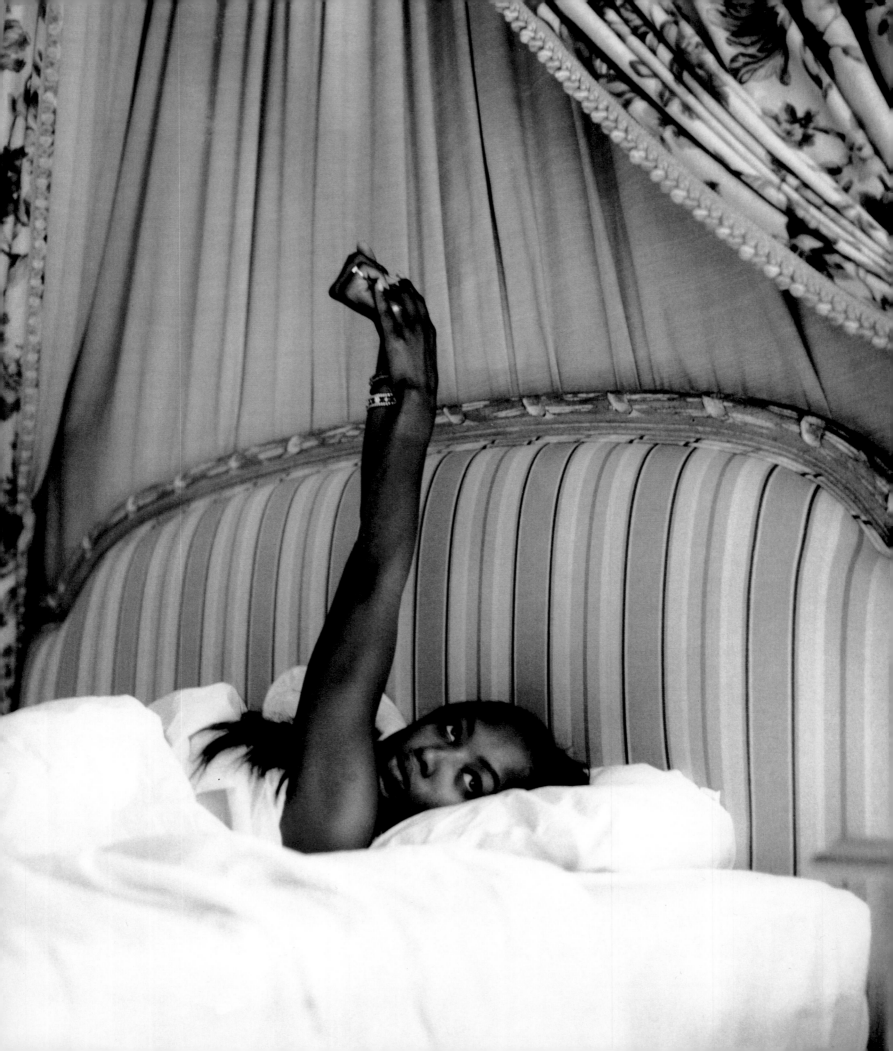

← Naomi Campbell

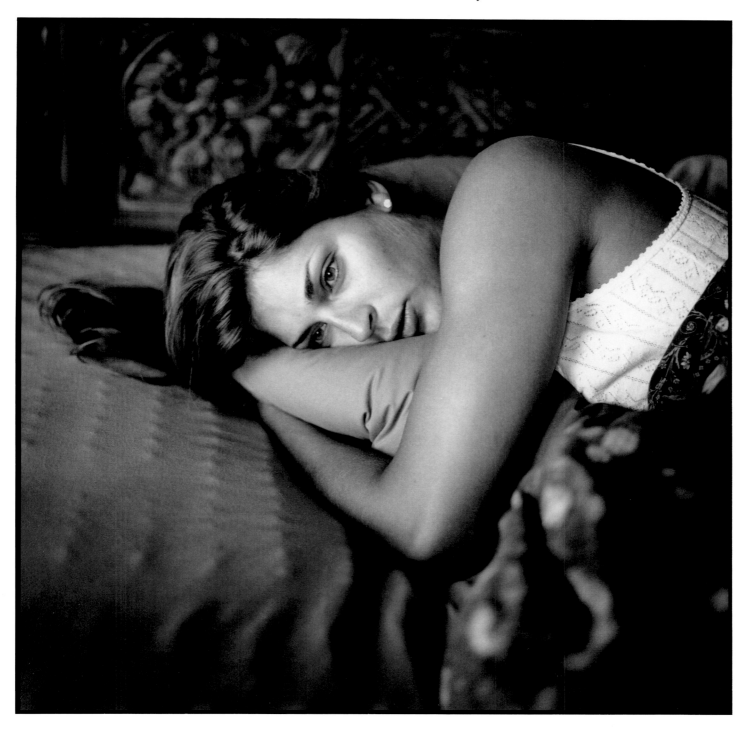

Gabrielle Reece, 9.00 am

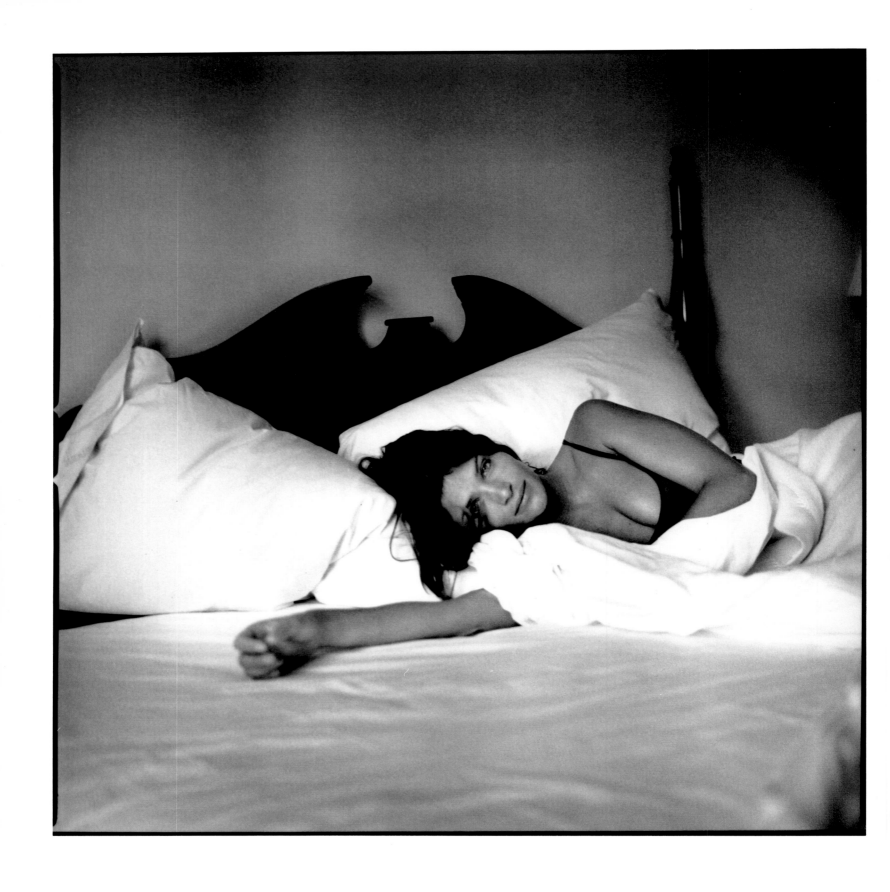

Helena Christensen , 8.55 am

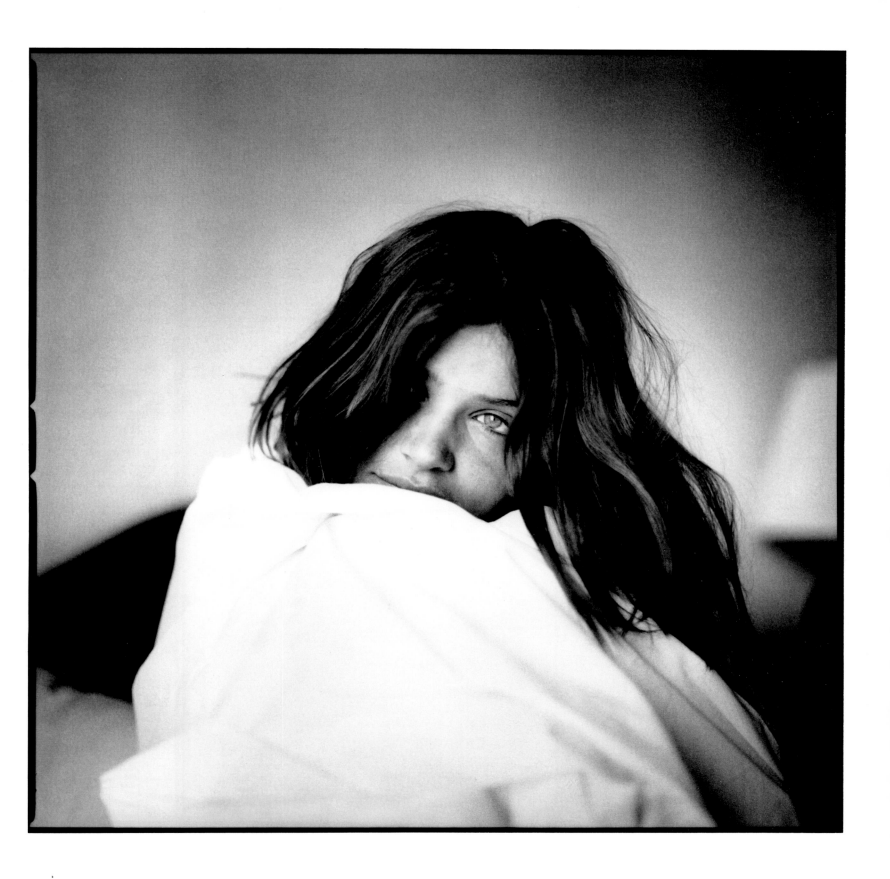

. . . Hollywood

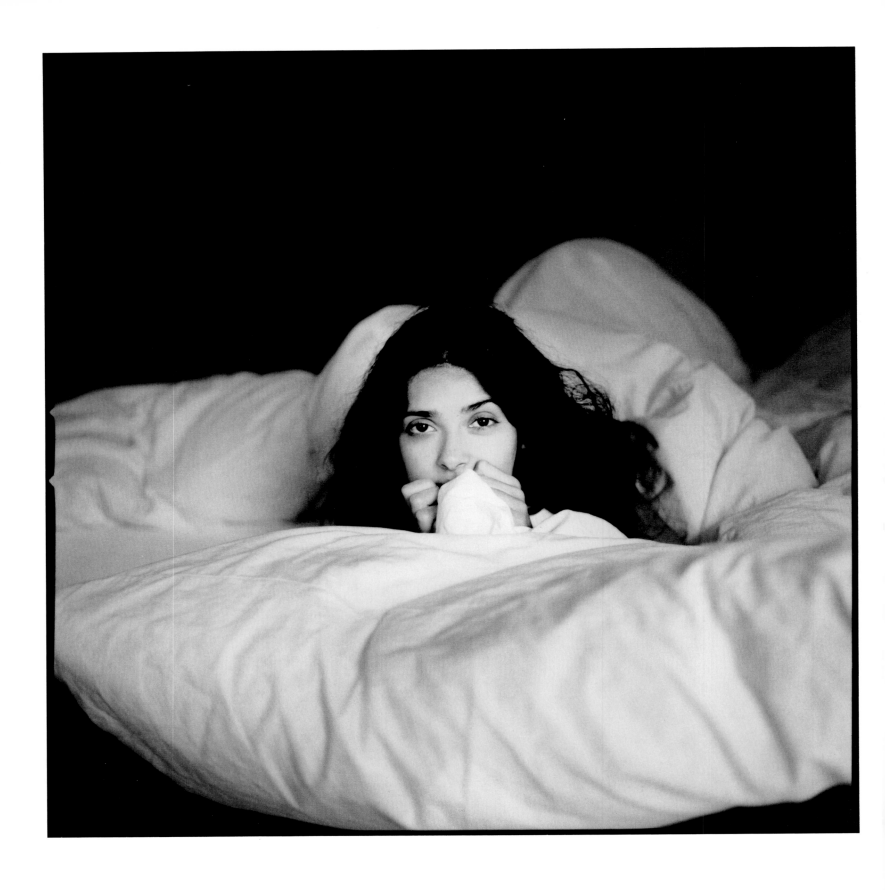

Salma Hayek, 9.09 am

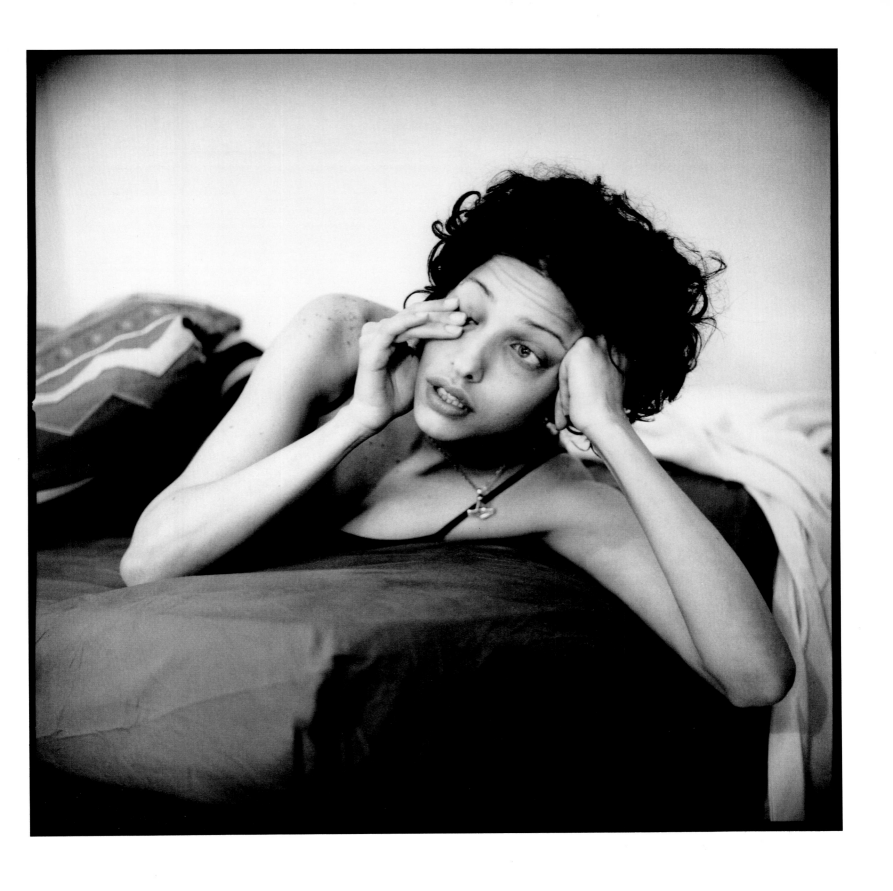

Daniela Rotelli, 9.36 am

Paris

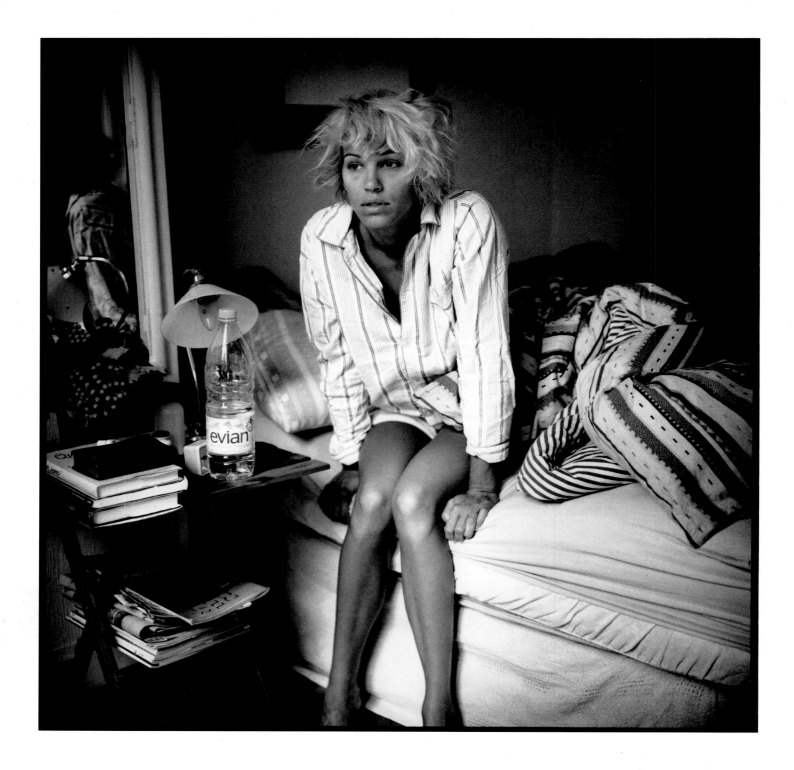

Emma Spöberg, 9.19 am

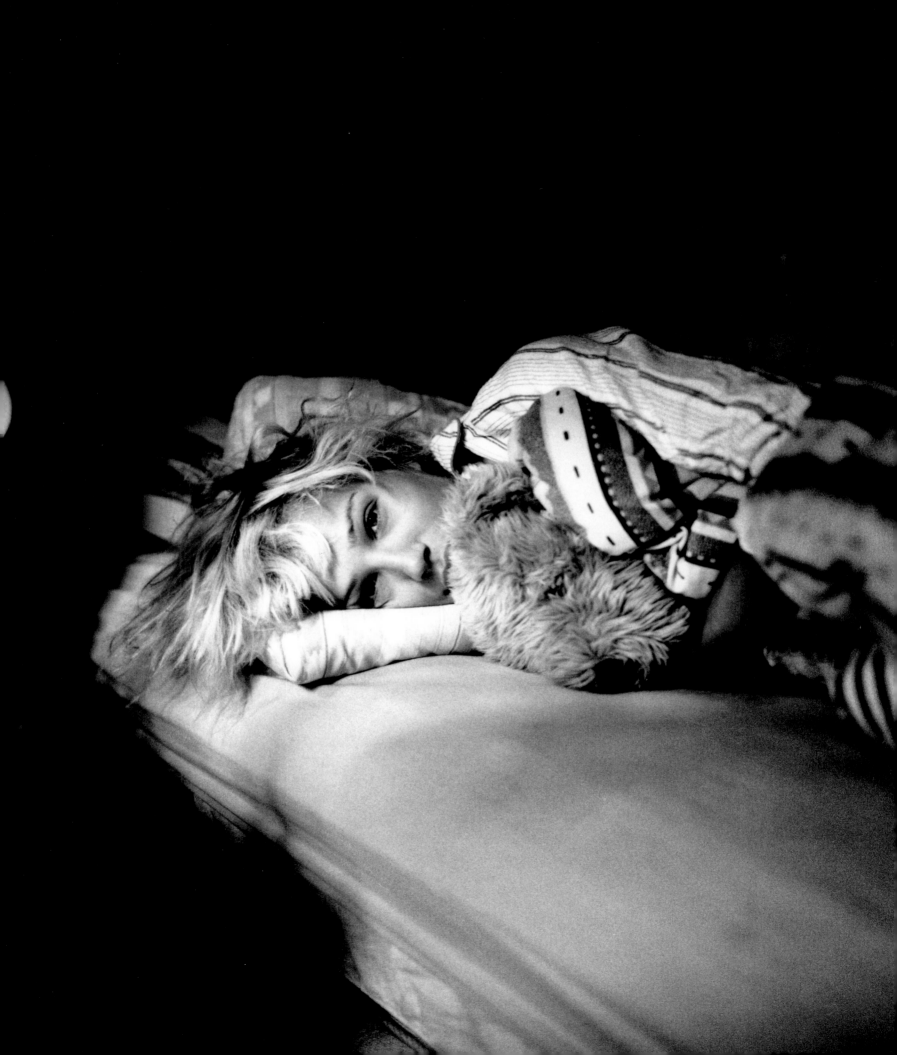

Jay is the most sensuous, feminine, and elegant well dressed woman I have ever met ... but she is a man !!!

He walks like a gazelle and dances like bamboo in the wind ... his wardrobe is richer than any dressing room at an "Haute Couture" show !!!

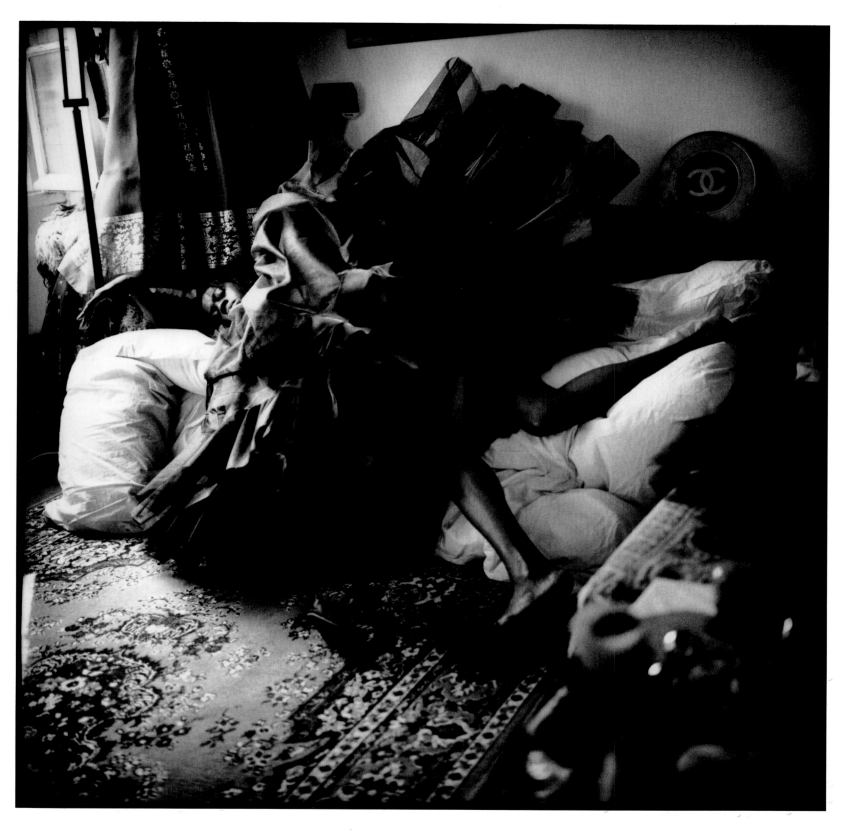

Jay Alexeander , 8.58am

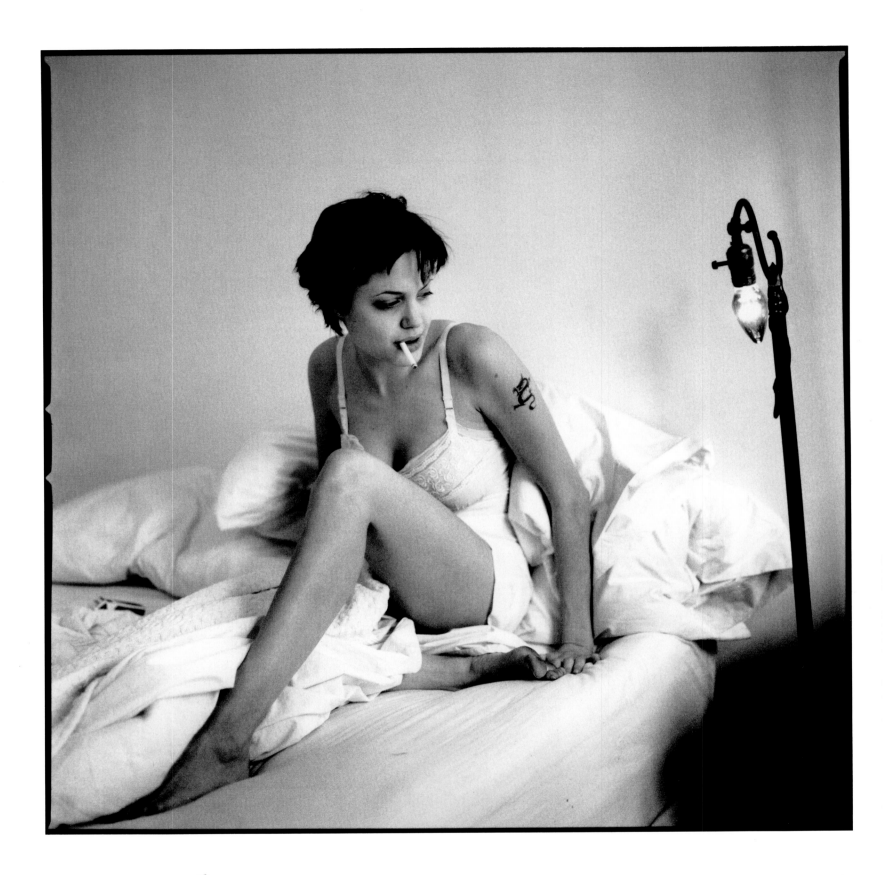

Angelina Jolie, 9.00 am

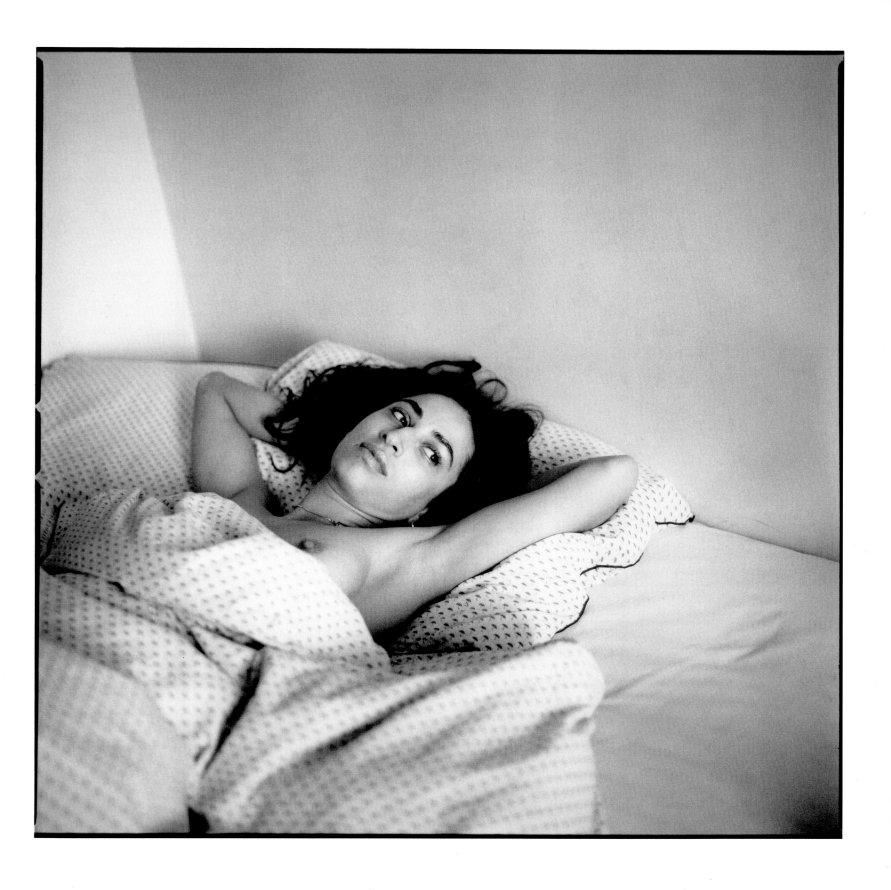

Jale Arikan, 9.47 am

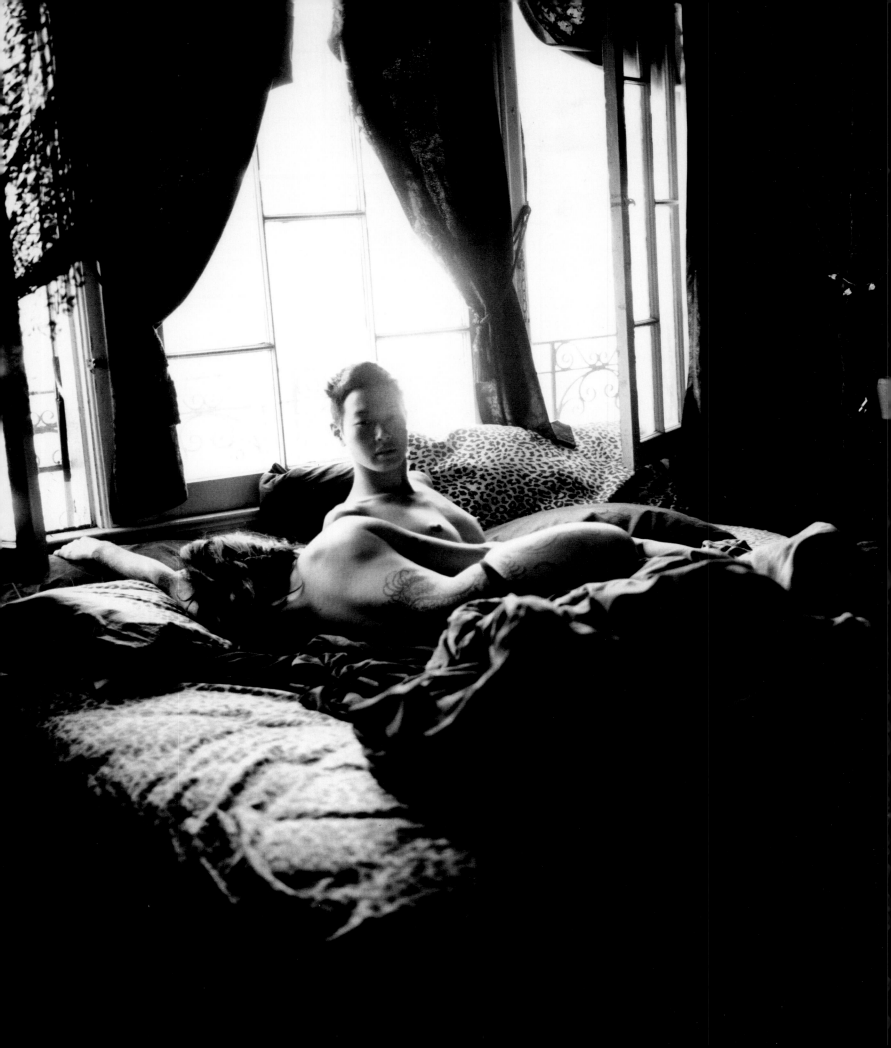

Los Féliz

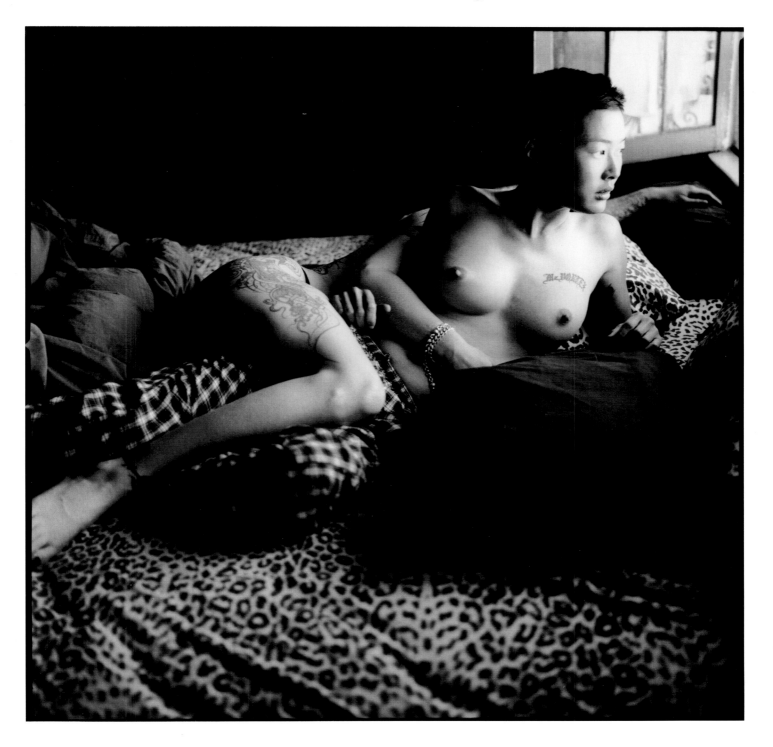

Jenny Shimizu, 9.30 am

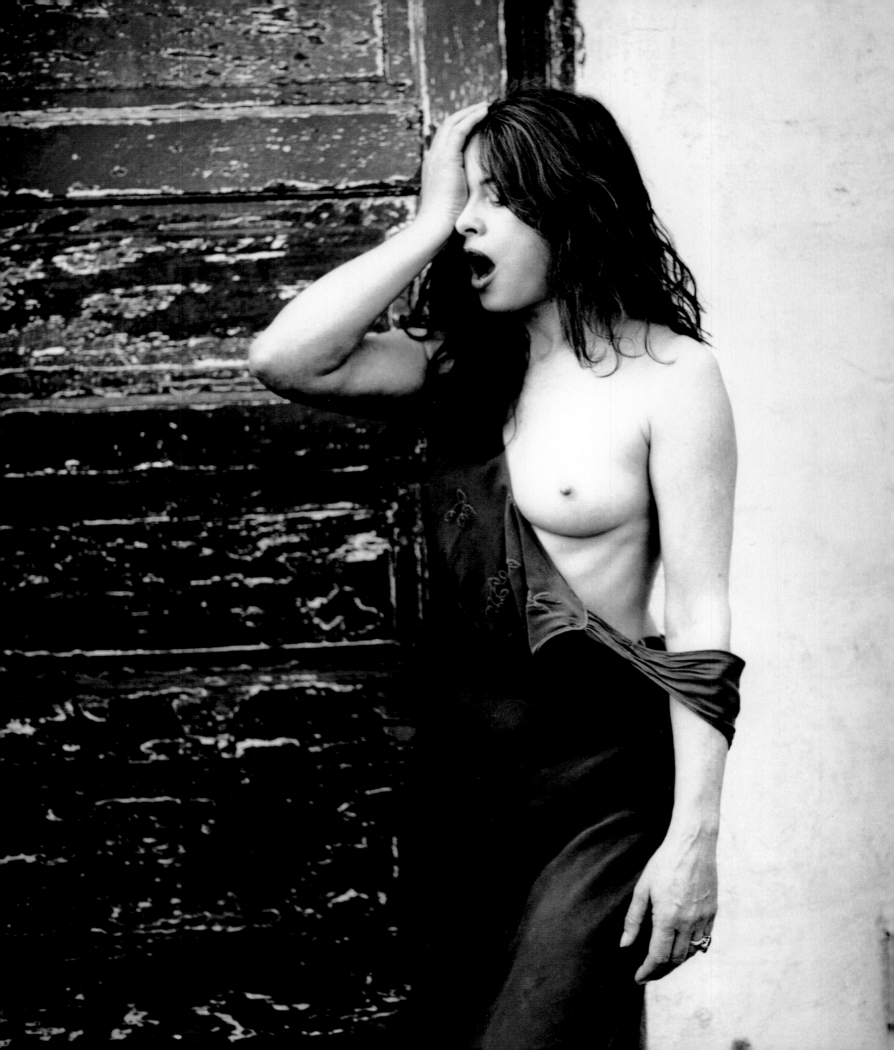

Uxhi Obermaier →

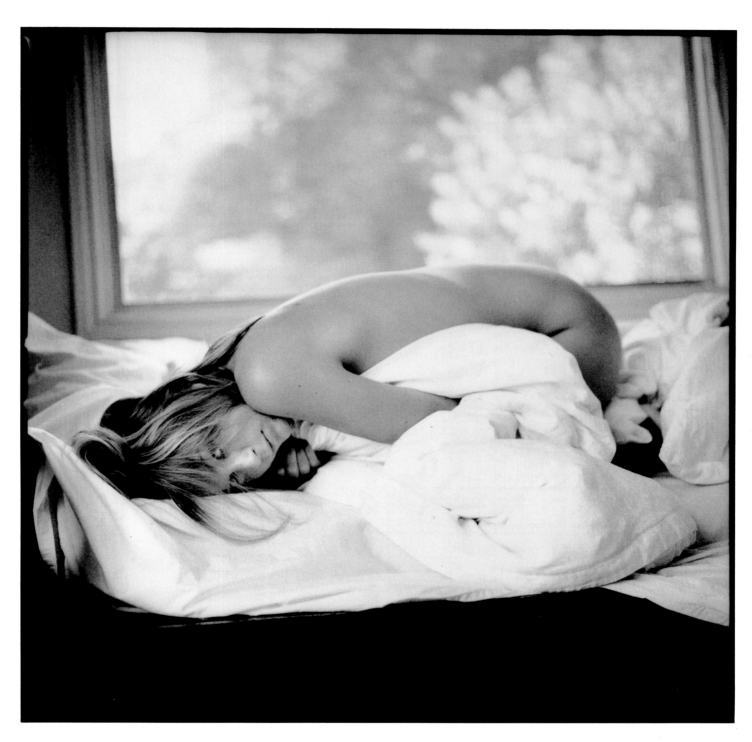

Georgina Cates, 9.17am

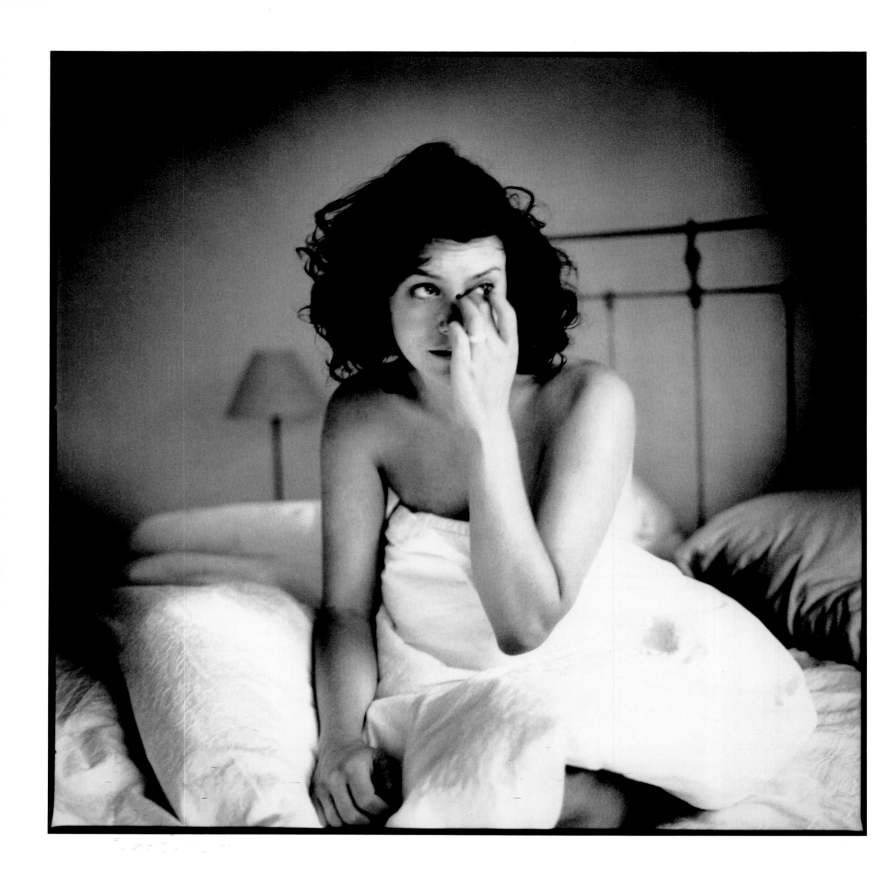

Ione Skye , 8.51 am

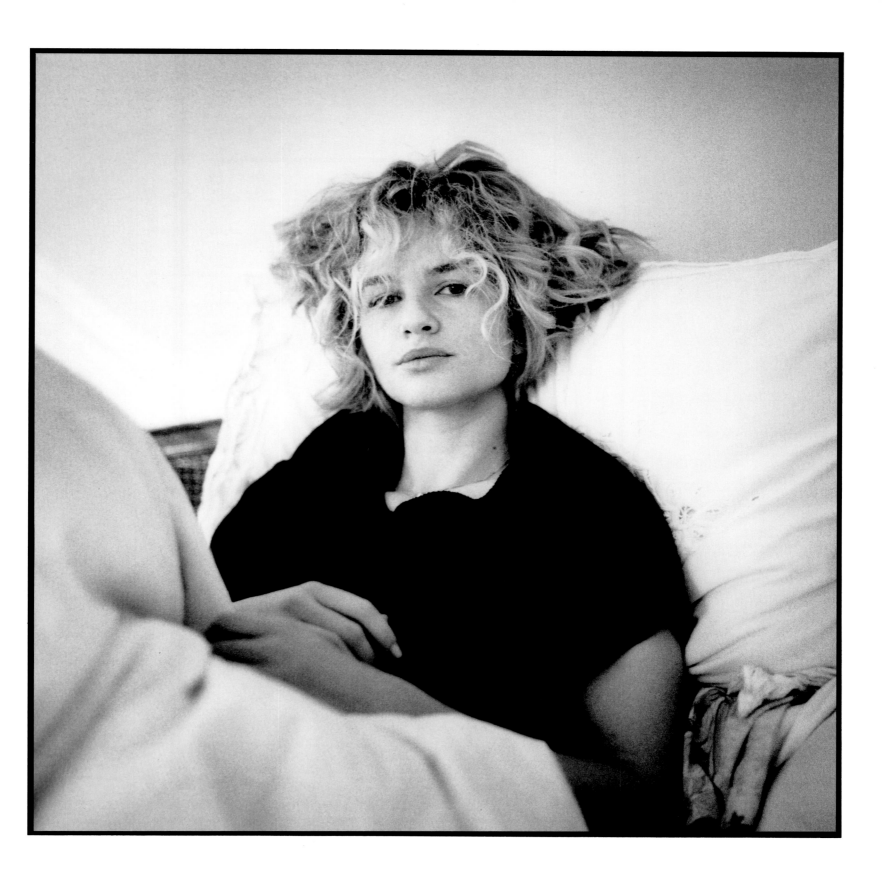

Isabelle Pasco, 9.00 am

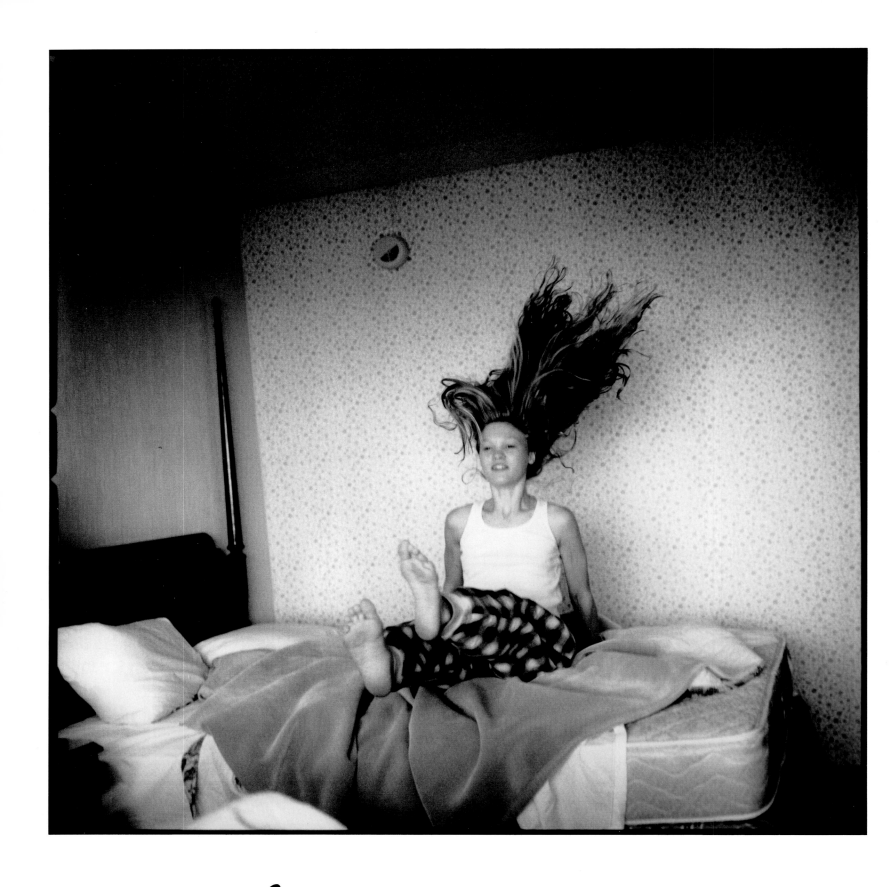

Julia Stiles, 9.01 am

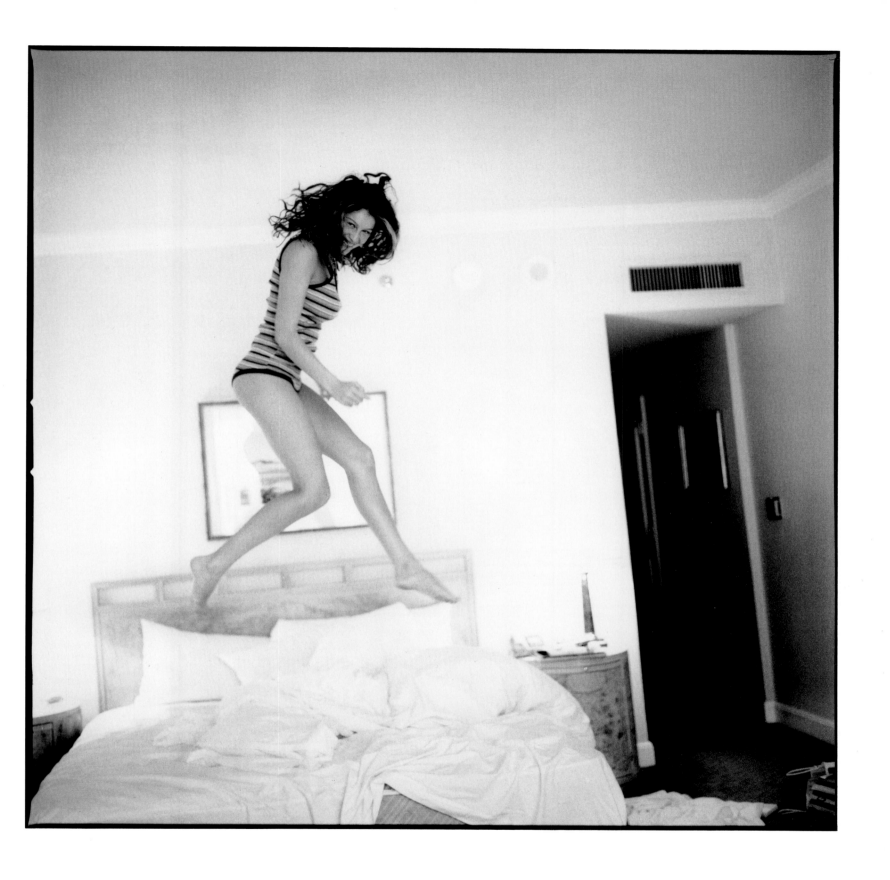

Laetitia Casta, 7.13 am

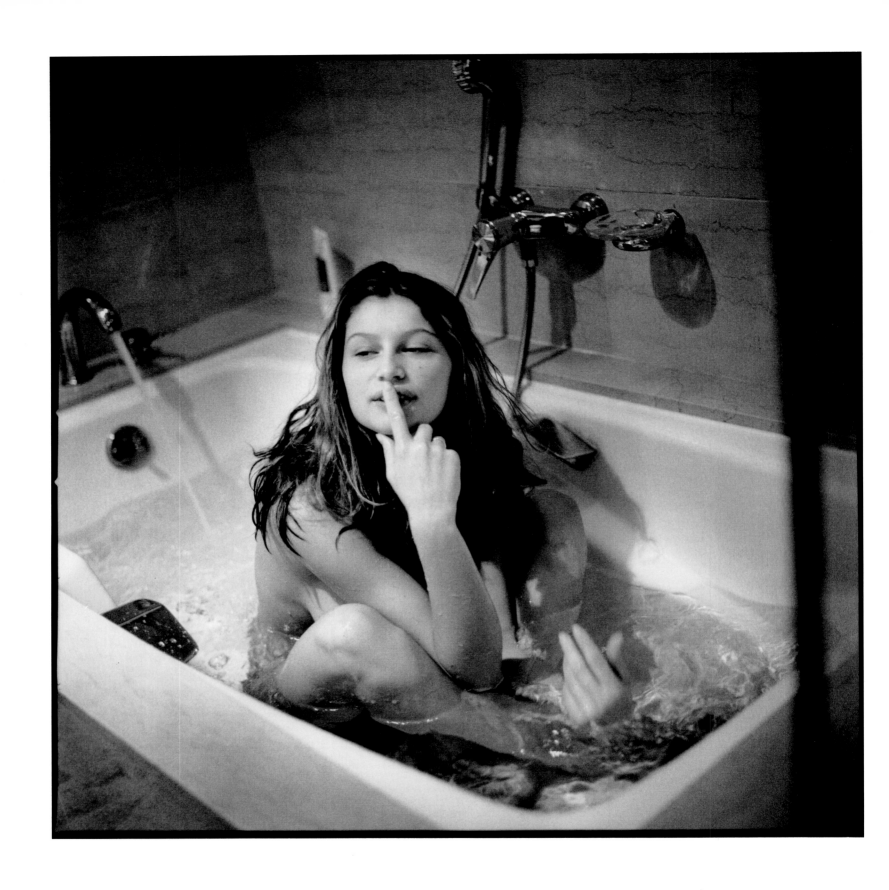

Laetitia playing in the bath . . .

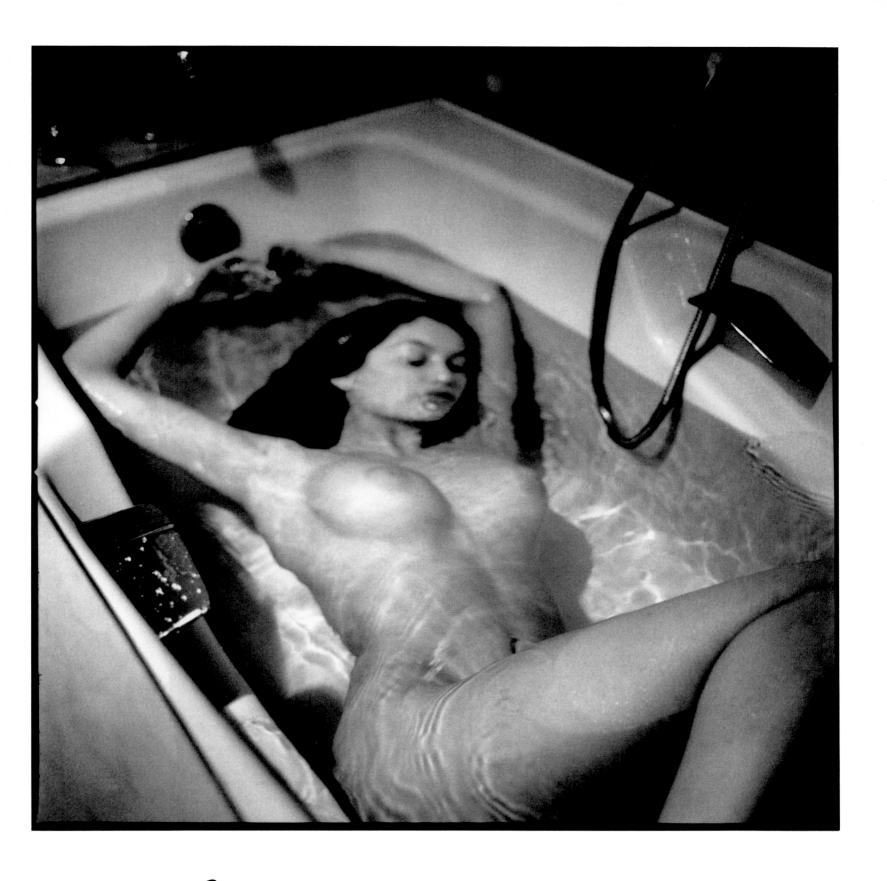

Laetitia under water !!!

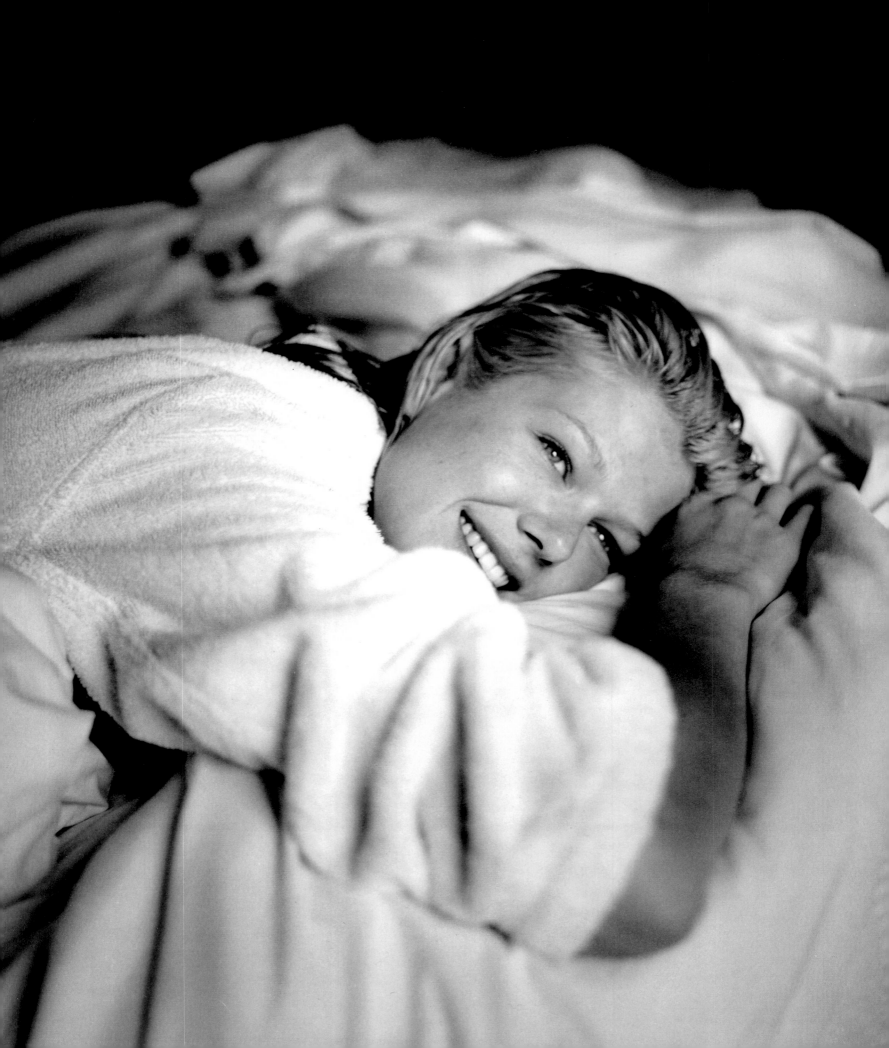

Ingrid Seynhaeve

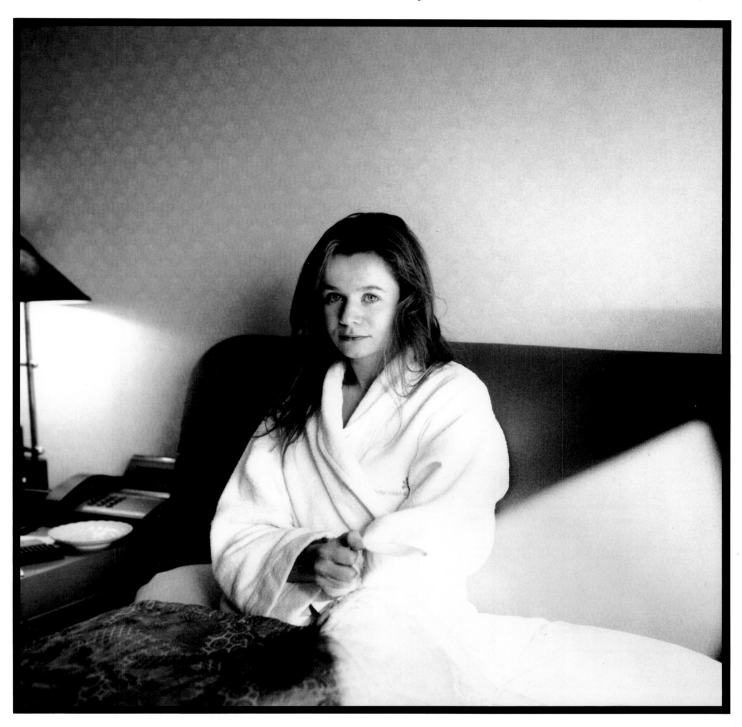

Emily Watson, 9:00 am

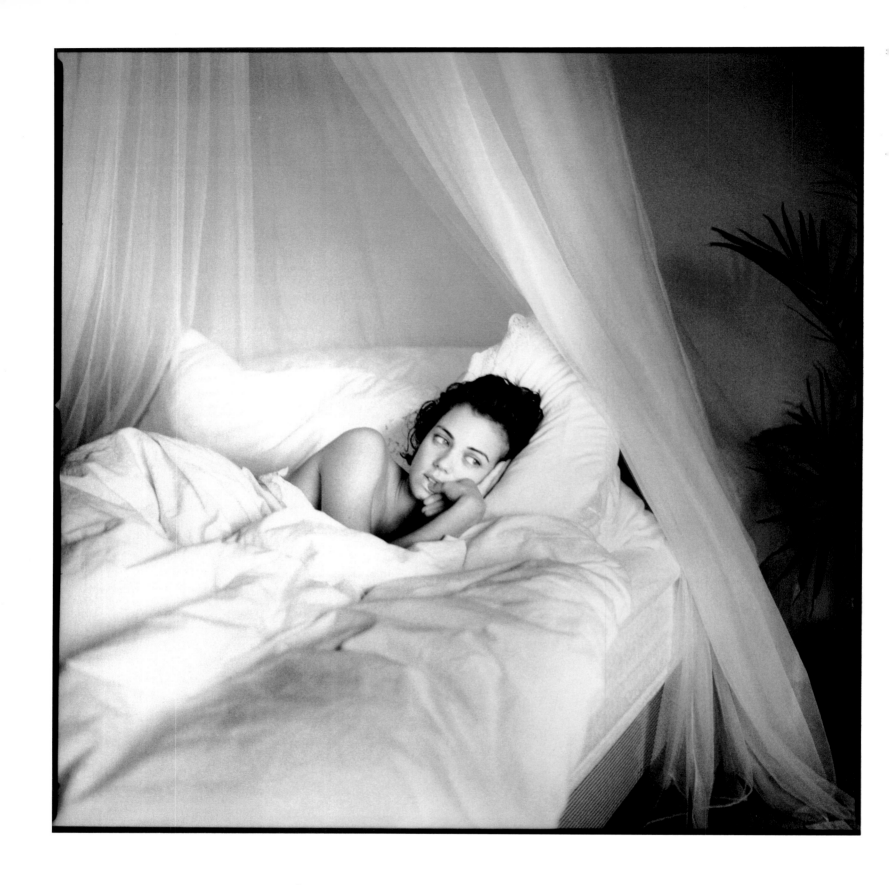

Mia Kirshner ...

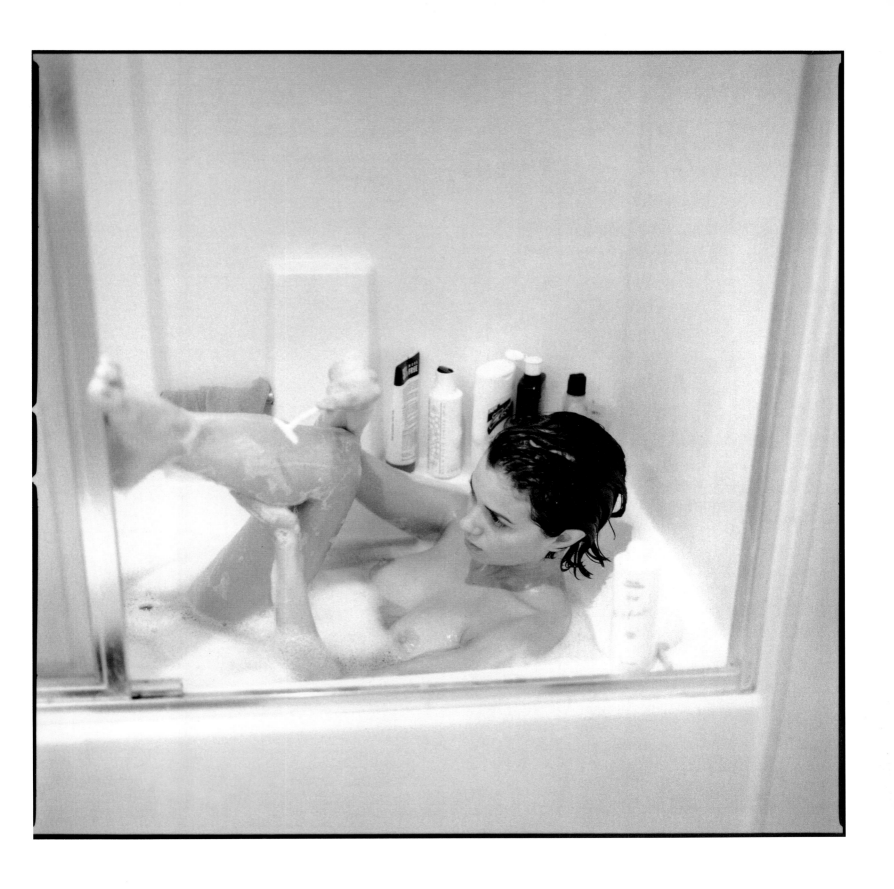

Los Angeles, 8.49am !!!

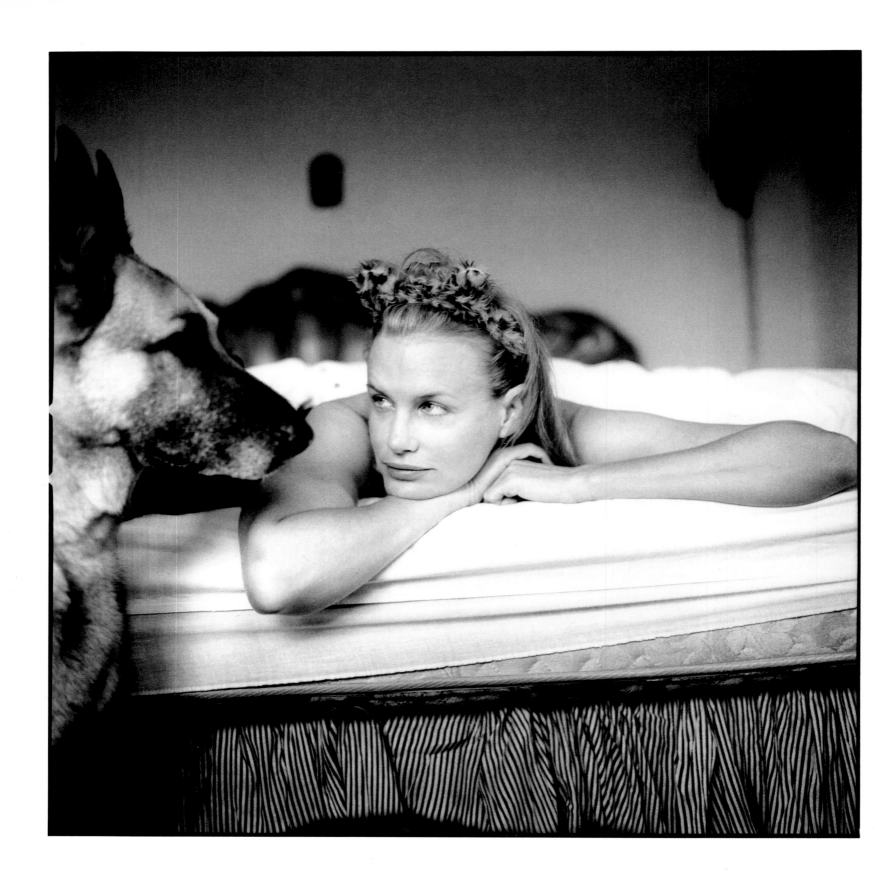

Daryl Hannah . . .

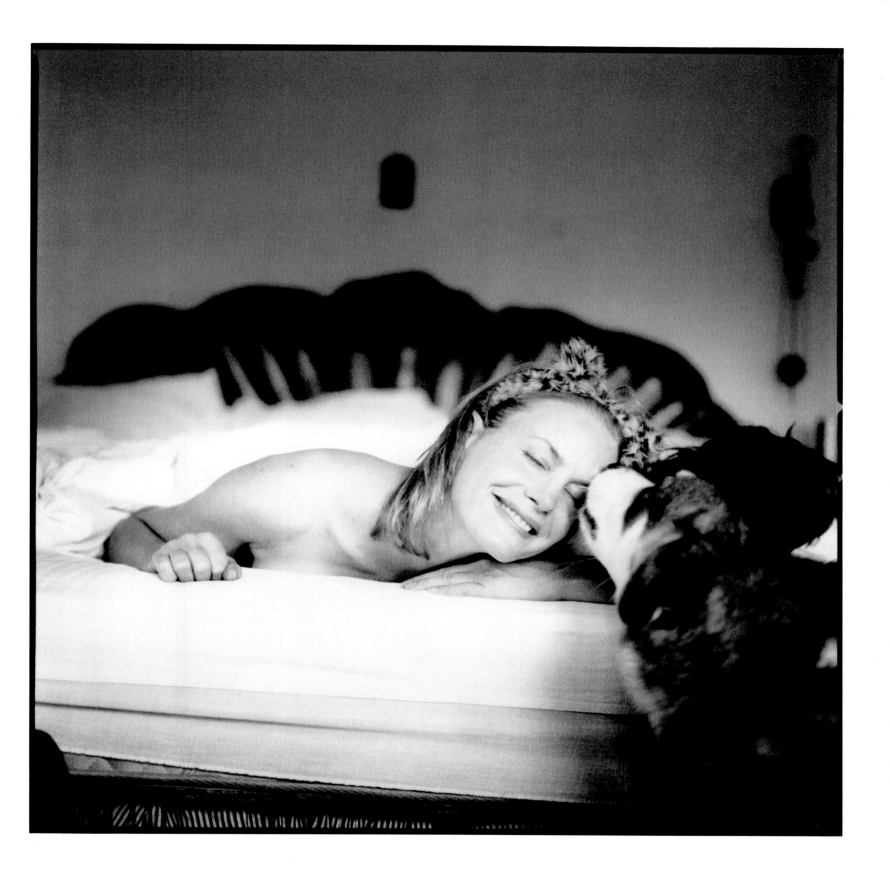

Santa Monica, 9.05am

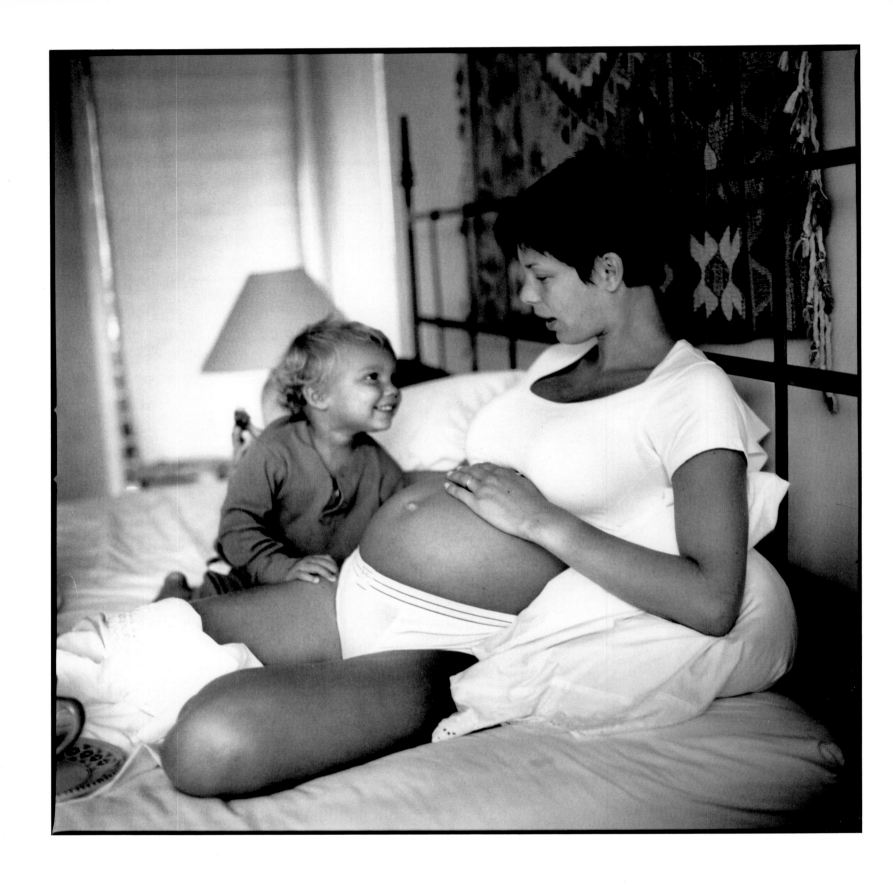

Sophia and Tess Medina , 9.01 am

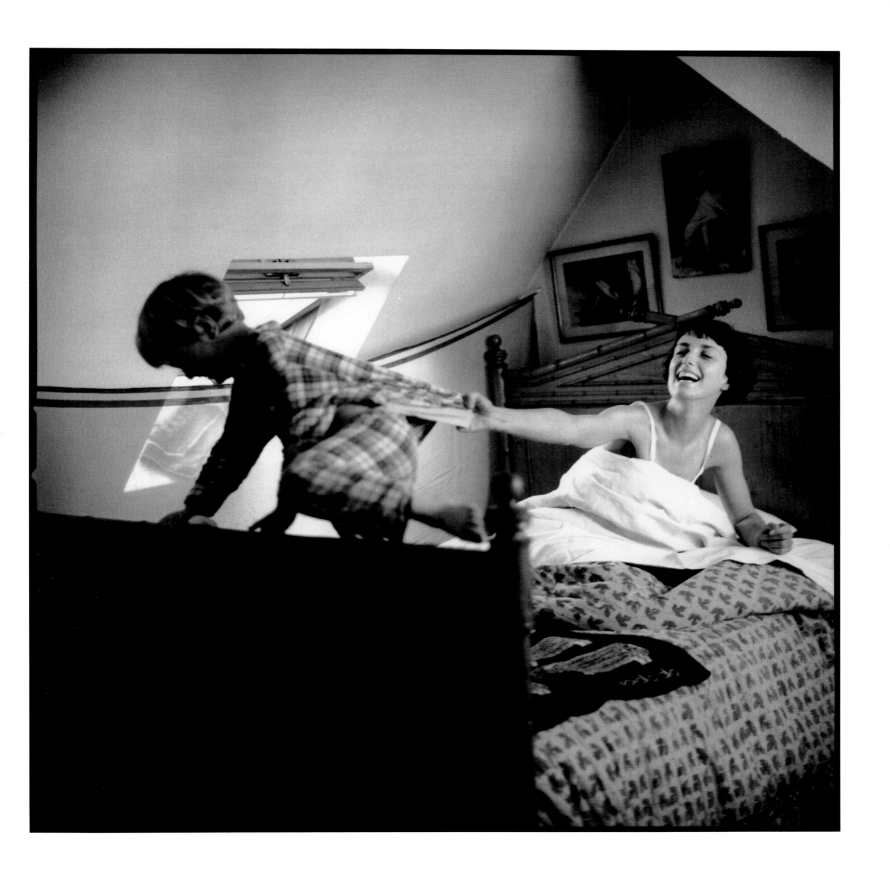

Charlotte Flossaut, 9.10am

Hollywood

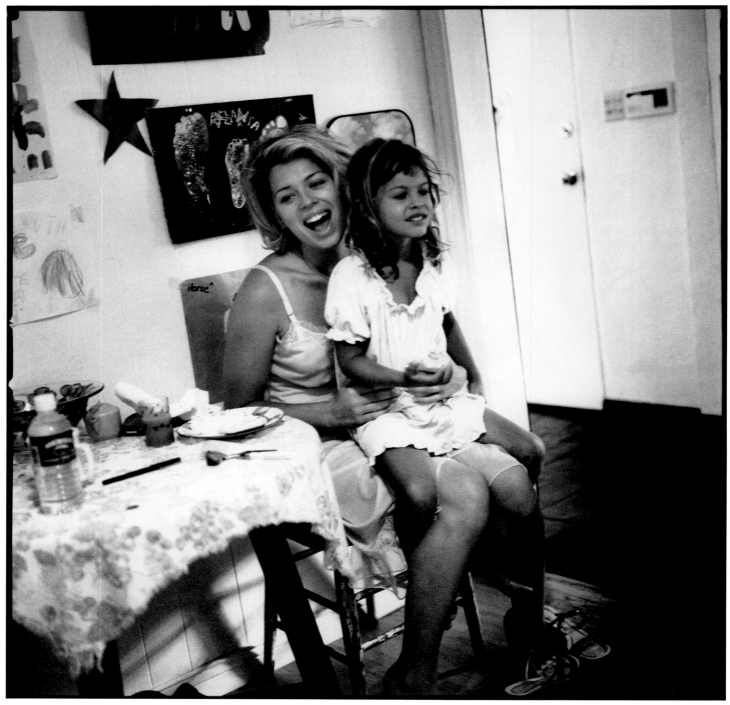

Amanda De Cadenet

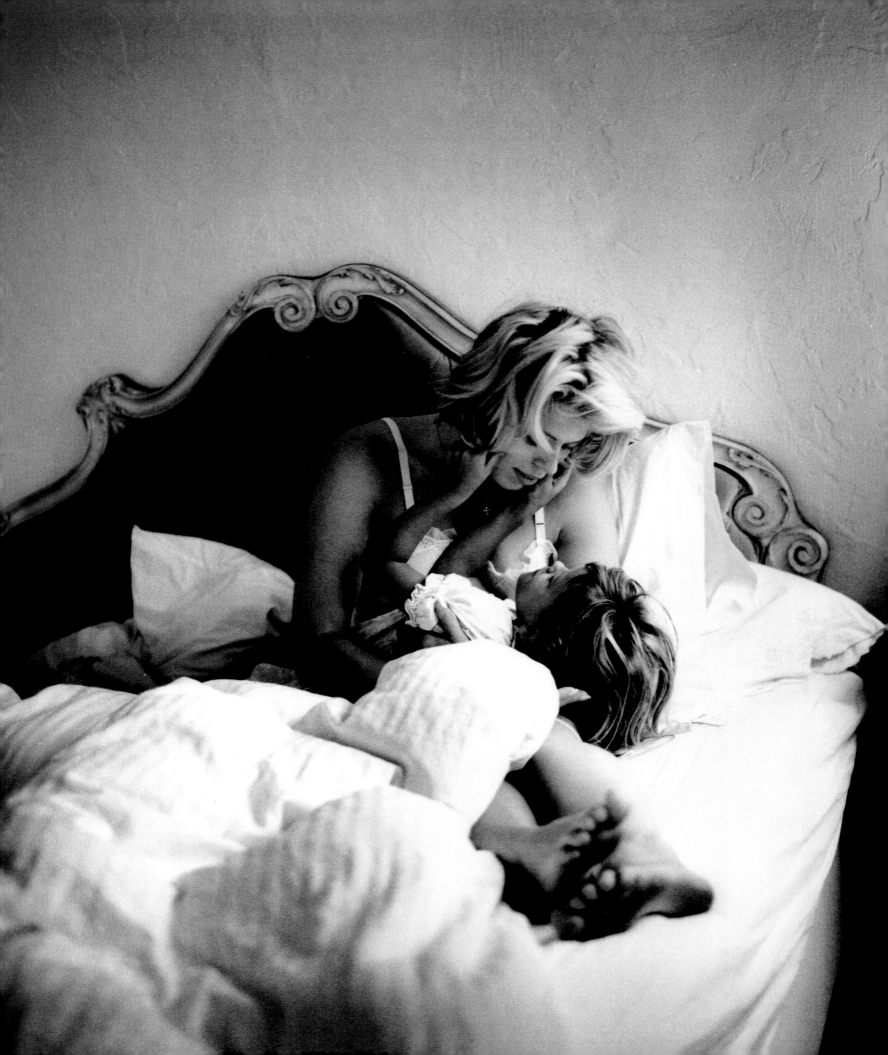

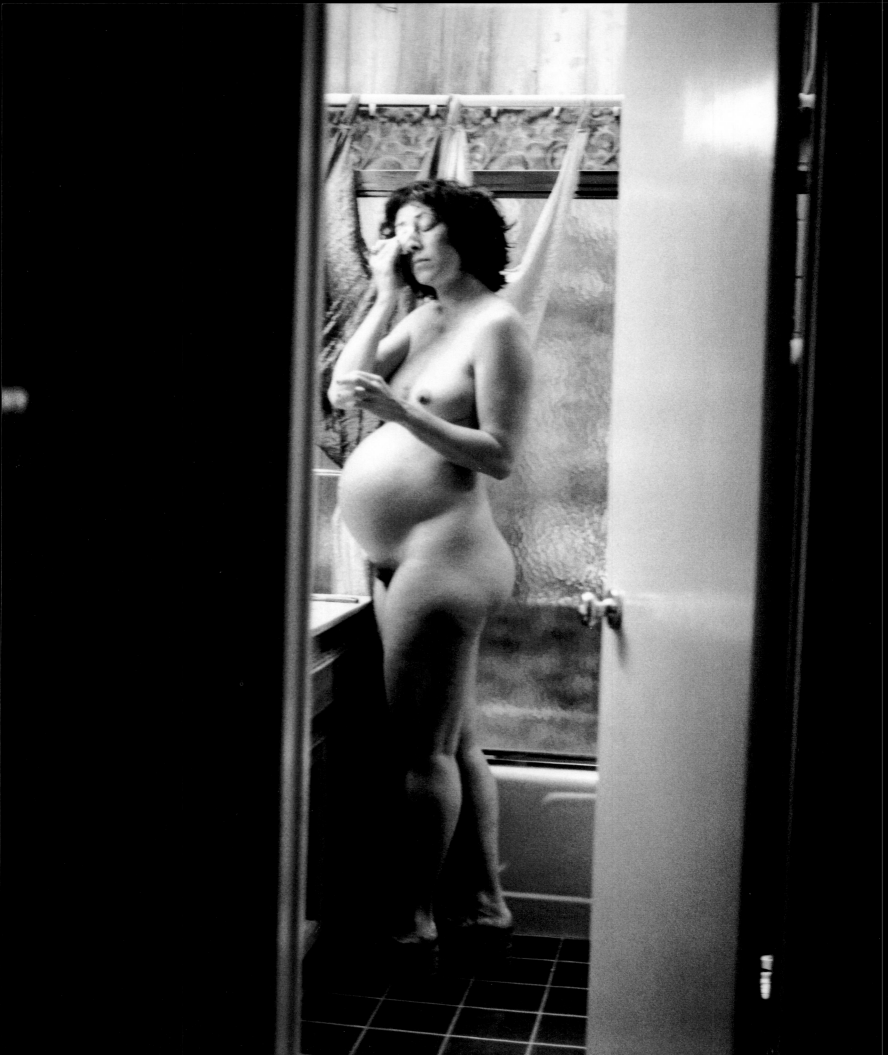

Topanga Canyon

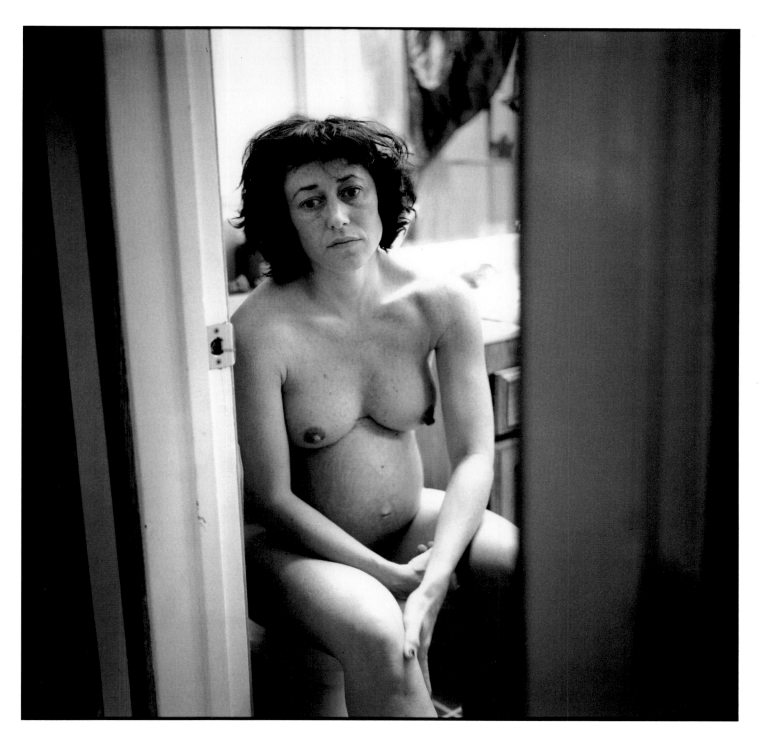

Elisa Bonora, 8.49 am

Deborah was surrounded by a mosquito net and looked like a mermaid in her seaweed tent !!!

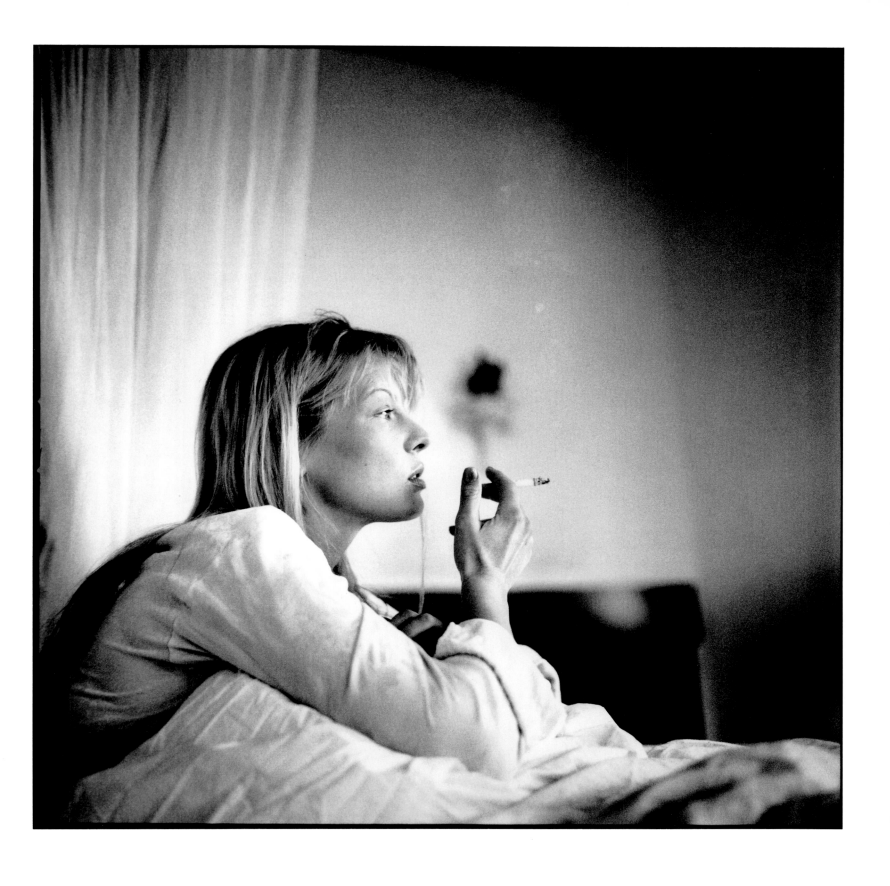

Deborah Unger, 9.40am

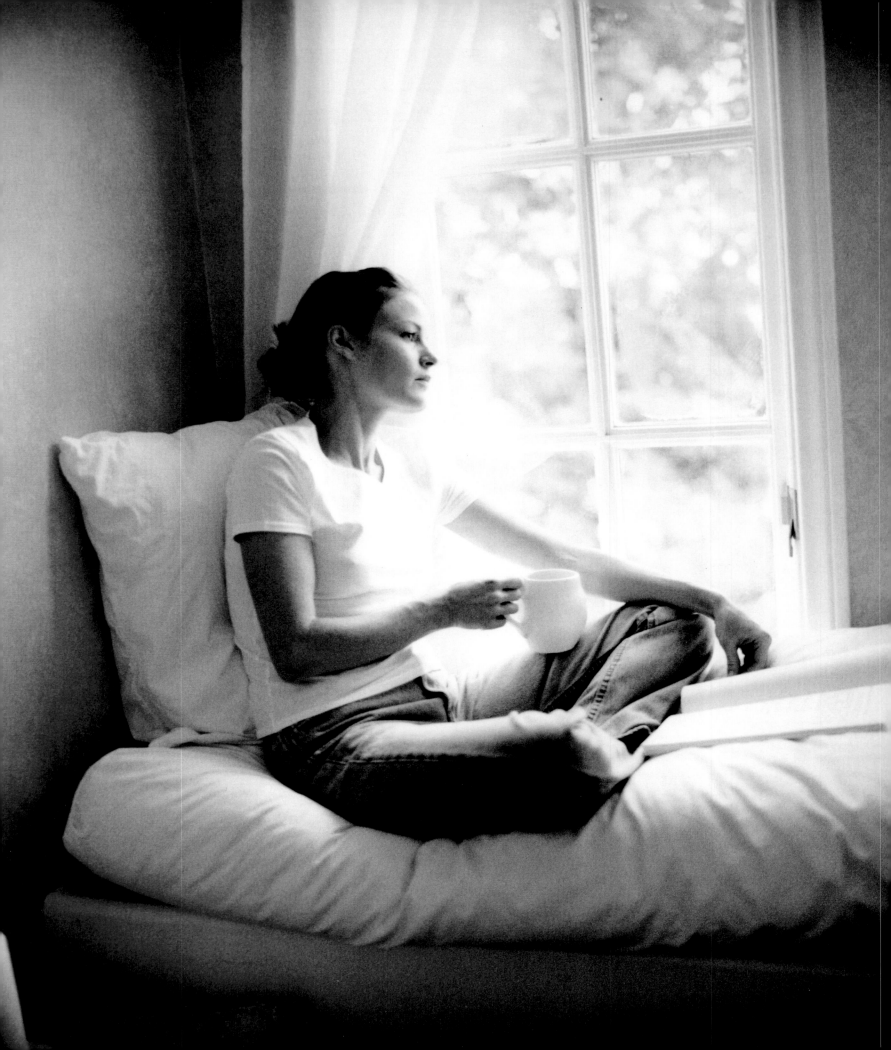

Laura Leighton

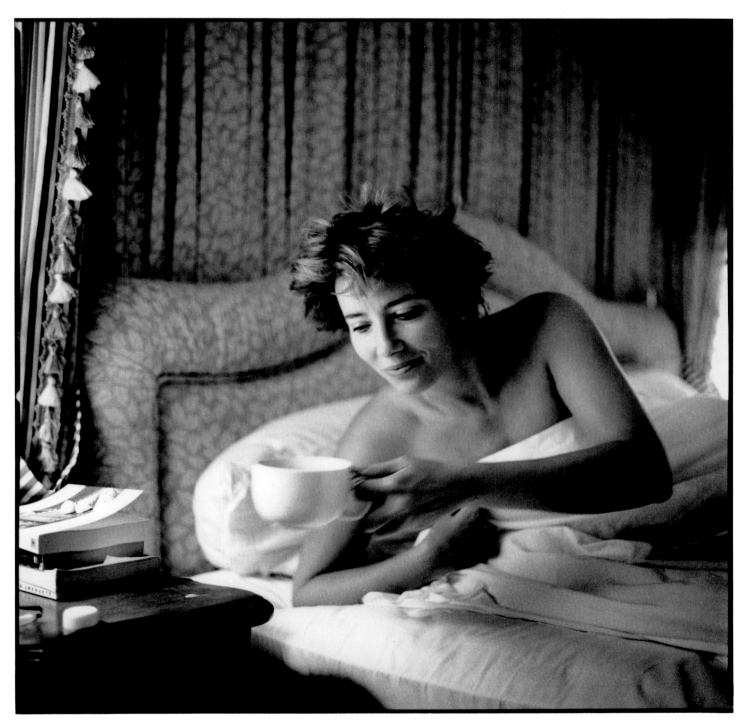

Emma Thompson, 7.58am

Emma was so tired from many weeks of shooting; I caught her on her only day off. She was surrounded by books, magazines, scripts, and a good looking boyfriend who brought her a very special surprise for breakfast!

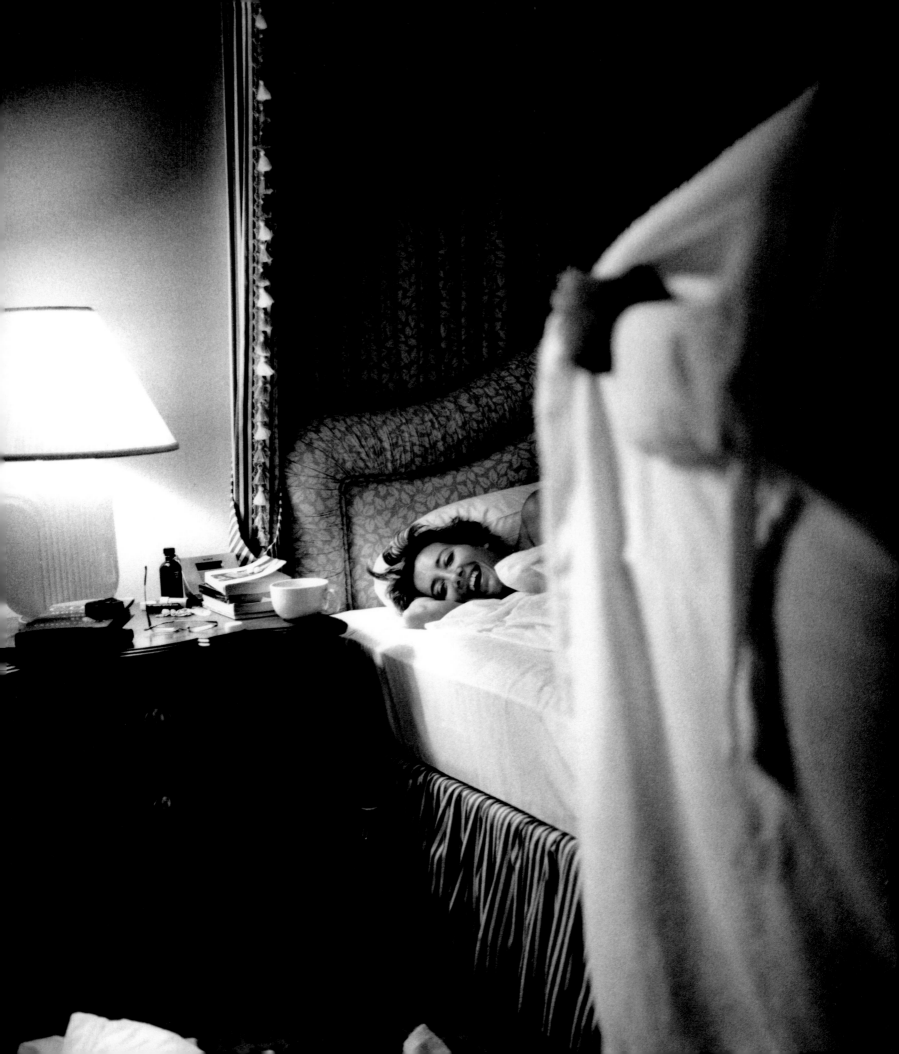

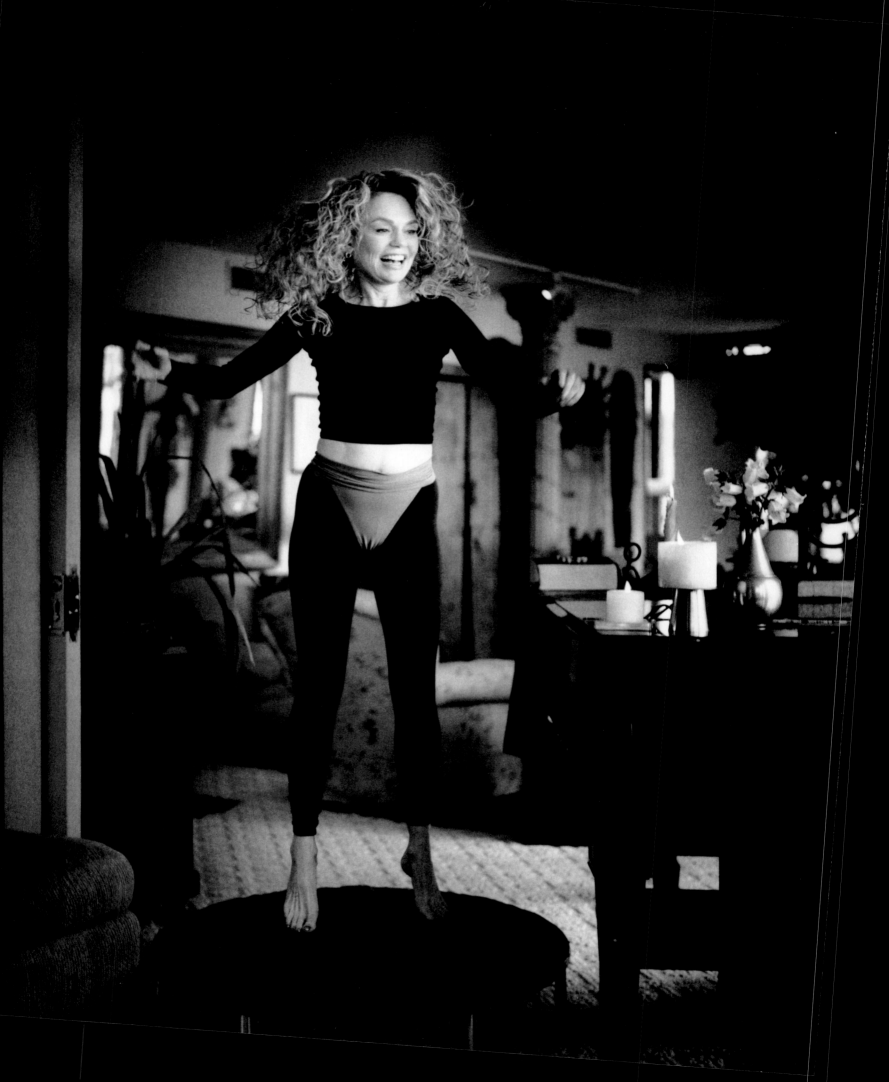

← Dyan Cannon

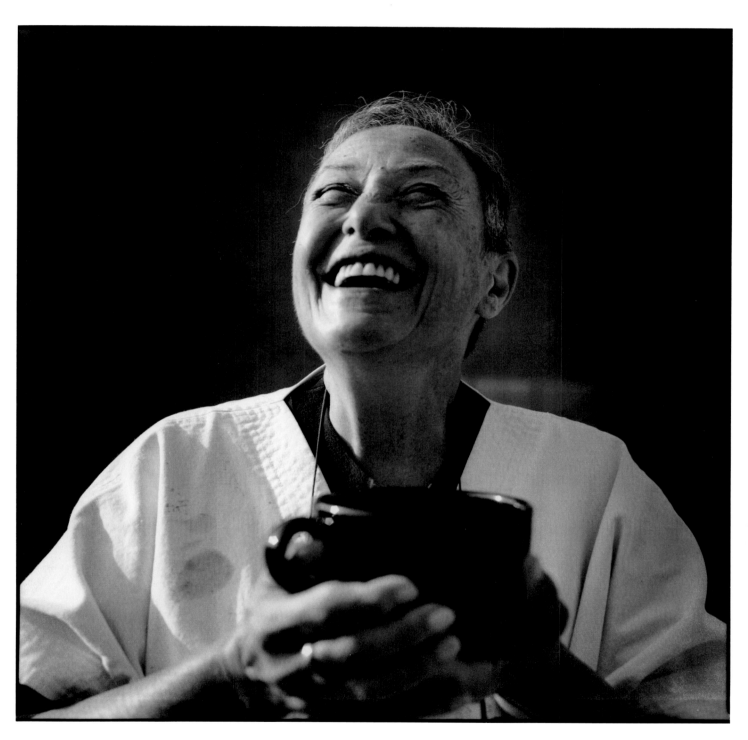

Huguette Caland, 9.00 am

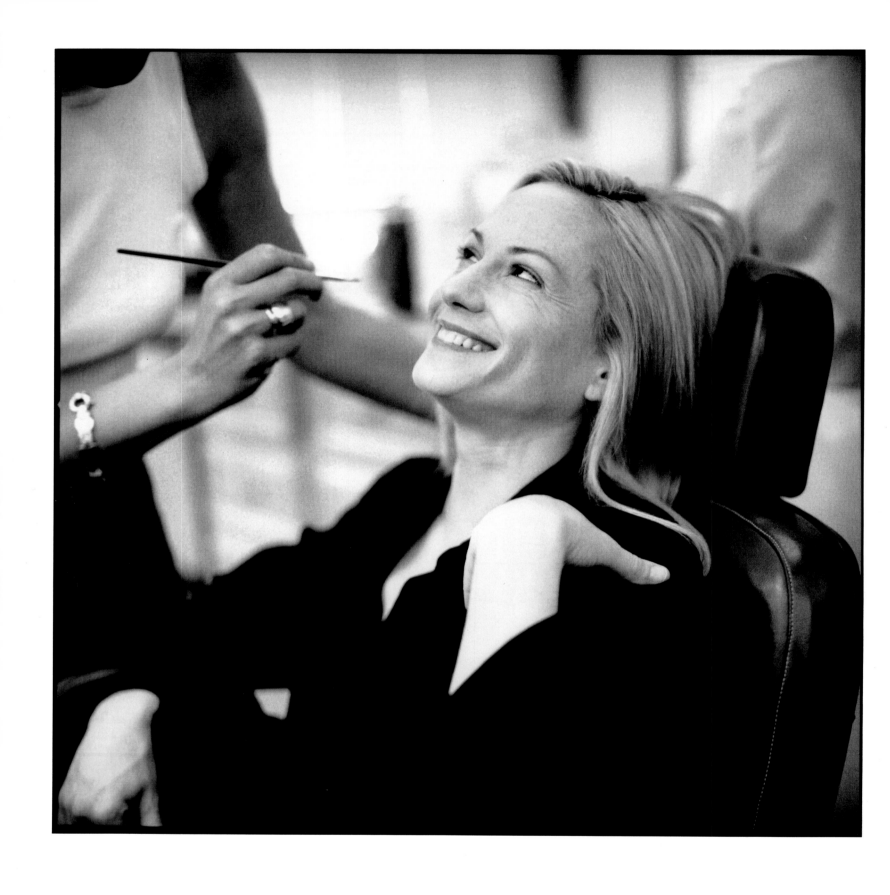

Holly Hunter, 9.15 am

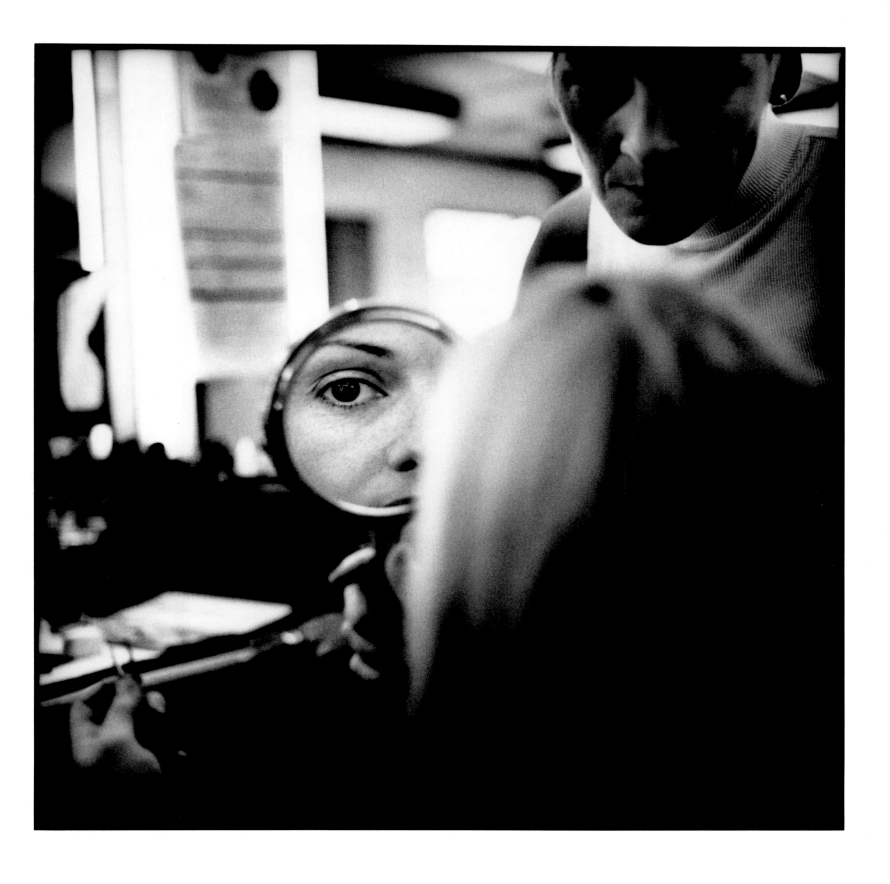

Holly and Kathrine James ...

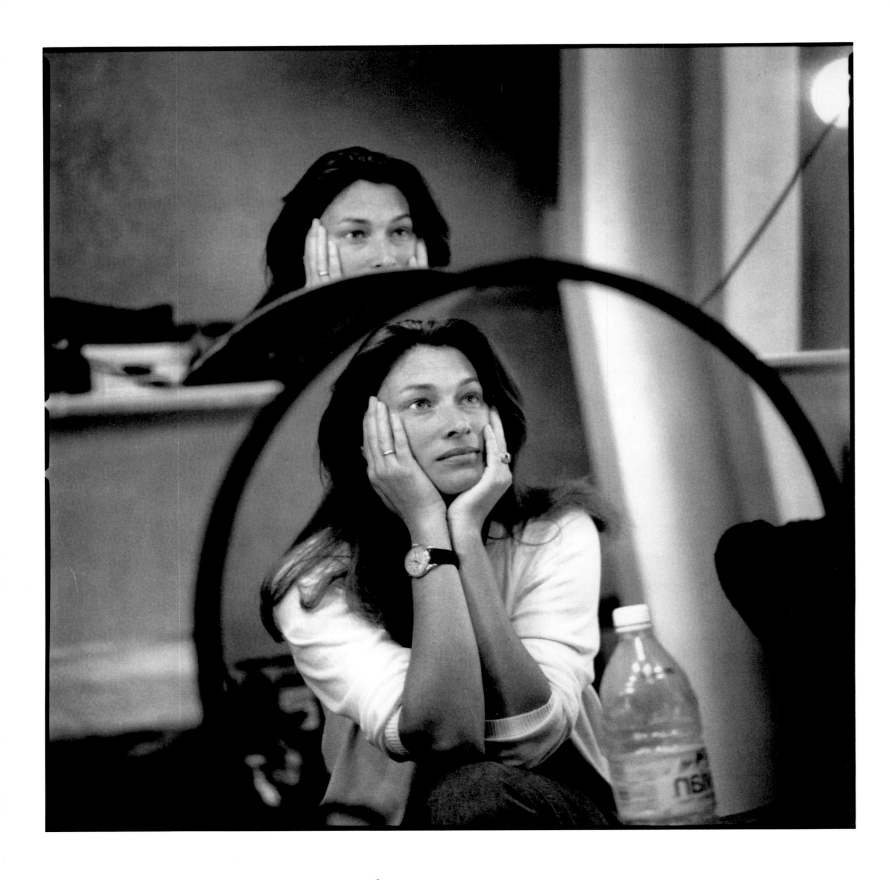

Rosemary McGrotha, 9.59am

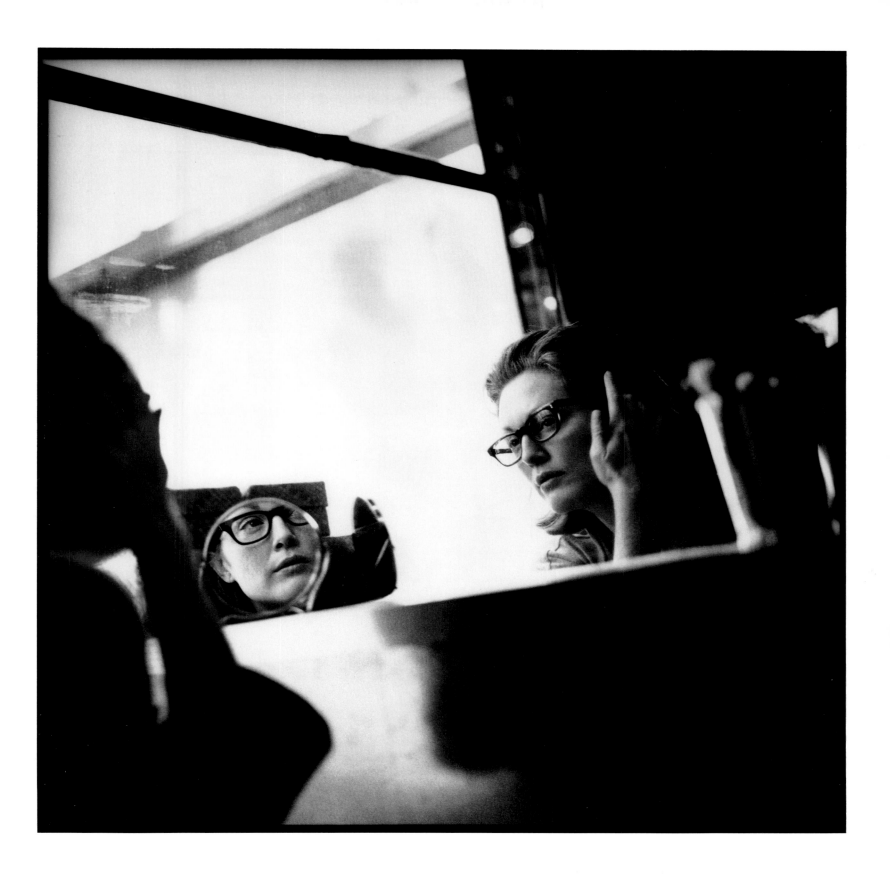

Julianne Moore, 9.27am

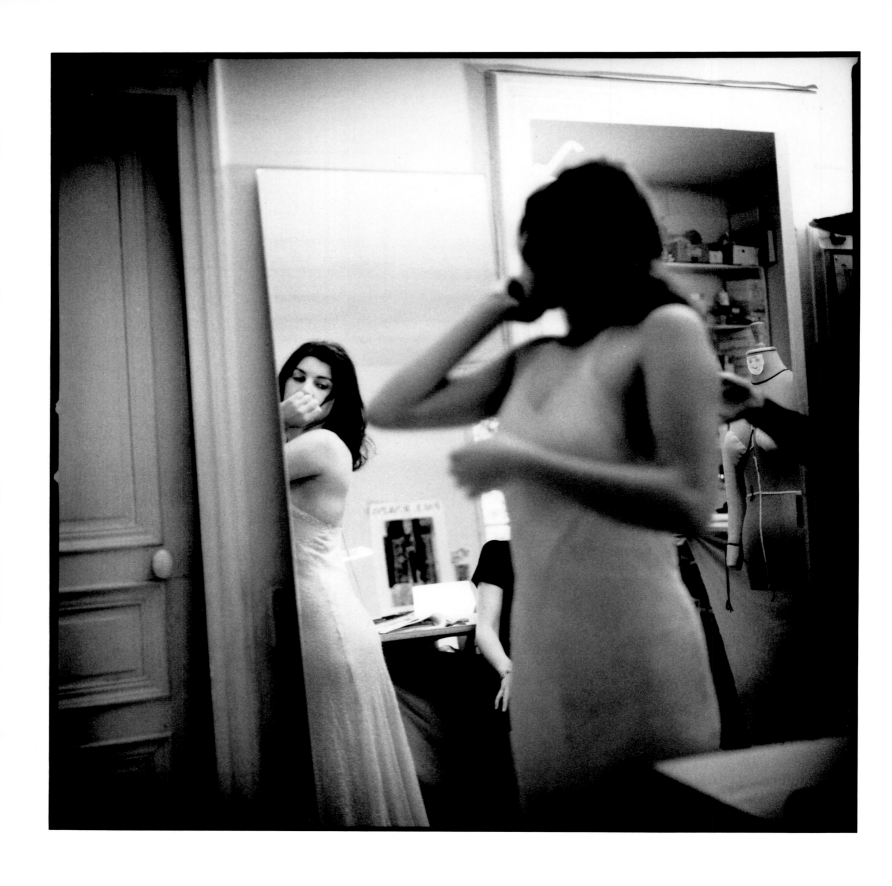

Clara Bellar, 9.43 am

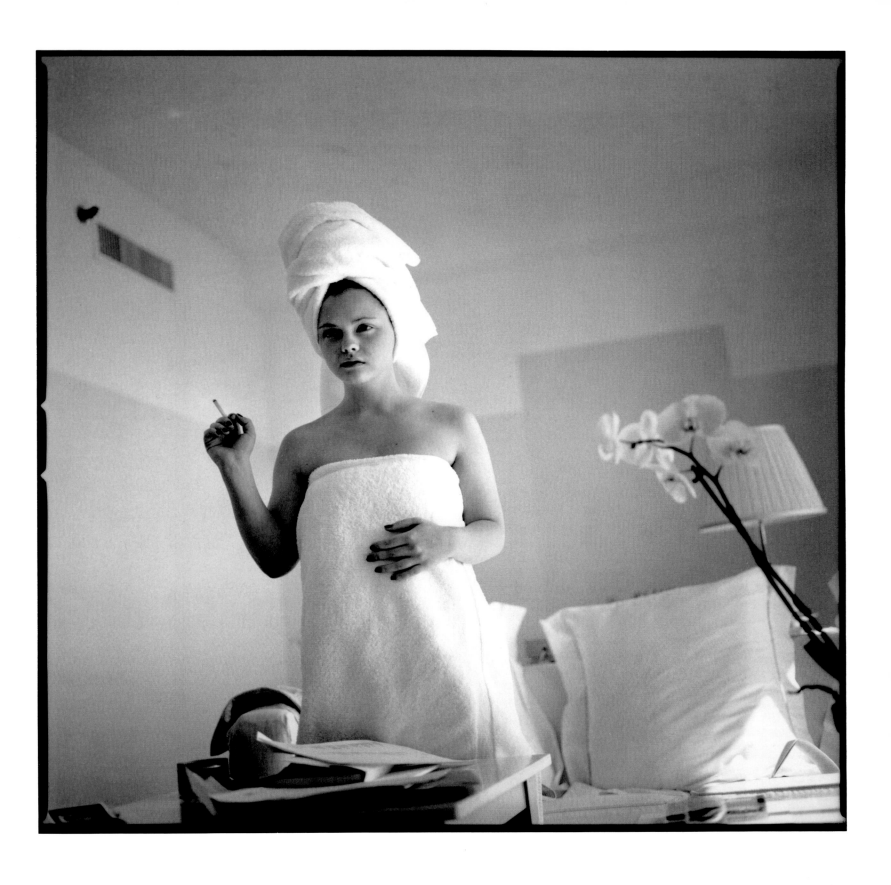

Christina Ricci , 7.50 am

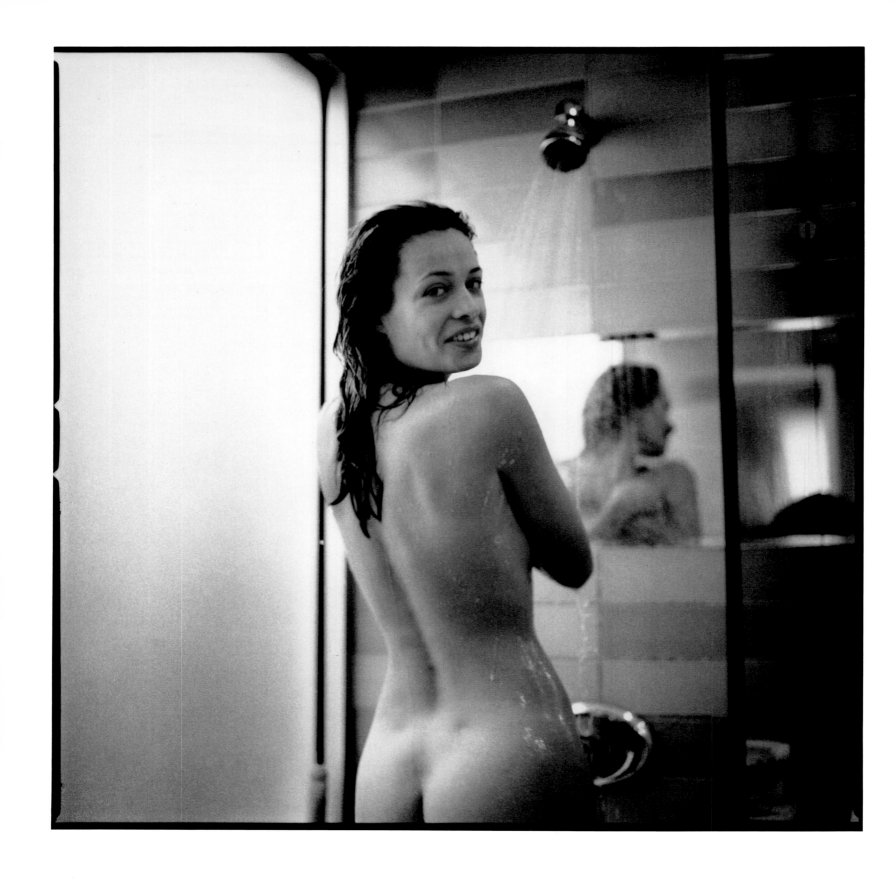

Frédérique van der Wal . . .

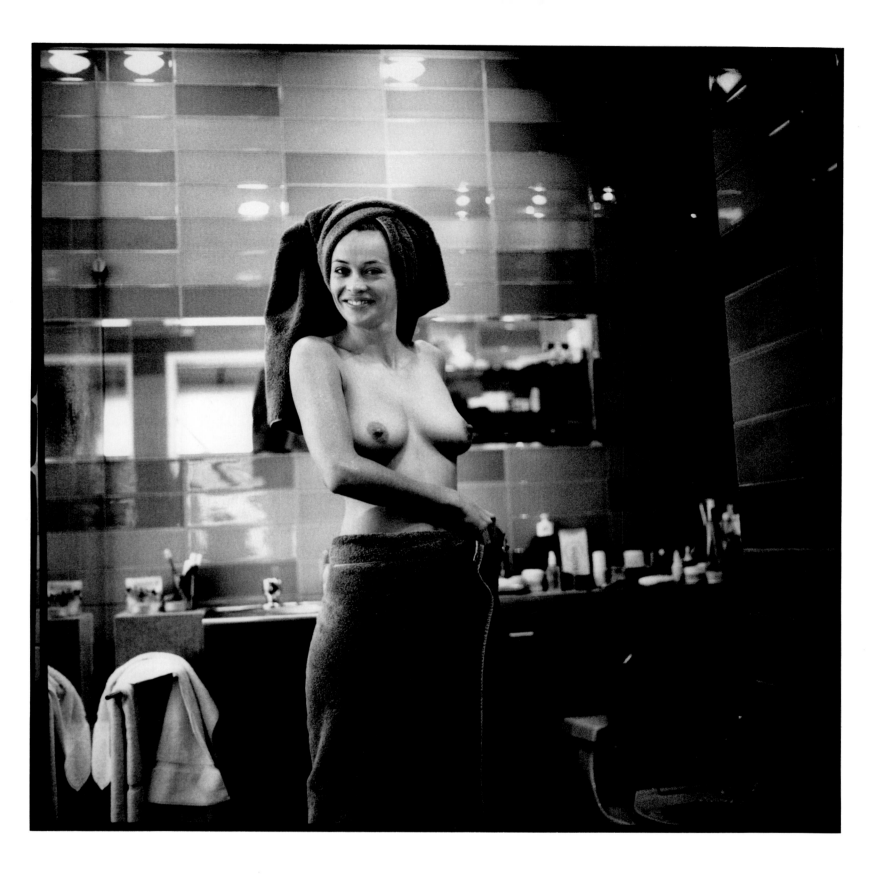

New York !!!

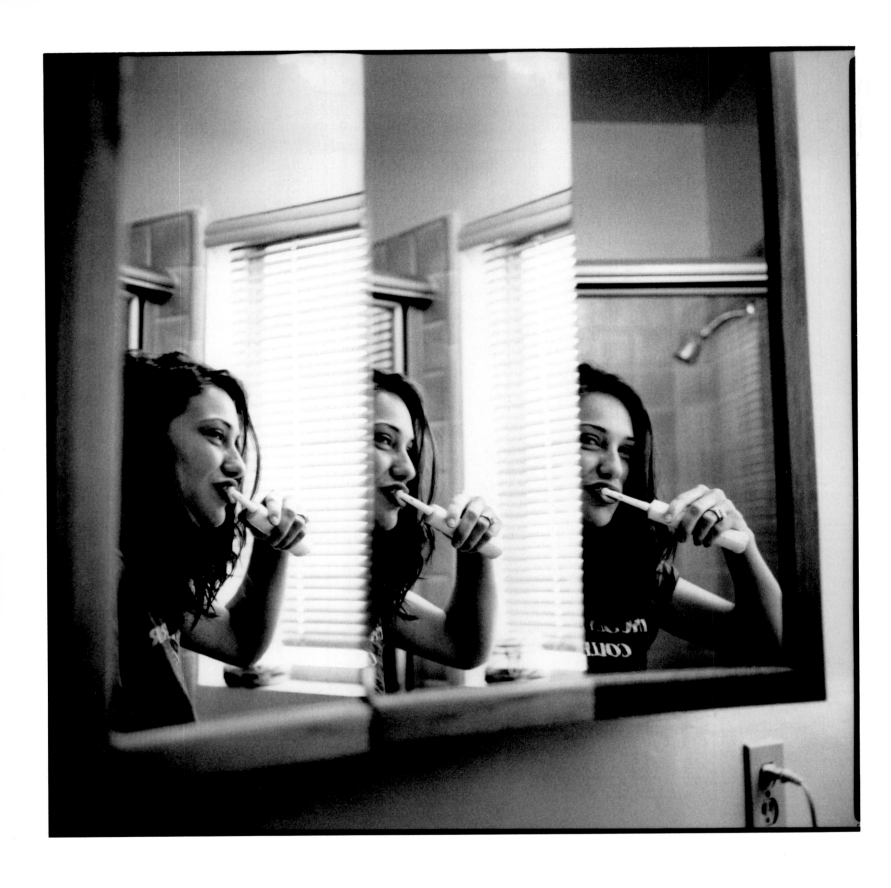

Claire Forlani, 8.58 am

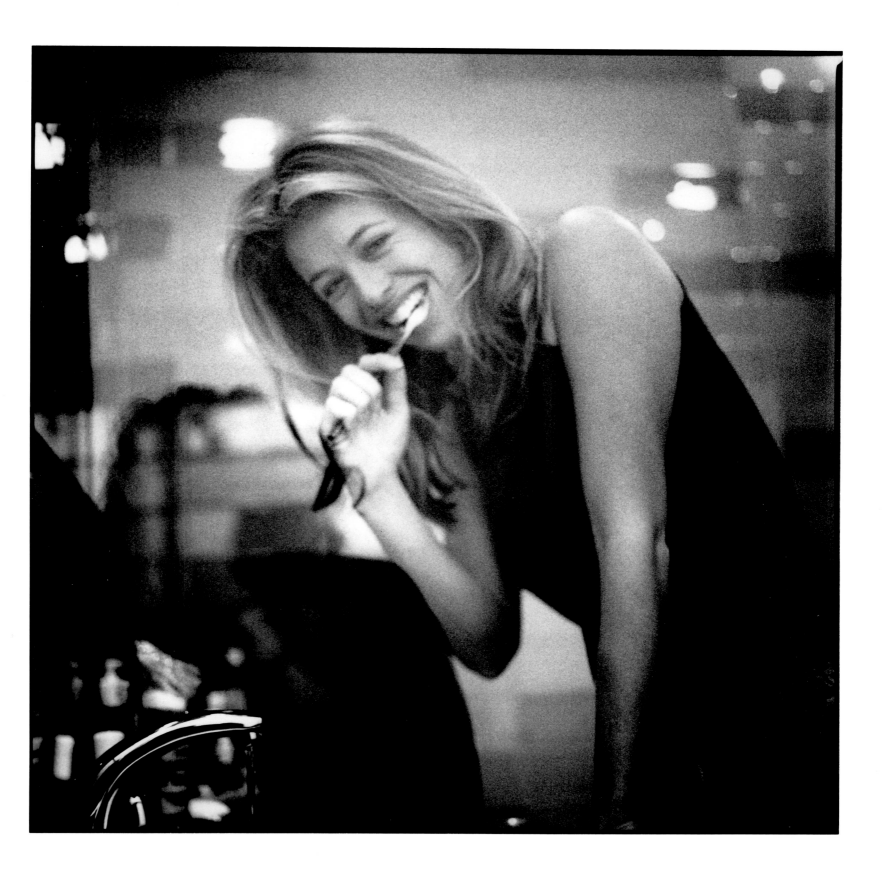

Frédérique, 9.41 am

Denise Richards →

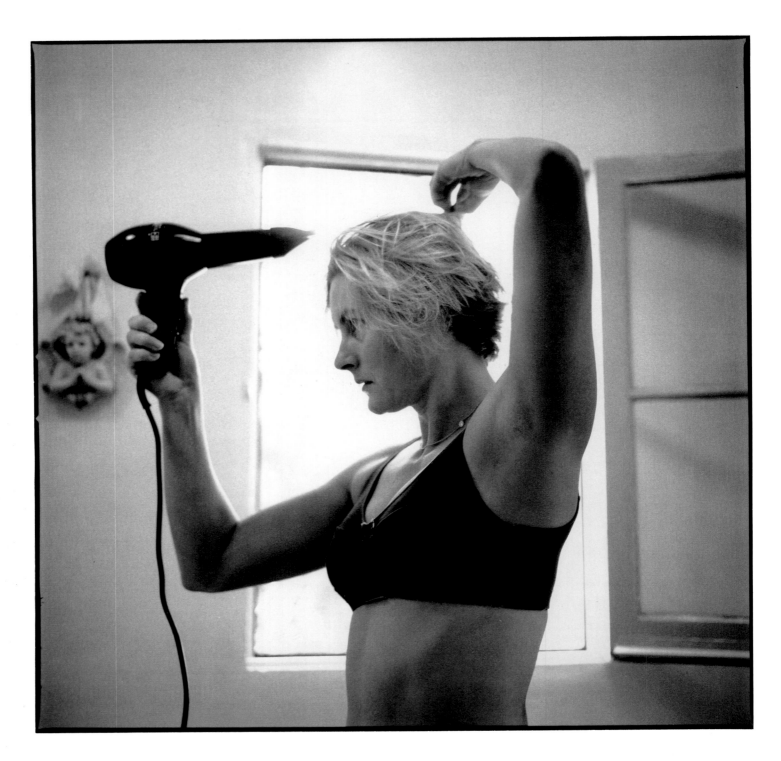

Denise Crosby, 9.15 am

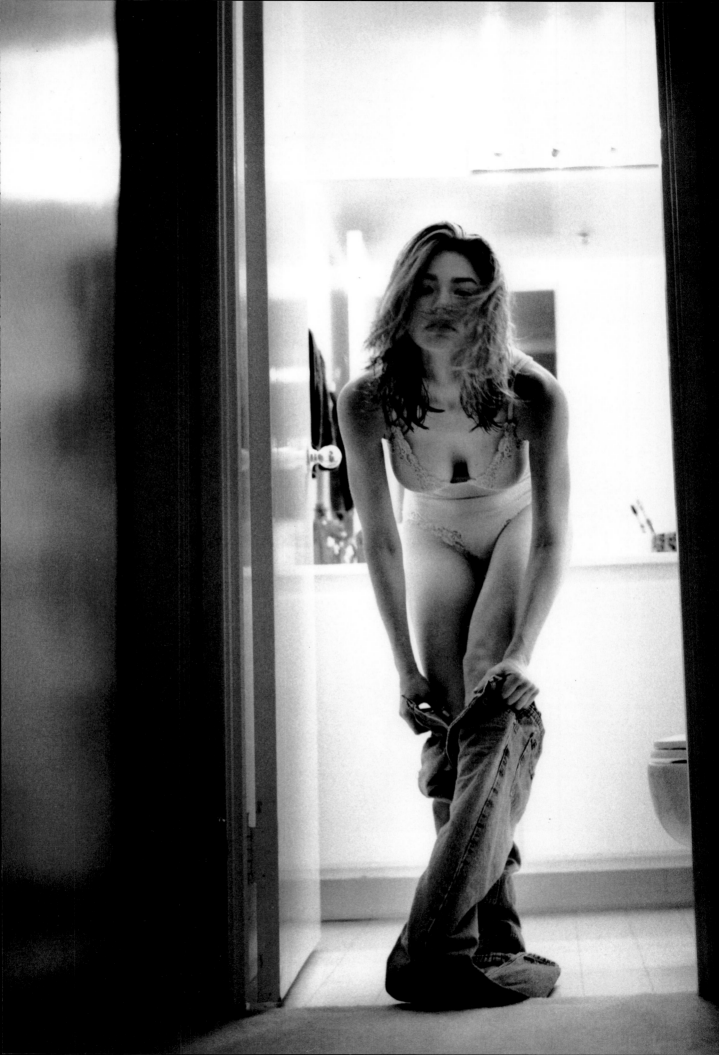

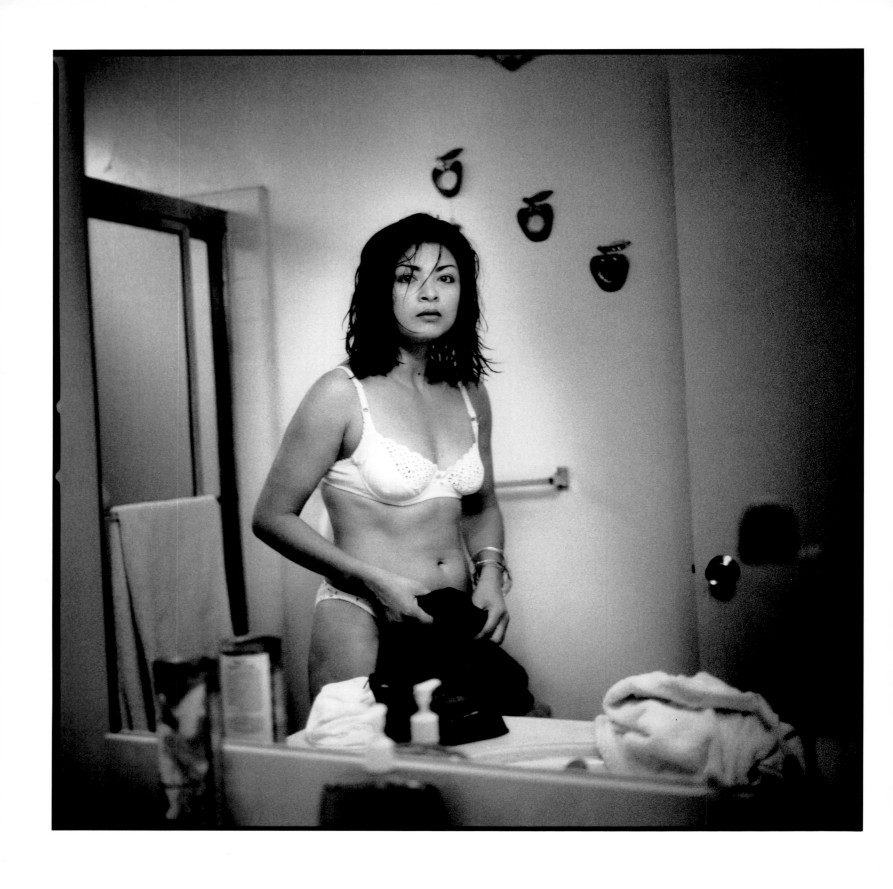

Elpidia Carrillo, 9.05am

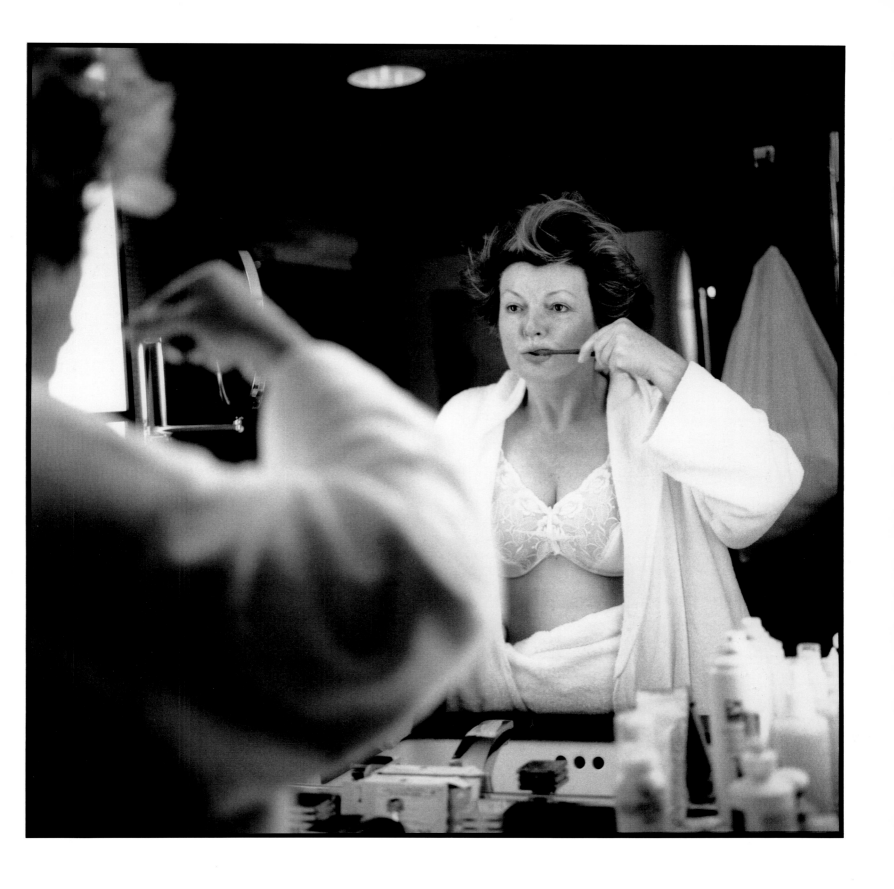

Brenda Blethyn, 8.00 am

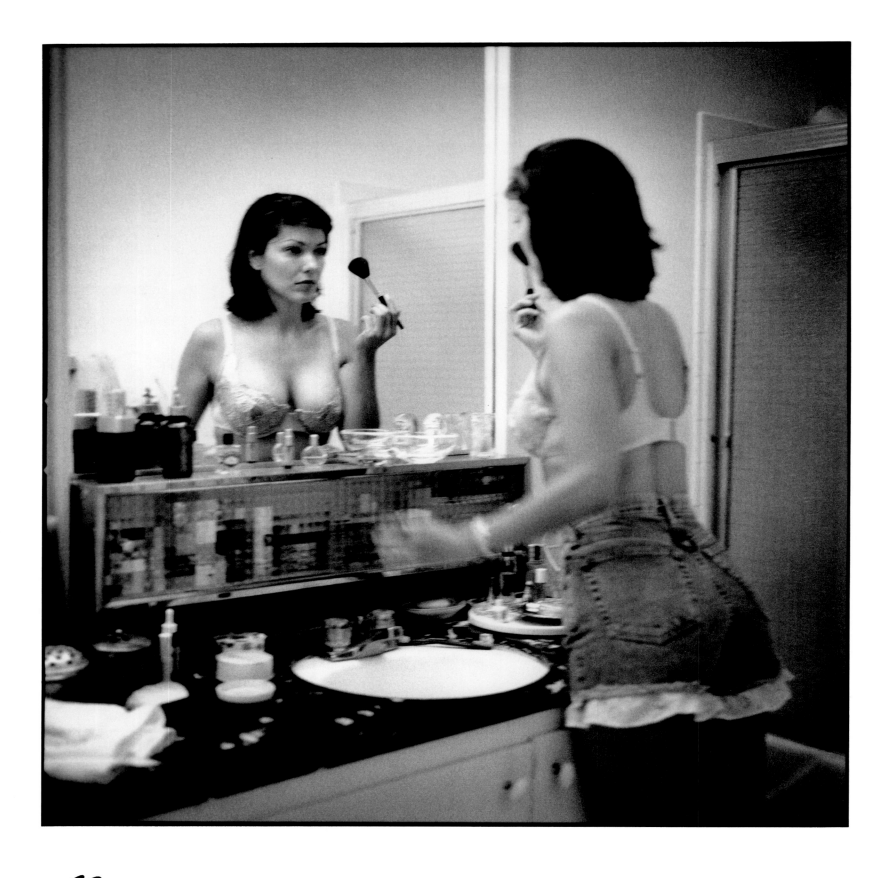

Laura Harring Von Bismark , 8.58am

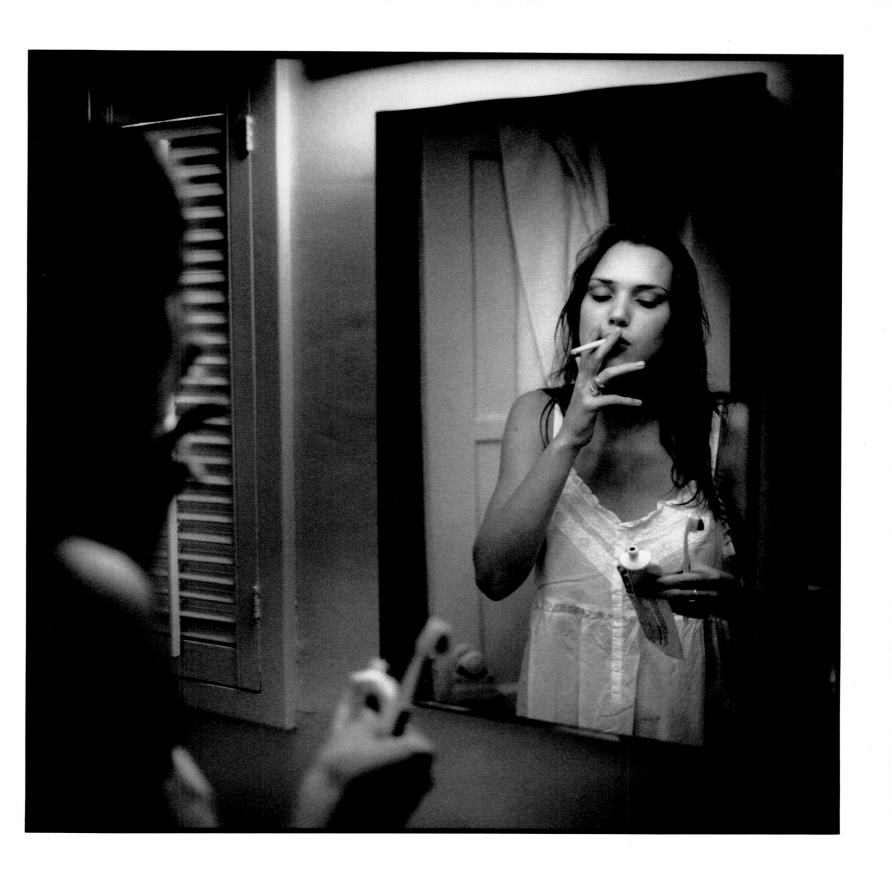

Stephanie Smith, 9.03 am

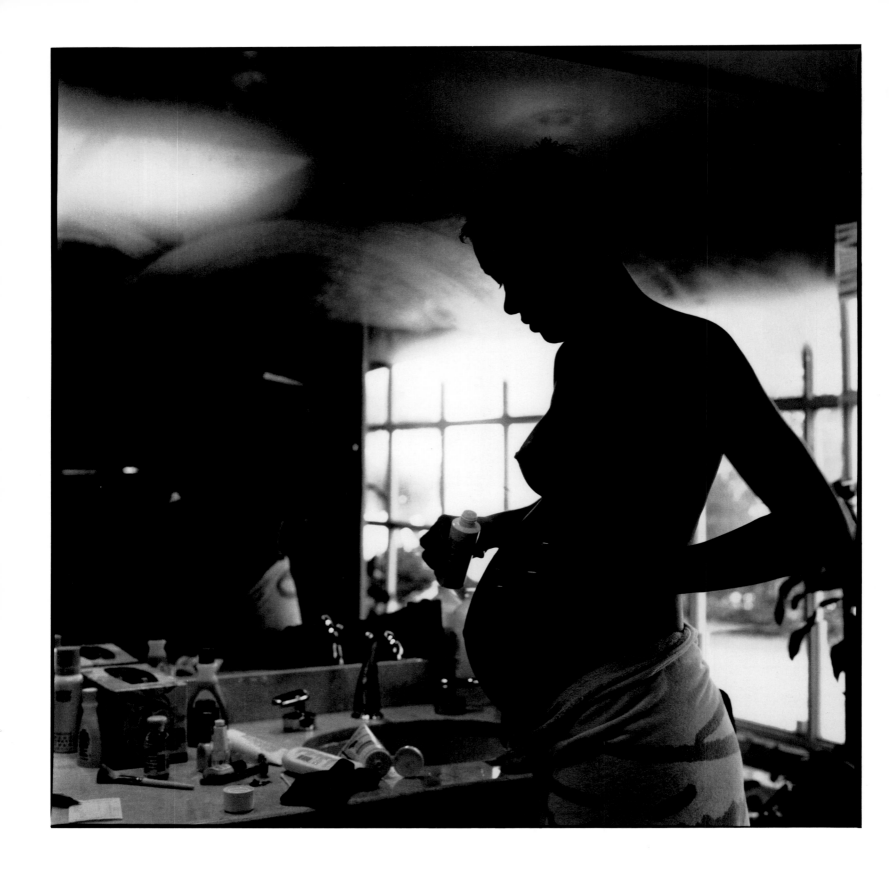

Rizia Moreira, 9,55 am

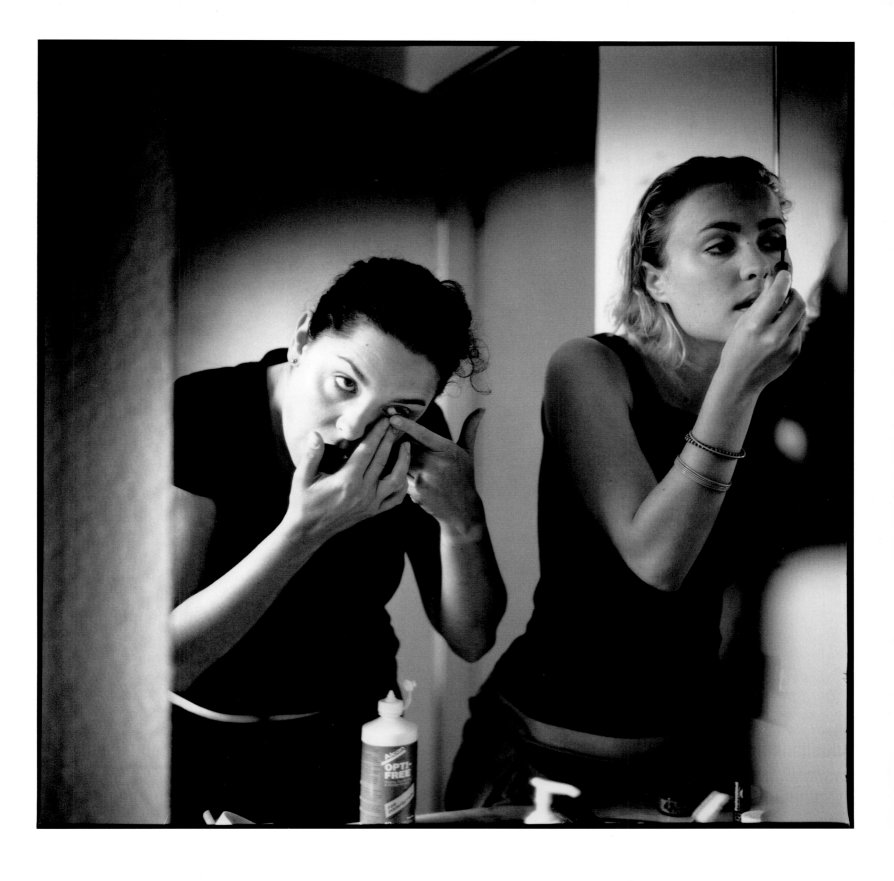

Yael Bergman and Rahda Mitchell 9.35 am

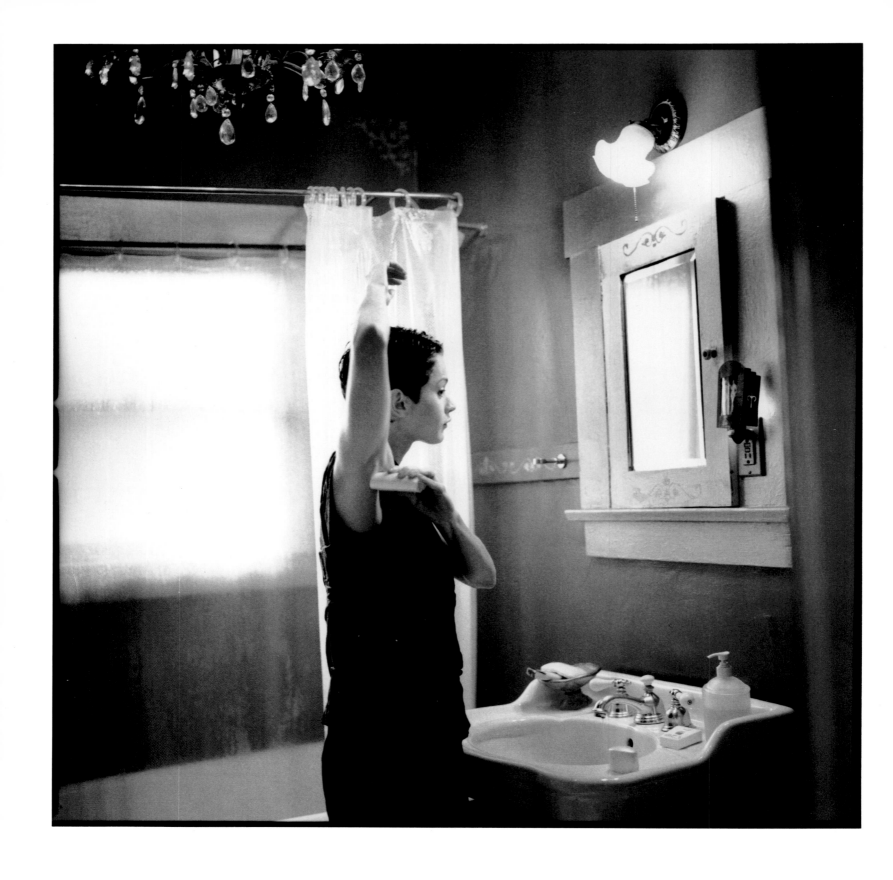

Robin Tunney . . .

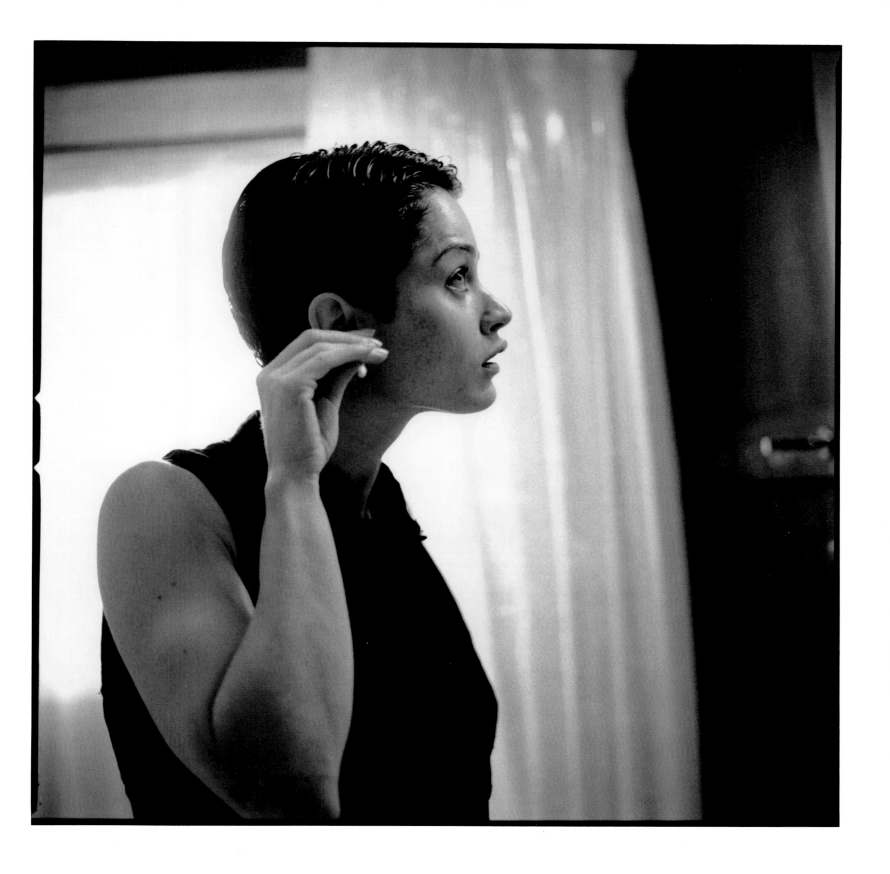

Venice, 8.45 am

Arielle has an Indian butler, who answered the door when I arrived. She received me in a long silk nightgown; she looked beautiful and regal.

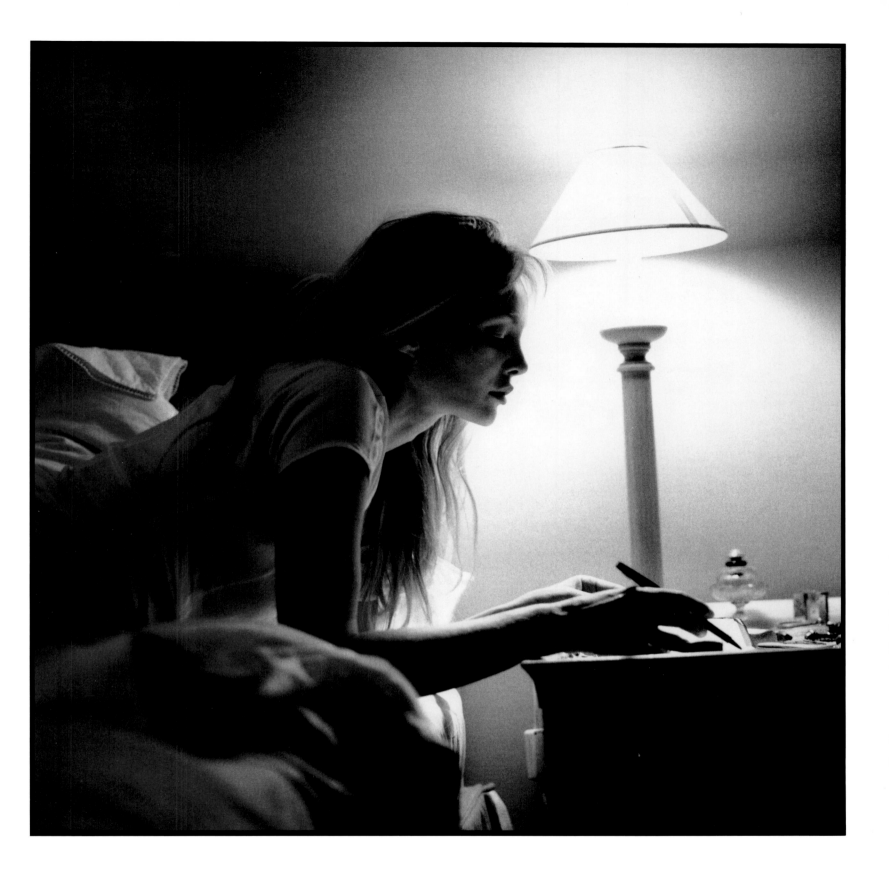

Arielle Dombasle, 9.01 am

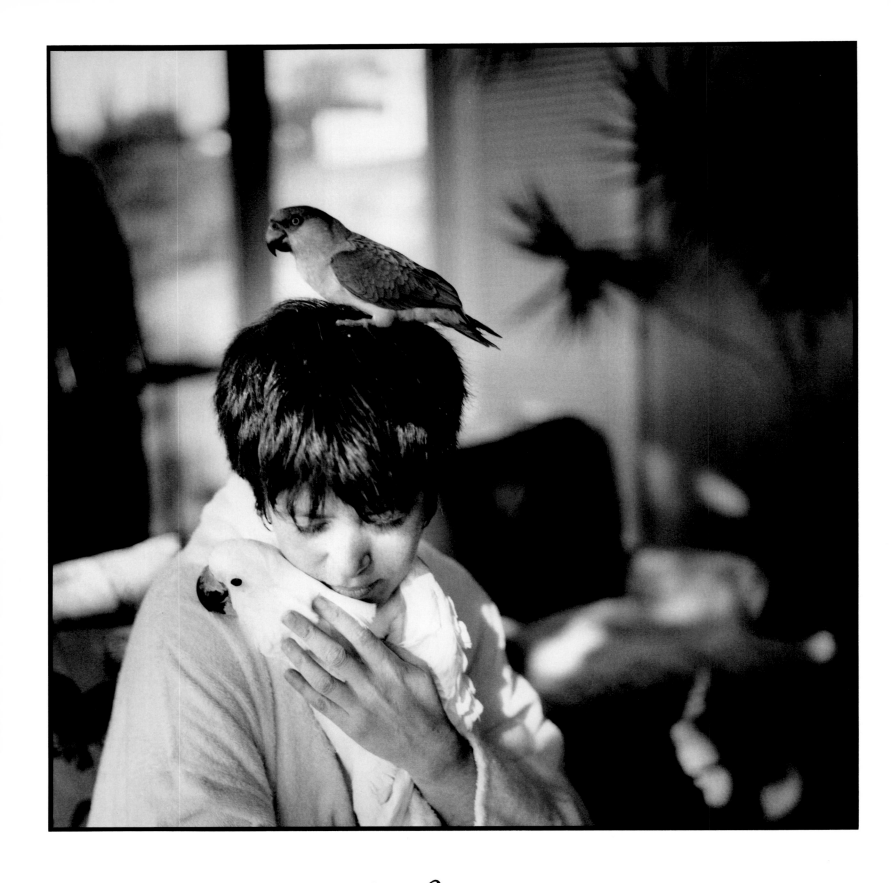

Diane Warren, 9.31 am

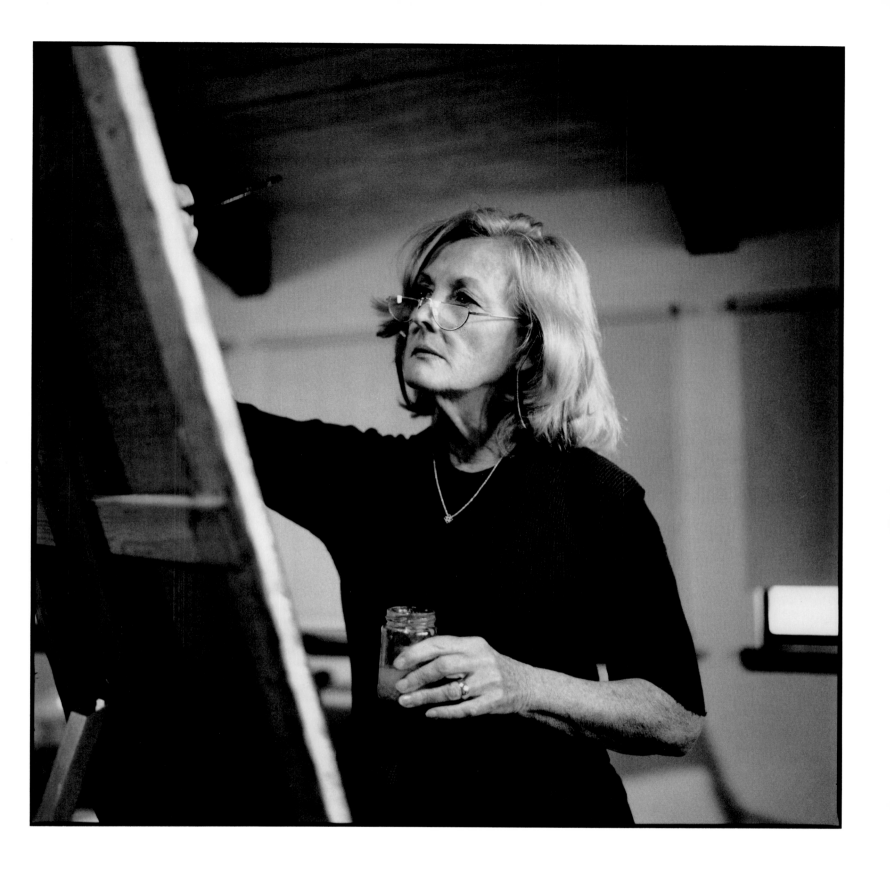

Eileen Ryan Penn, 9.23 am

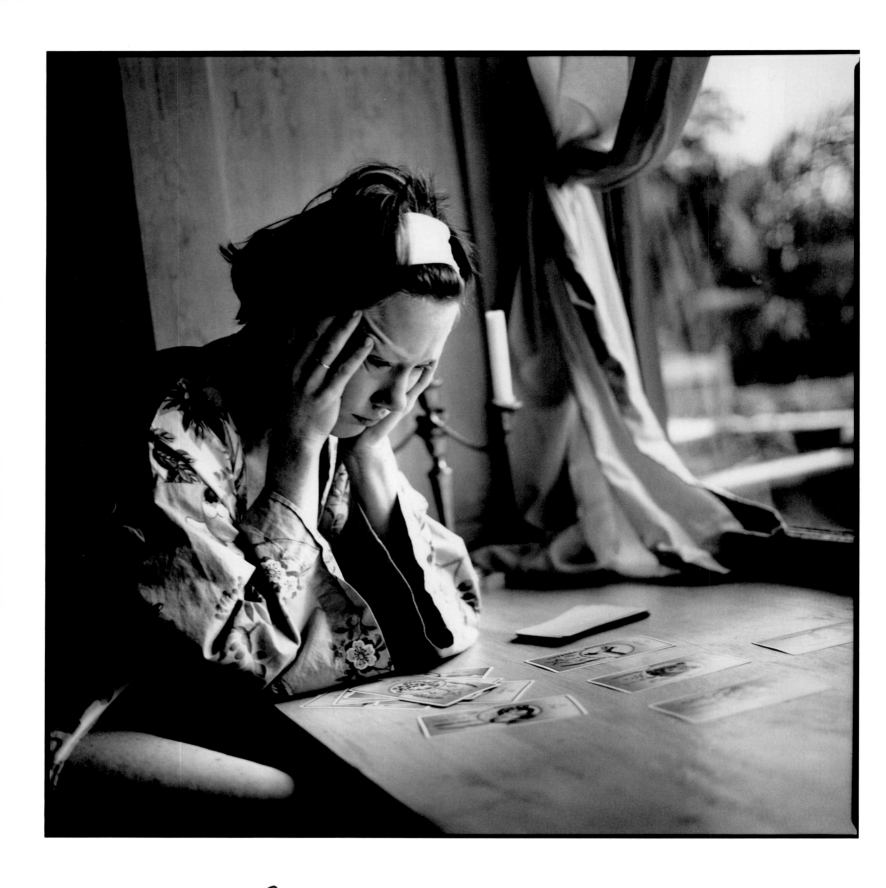

Ann Cusack, 8.20 am

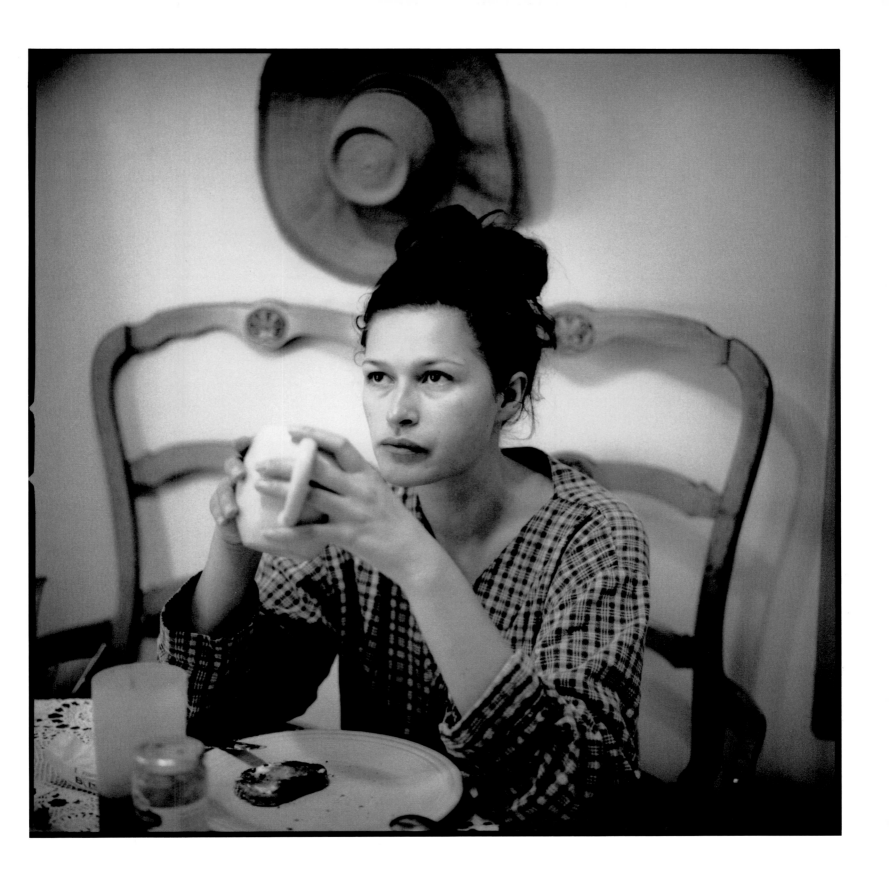

Karina Lombard, 9.47 am

Alexandra is beautiful, strong, and extremely talented. Her wisdom and awareness fascinated me!!!

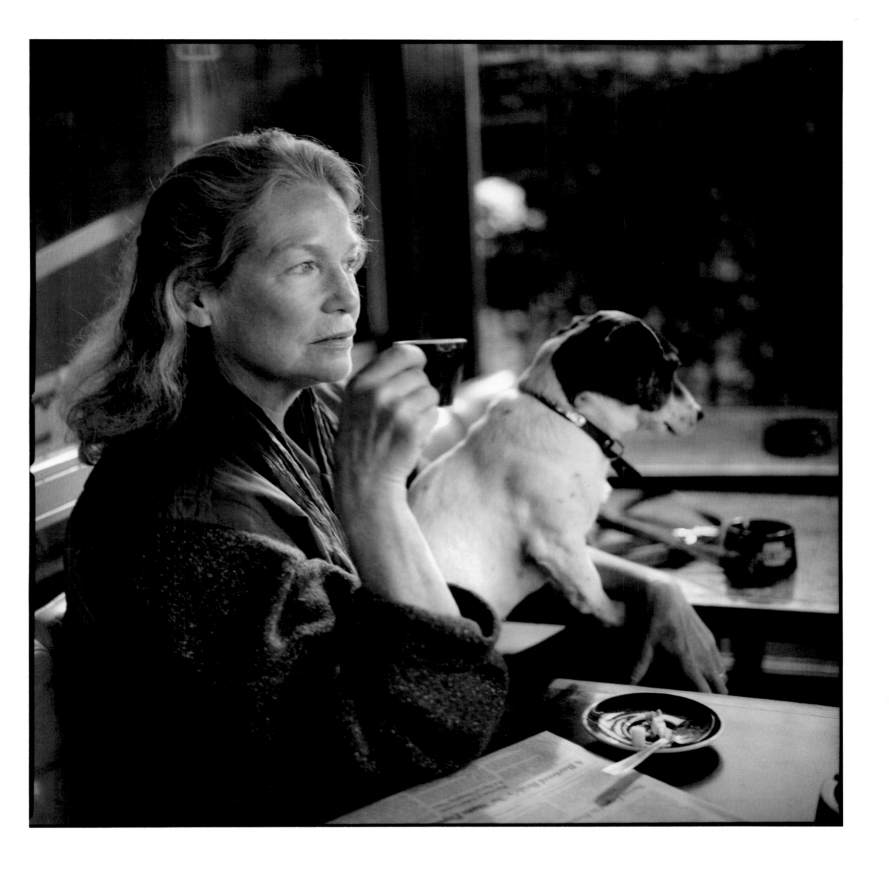

Alexandra Stewart, 9.33 am

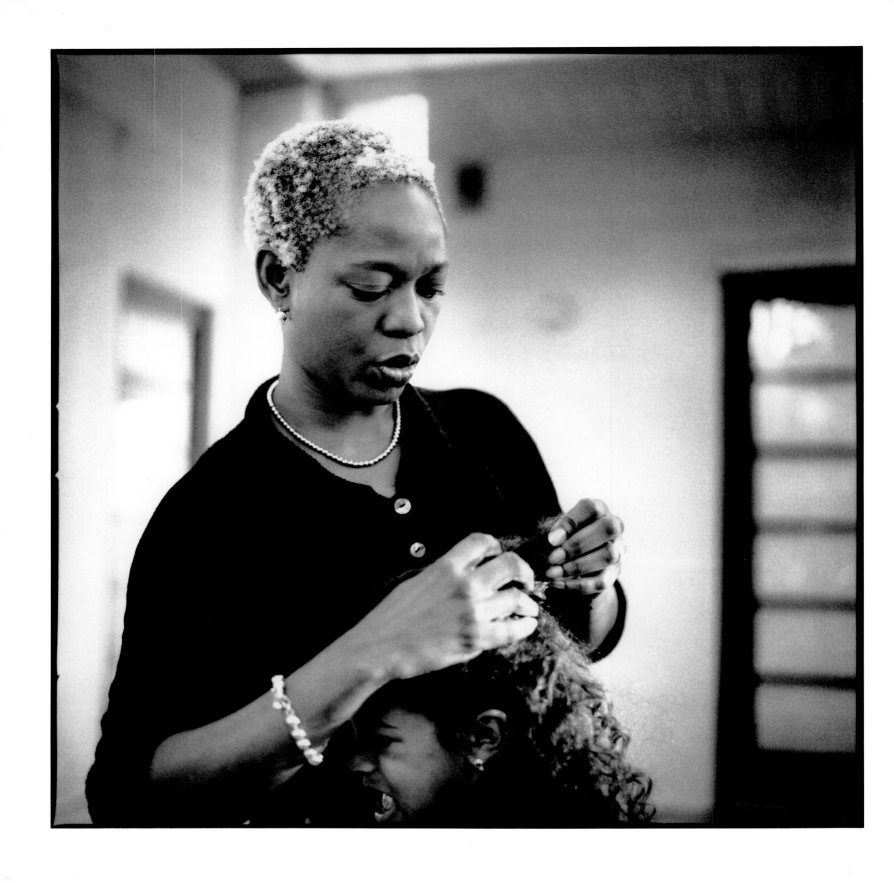

Alfre Woodard, 8.59 am

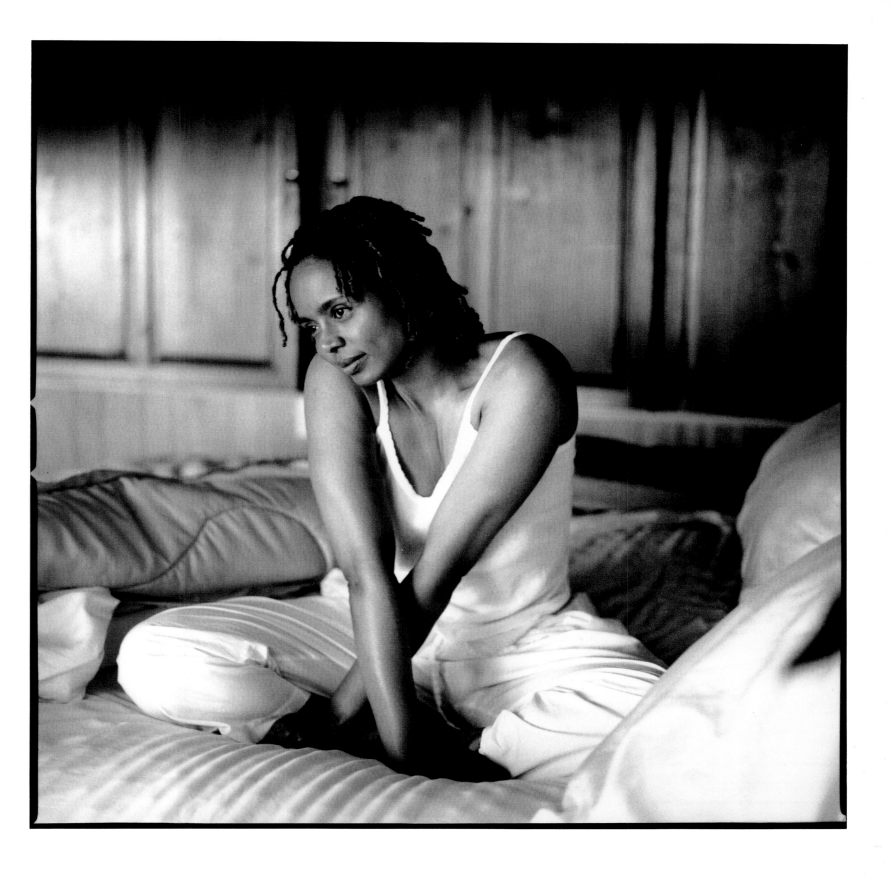

Debbi Morgan 9.49 am

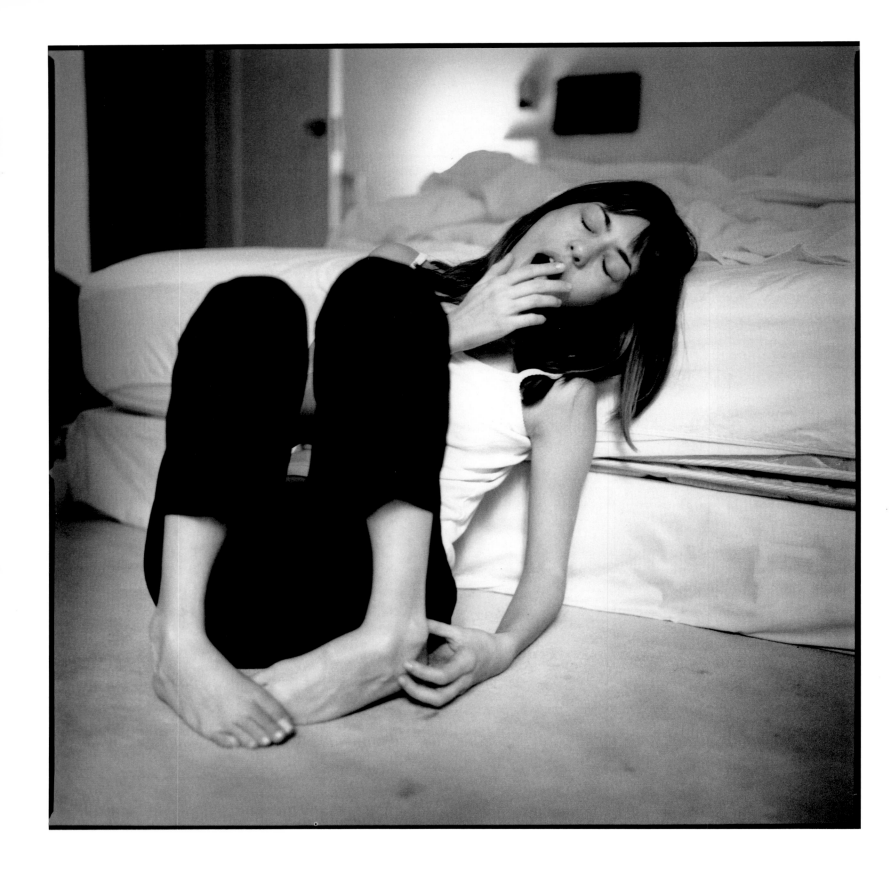

Sofià Coppola .9.29 am

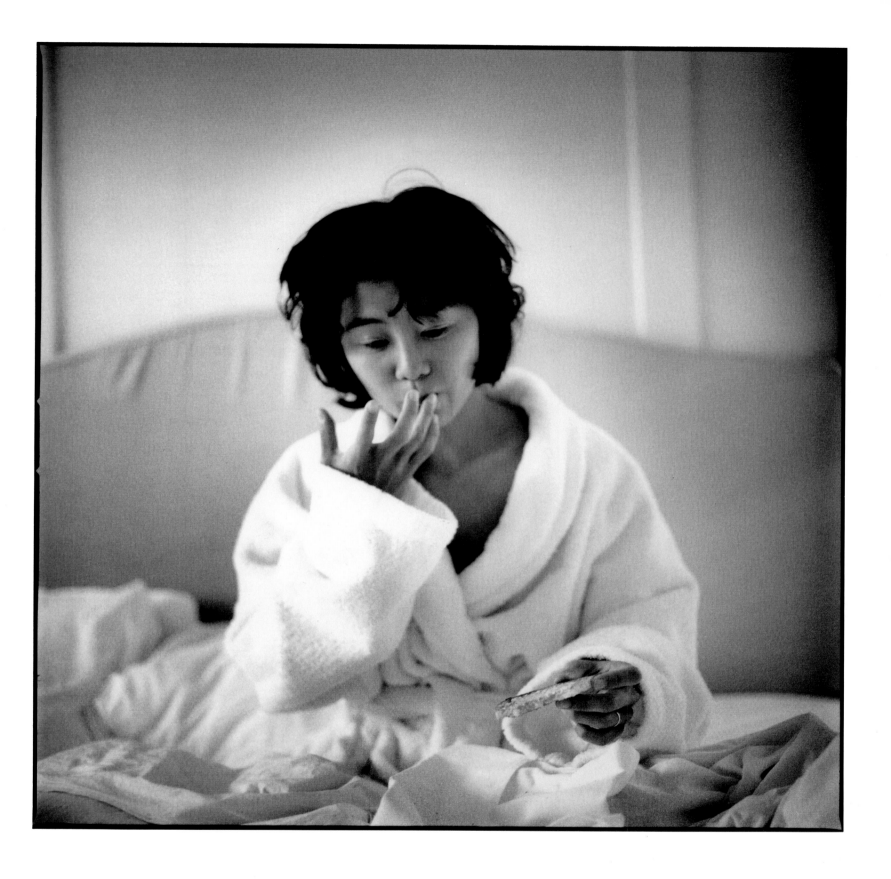

Nim Kim, 9.25 am

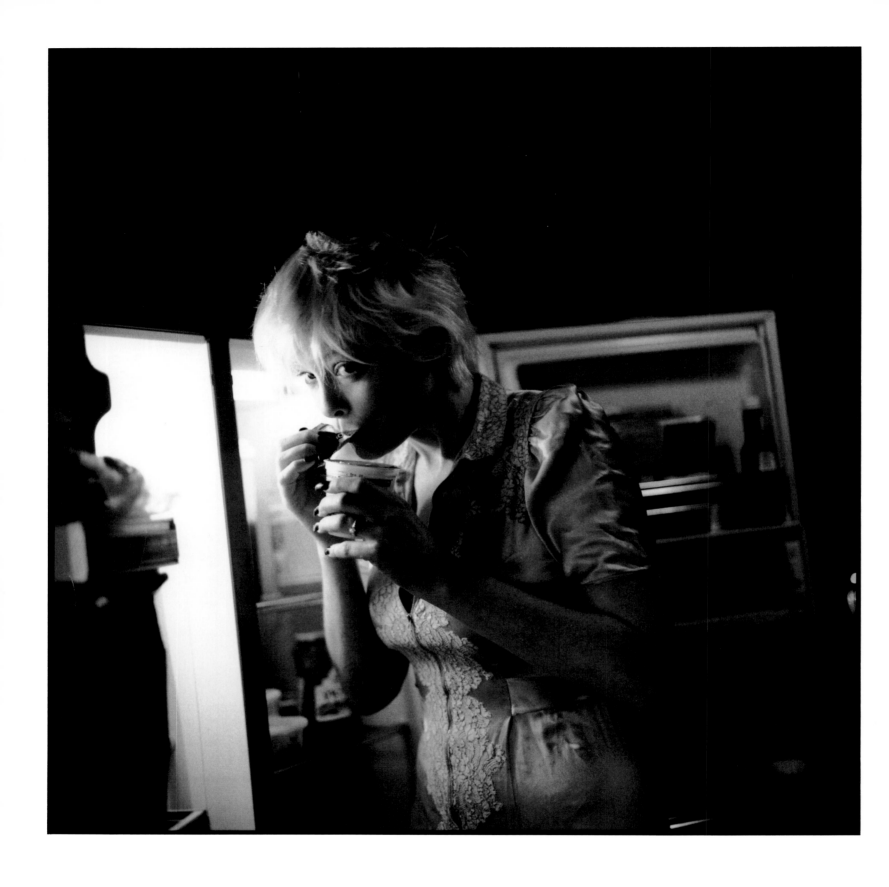

Pamela Gidley . . .

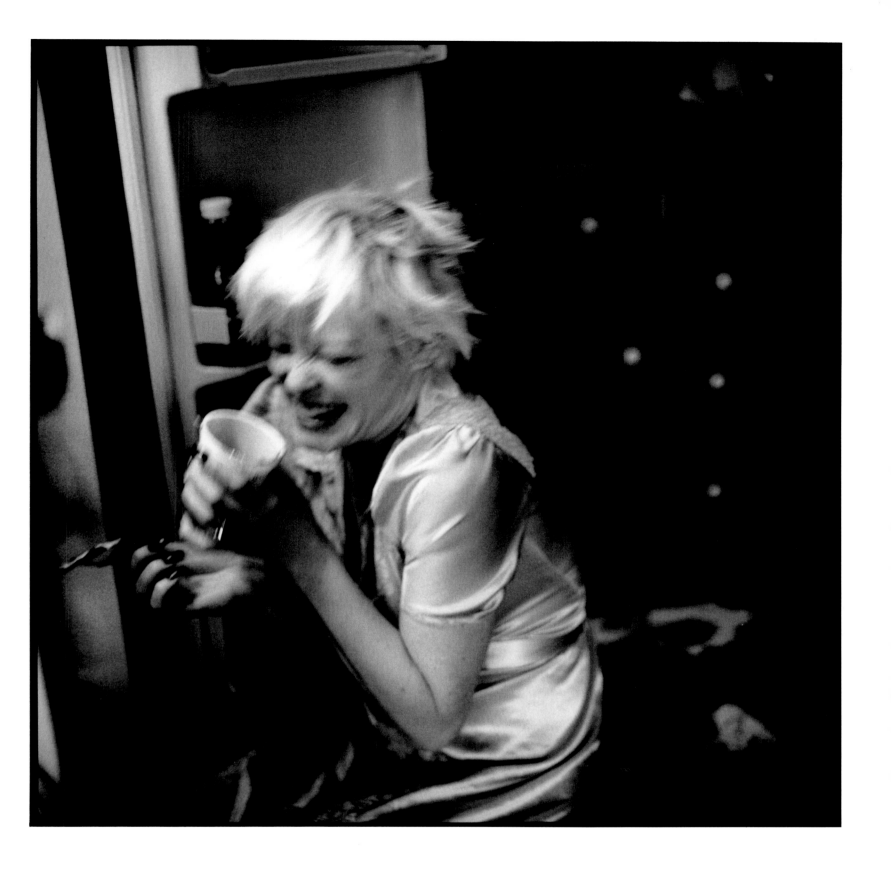

Los Angeles , 9.06 am

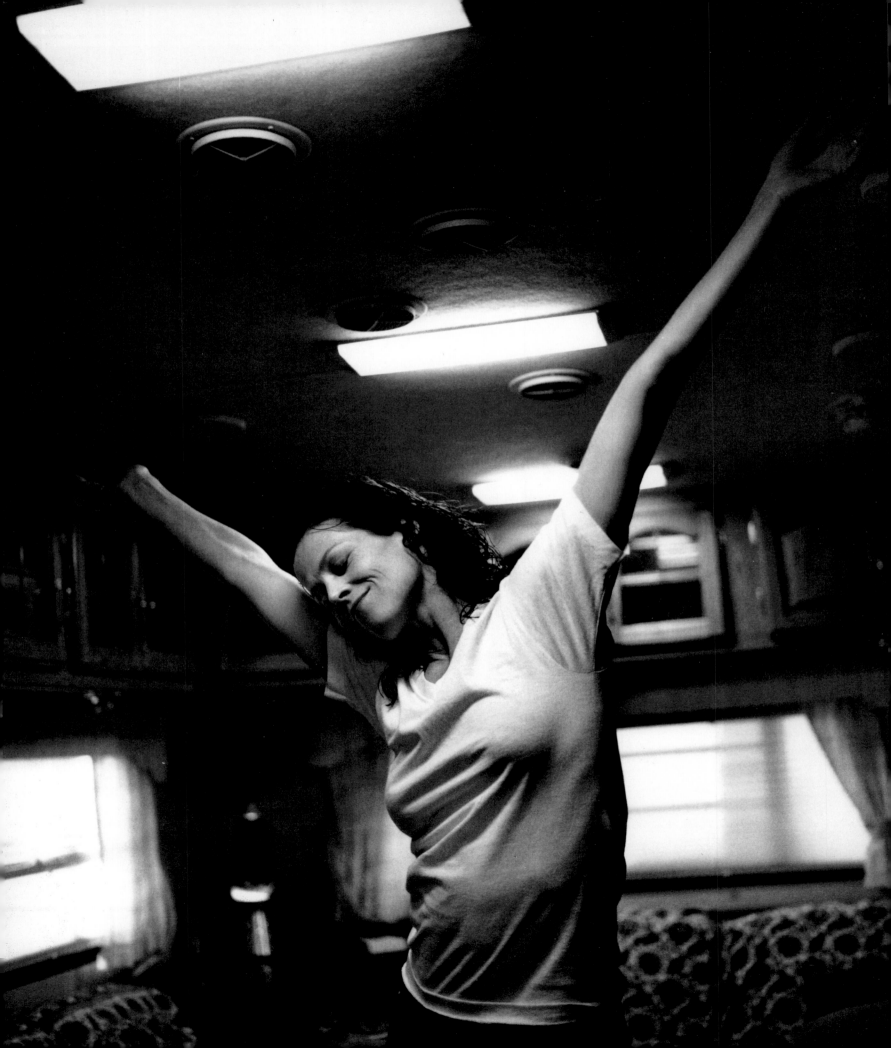

Century City

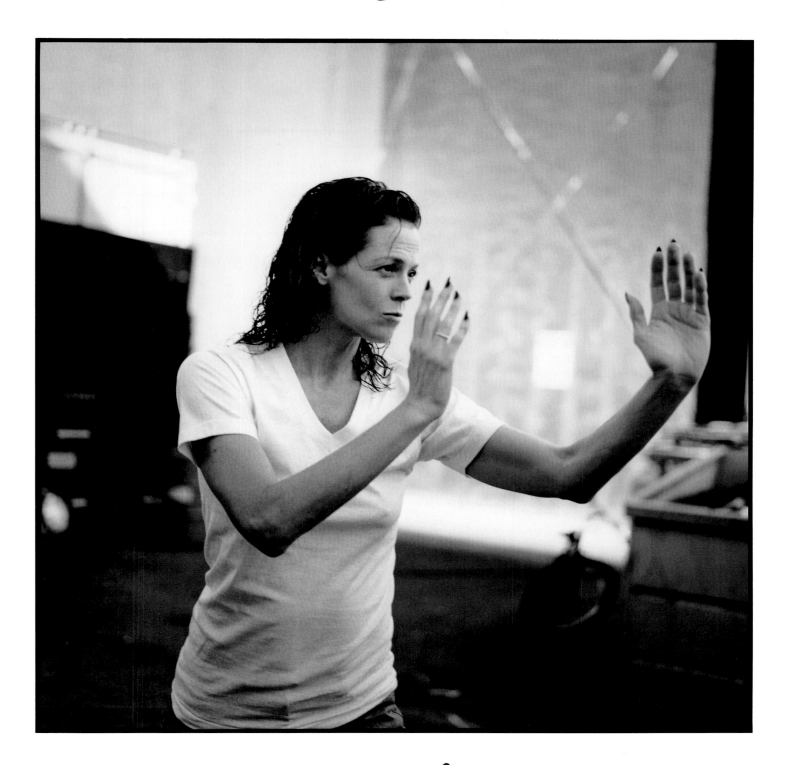

Sigourney Weaver, 8.30am

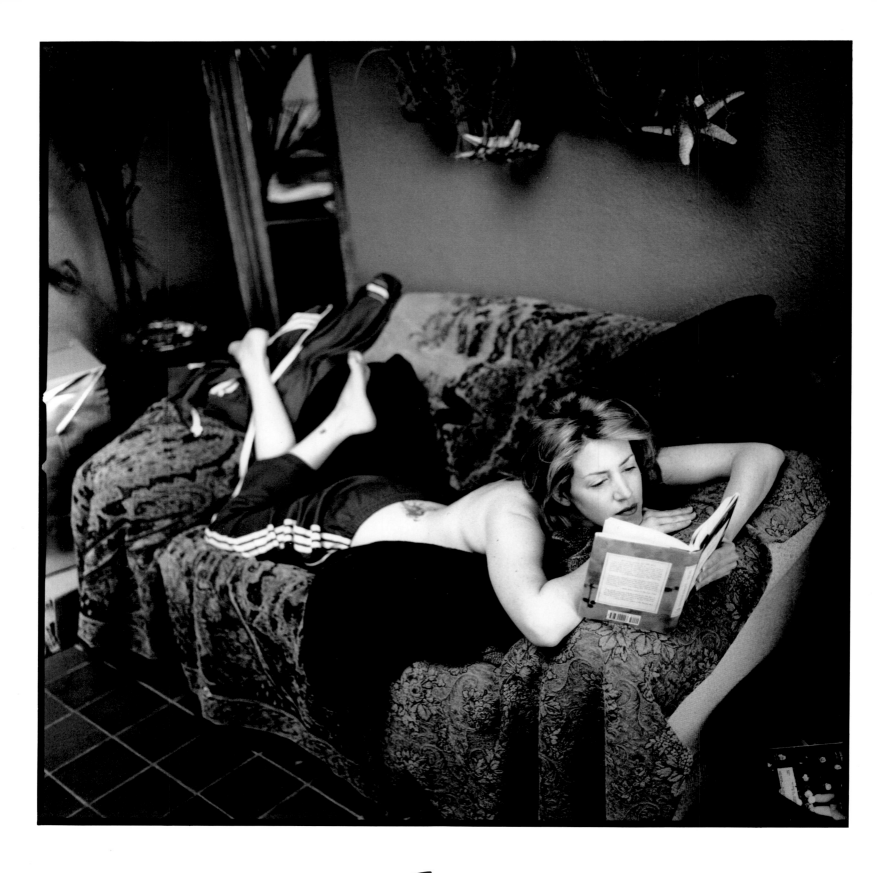

Joely Fisher, 9.29 am

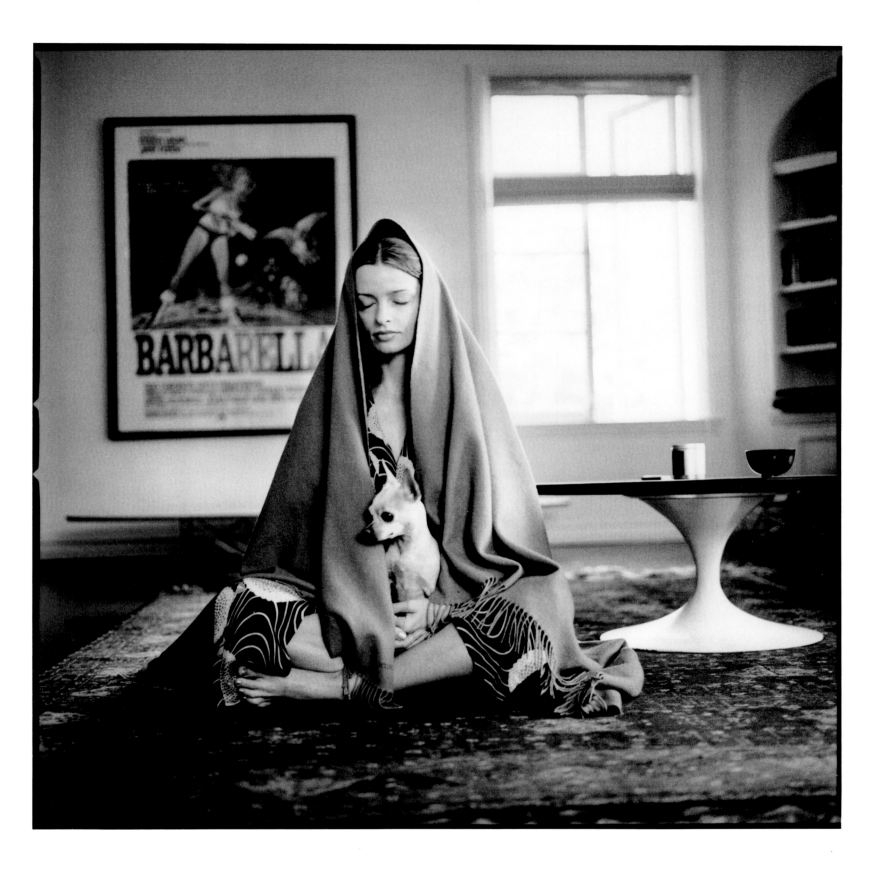

Lisa Marie, 7.59 am

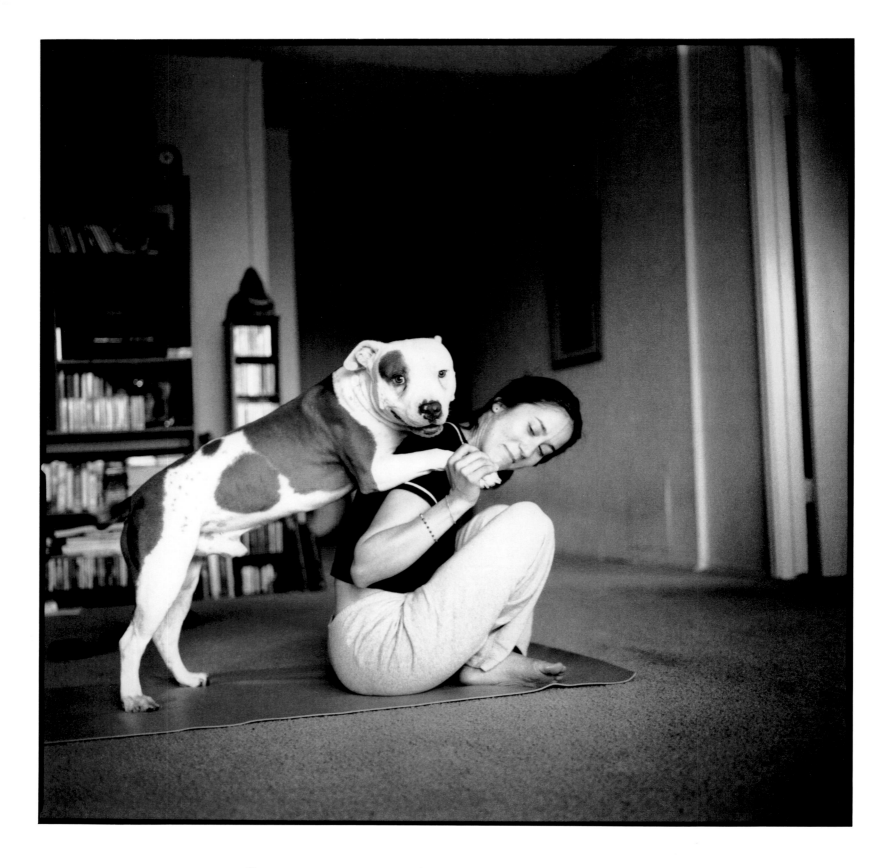

Lumi Cavazos, 9.28 am

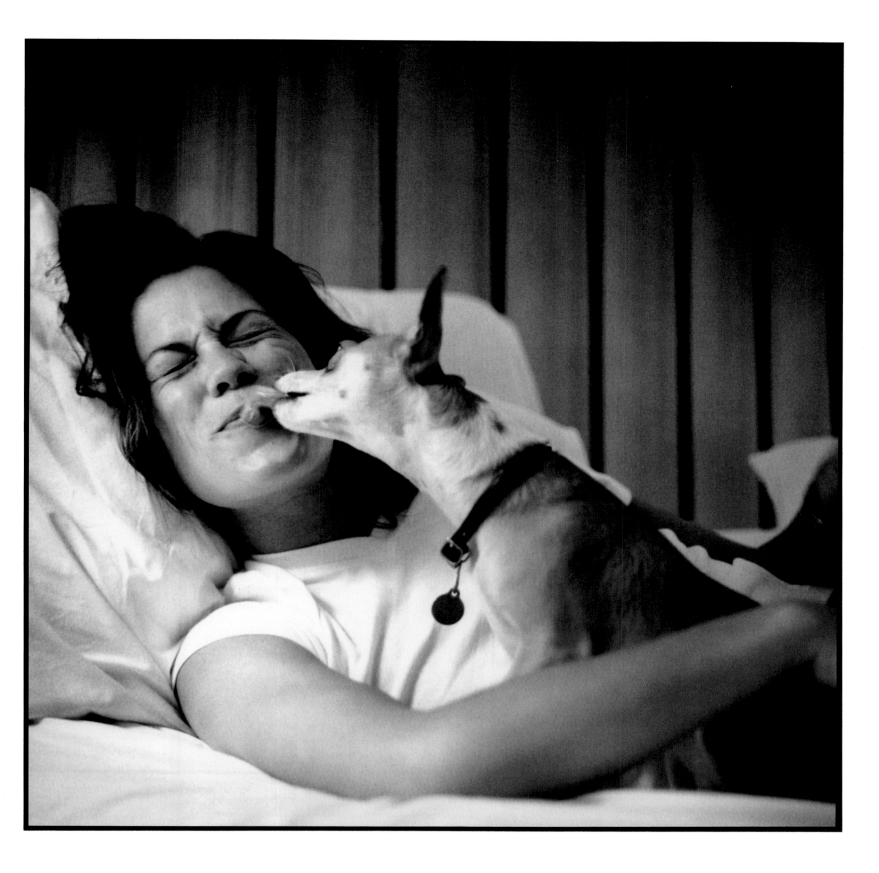

Maxine Bahns, 9.00 am

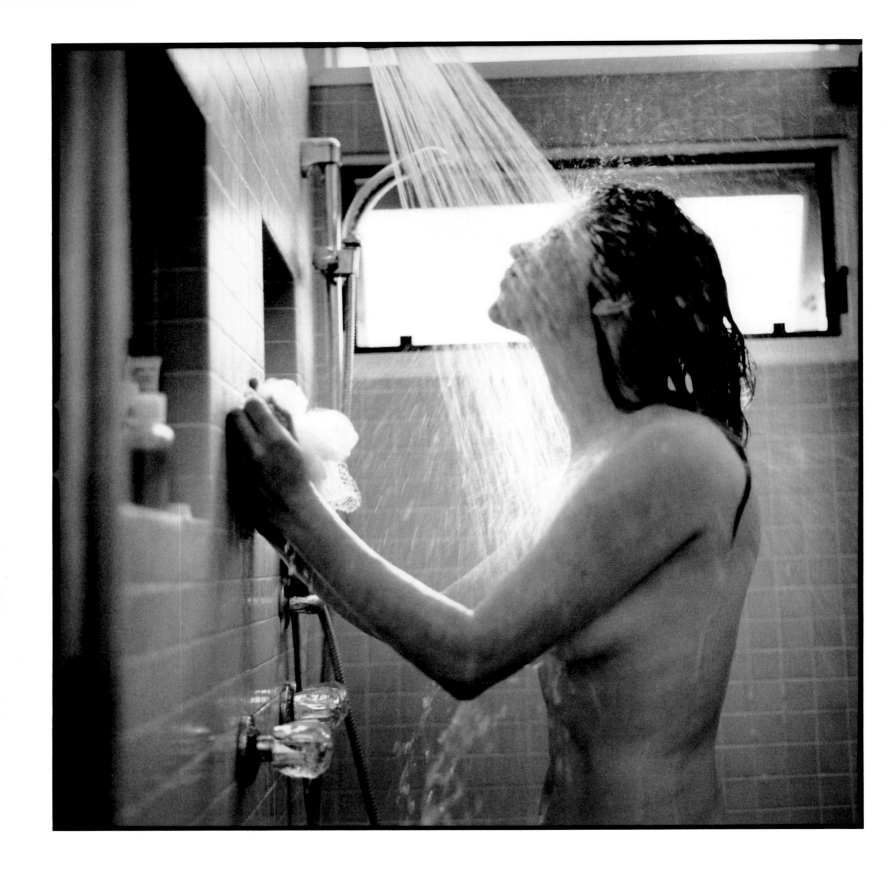

Daphne Zuniga , 9.15 am

94

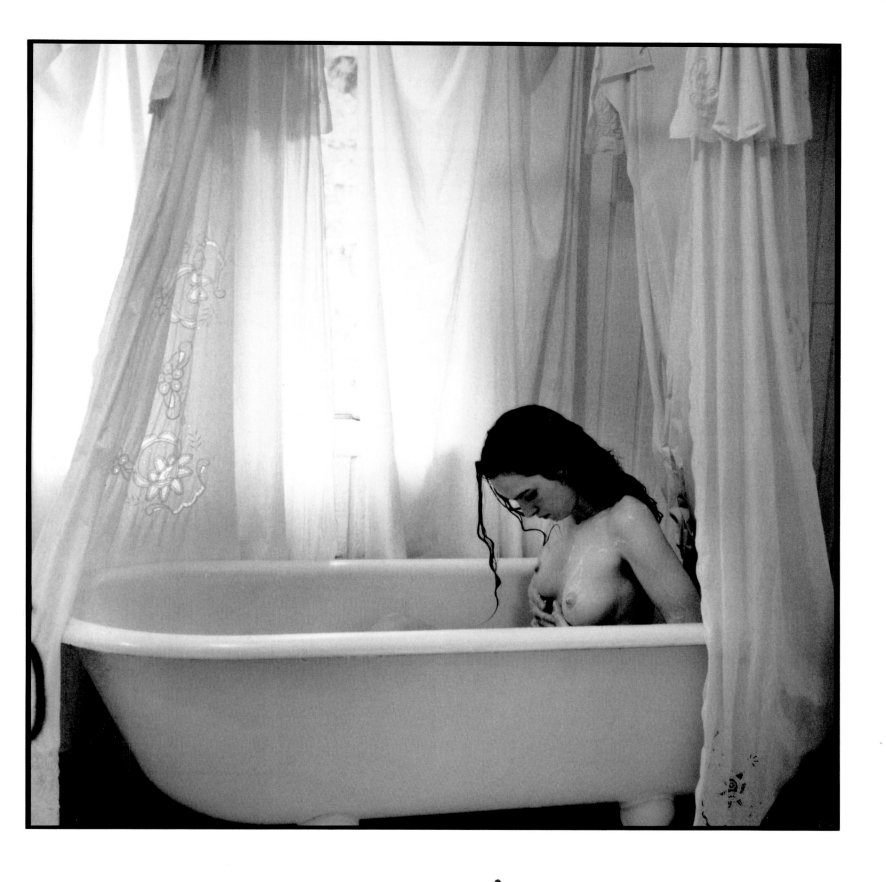

Sarah Jane Wylde, 9.50am

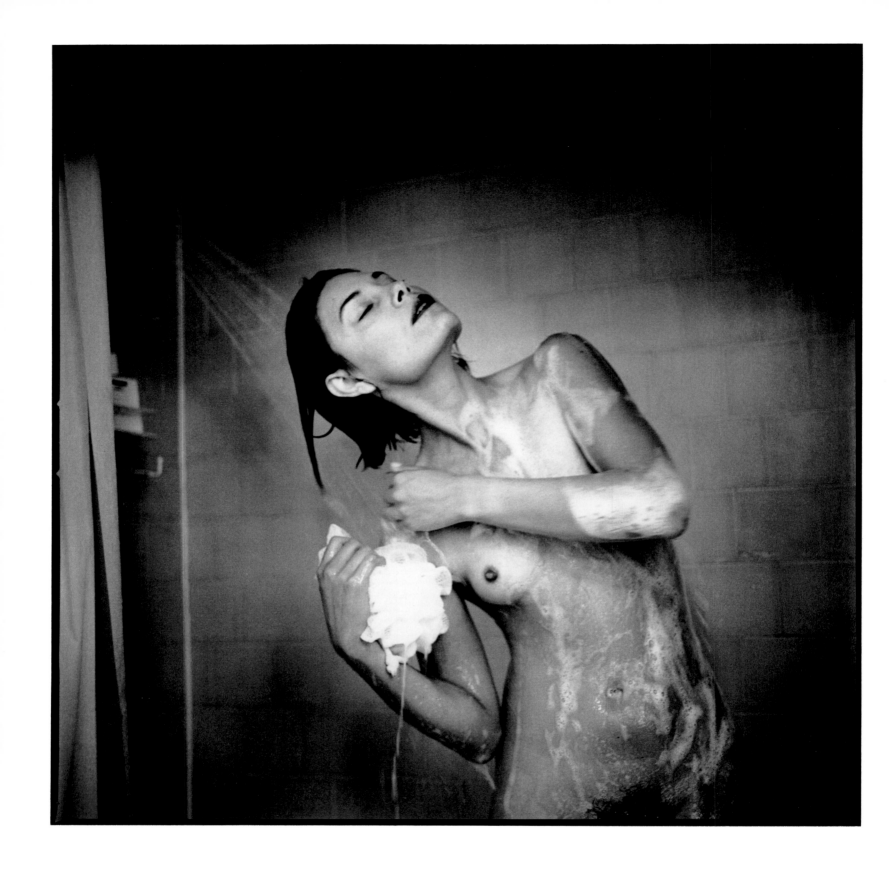

Coralie Langston - Jones, 9, 15am

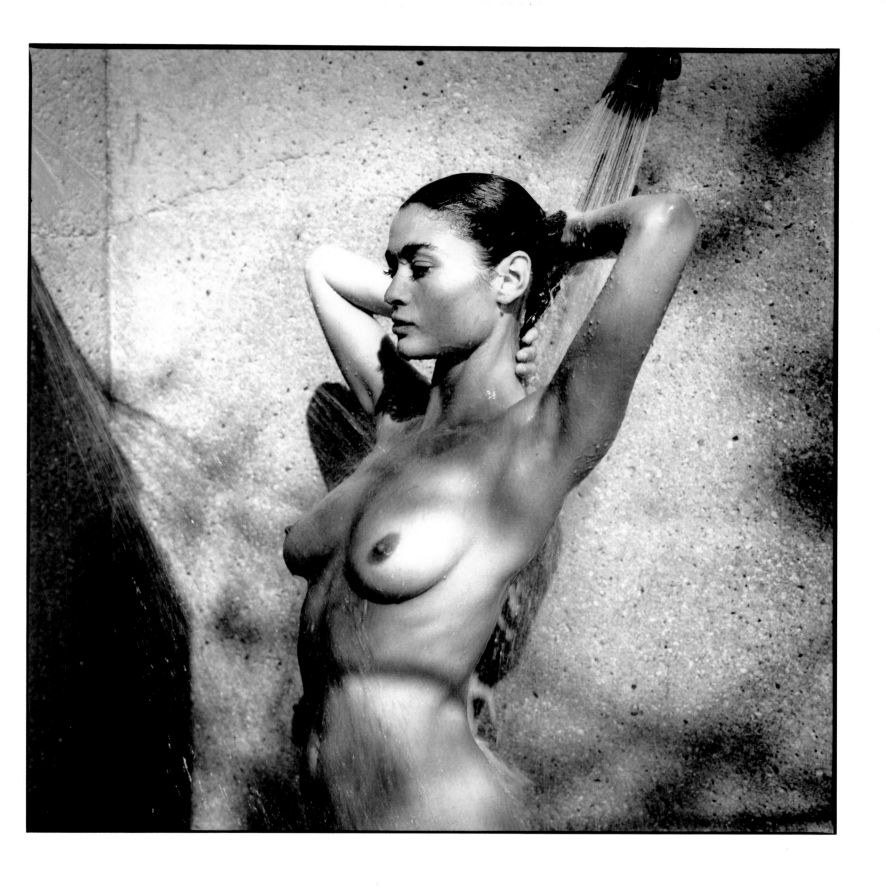

Charlotte Lewis, 9.53 am

Myrtille Blervaque →

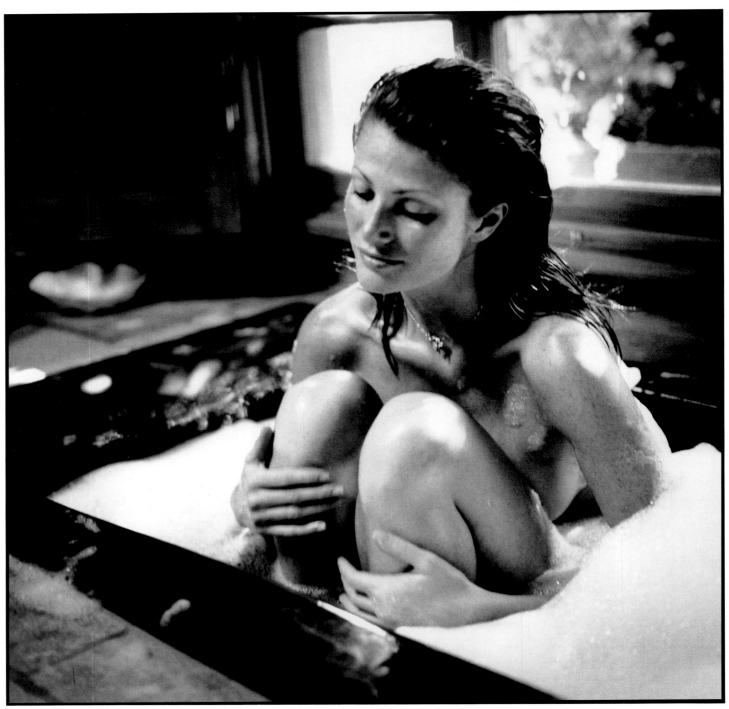

Angie Everhart, 8.03am

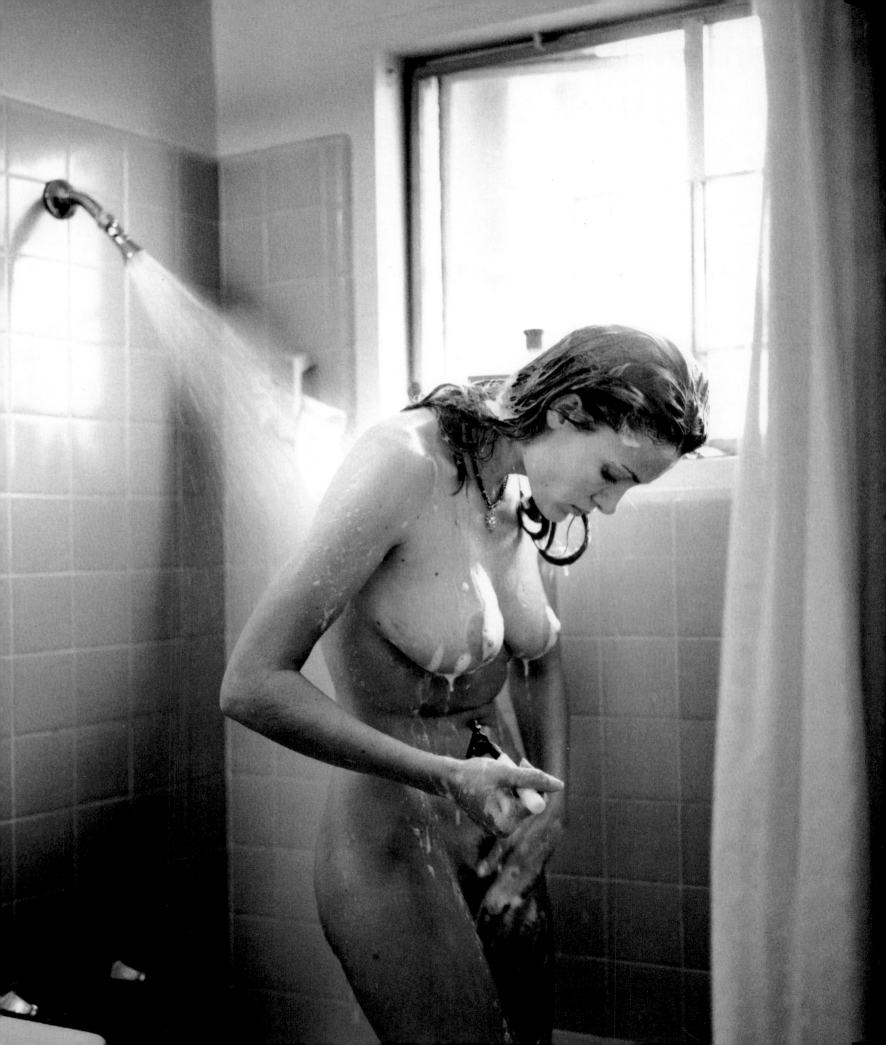

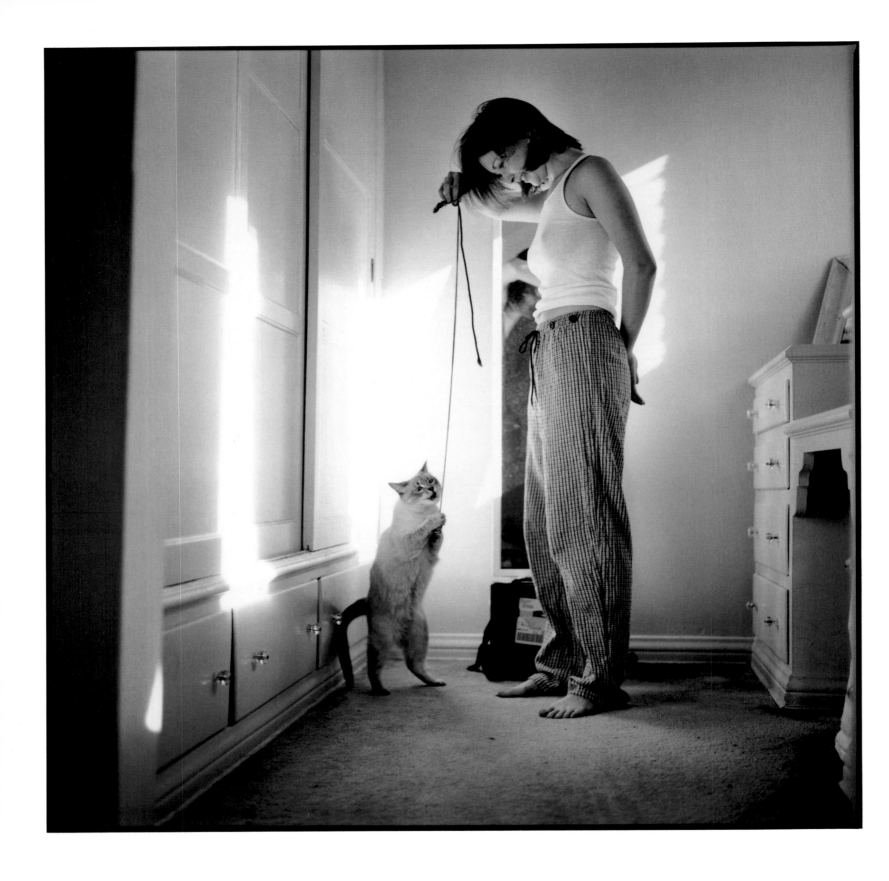

Trista Delamare , 9.00am

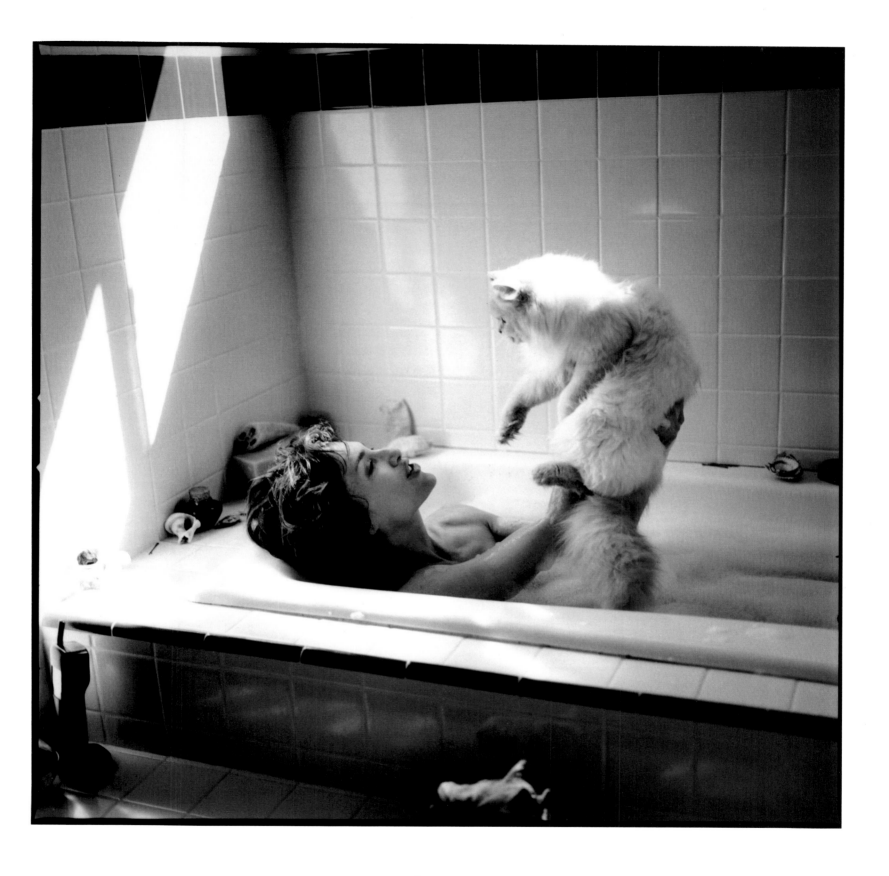

Barbara Williams, 9.04am

Colleen is not afraid to get her expensive panther mules soaked while washing her dogs!!!

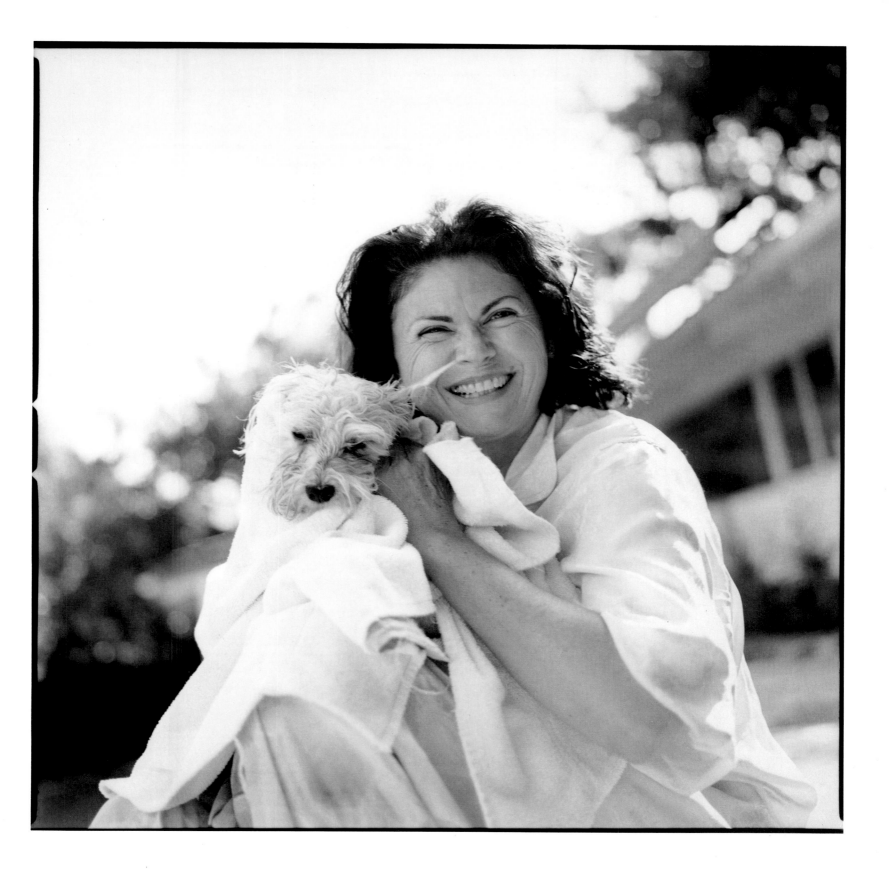

Colleen Atwood, 9.20 am

Demi Moore called me out of the blue toward the end of my deadline for this book and told me if I wanted to photograph her, it would have to be at her mother's; she would have no free time by herself until after July, which was too late.

The next time we spoke, Demi urged me to get there straight away because her mother was dying, and she wanted to be photographed with her.

My initial reaction was not to go; I saw this book as a celebration of life, a celebration to the rising sun, to all the pleasures of the unfolding day. I didn't see how death could fit into the intimate, joyful images I had already taken. But the more I thought about it, the more I realized that Demi had given me a beautiful gift.

She had given me the opportunity to photograph the most deeply intimate moment two people can share; the passing of a soul, a mother's soul, fully embraced and celebrated by the daughter she had given birth to. This was, at its deepest foundations, the celebration of life I was looking for! I spent two days with Demi and her mother Virginia. The troubles they had in their lives with each other seemed to totally dissolve in the tremendous affection they had for one another. I was a rare witness to a bonding of true love. It was not the crash course on death I imagined, but on love. We joked about leaving this world, and we sang and played guitar.

It was a wonderful, soulful experience for all of us. Forgiveness, loyalty, and death left me with a new meaning. It was an intense photo shoot, but beyond that, it was a beautiful lesson on life that I was so privileged to be a part of.

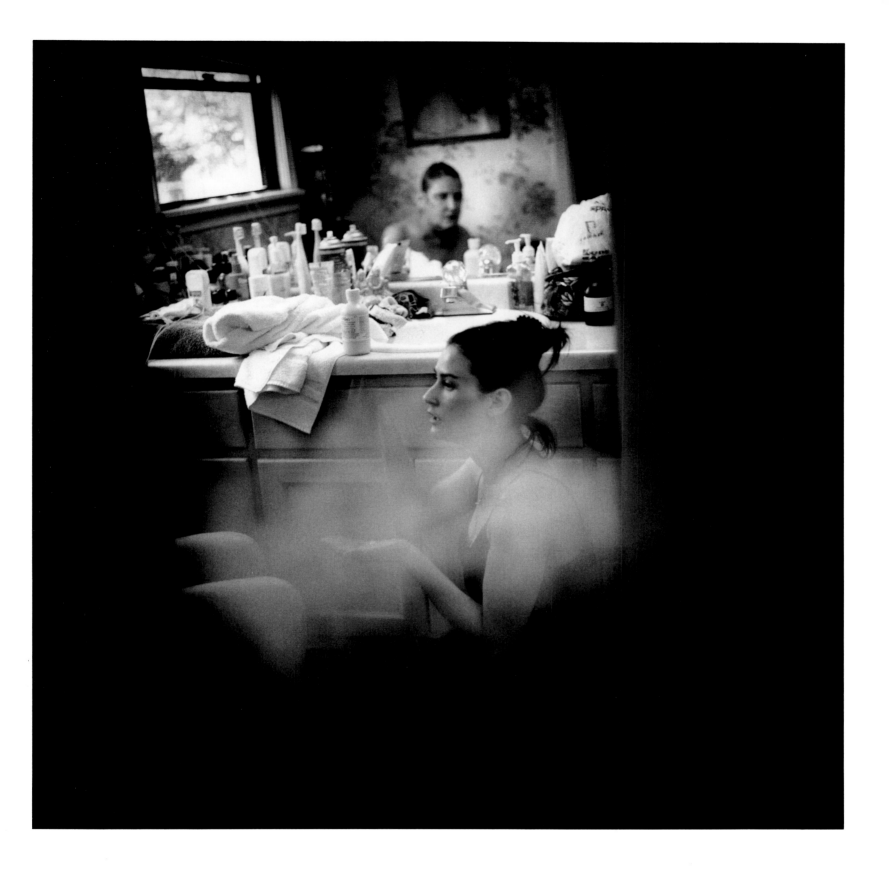

Demi Moore, 9.59 am

Rosanna Arquette →

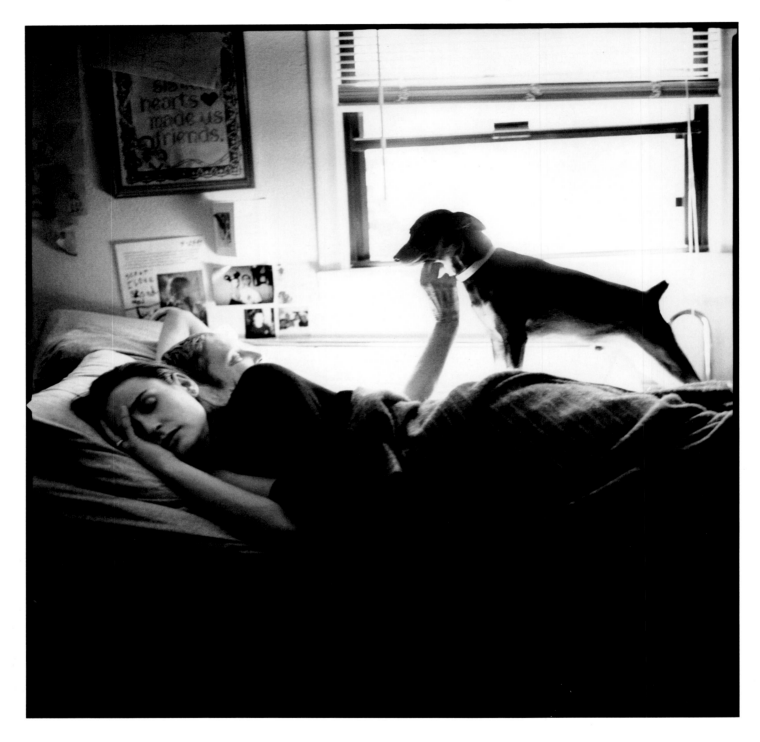

Demi, Virginia, and Ray, 9.39 am

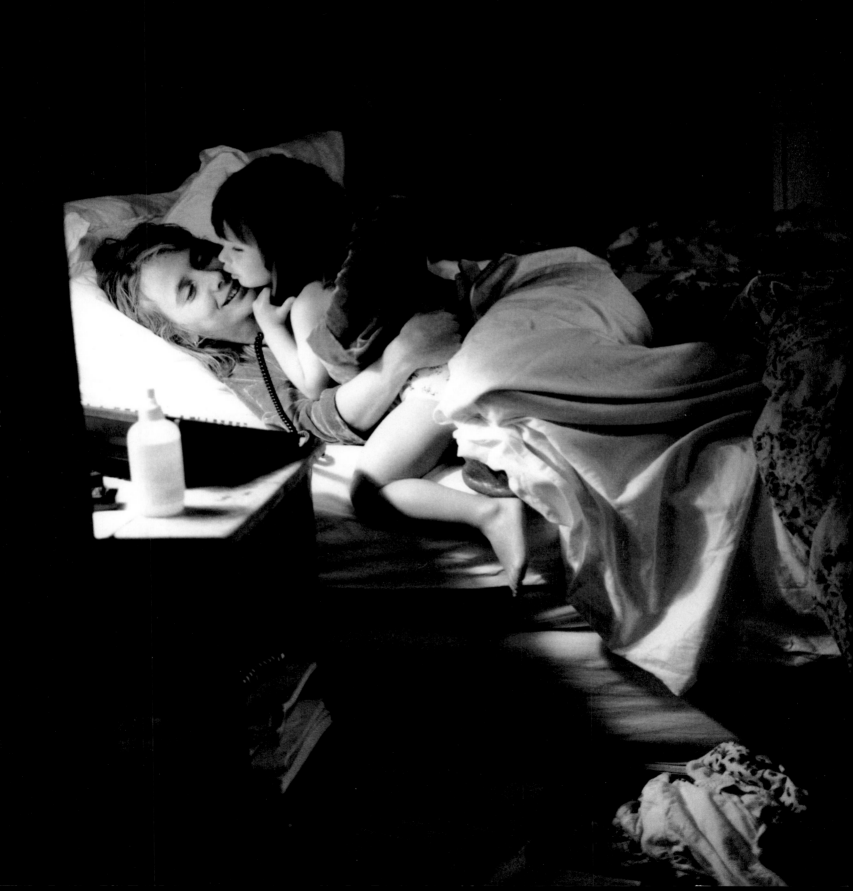

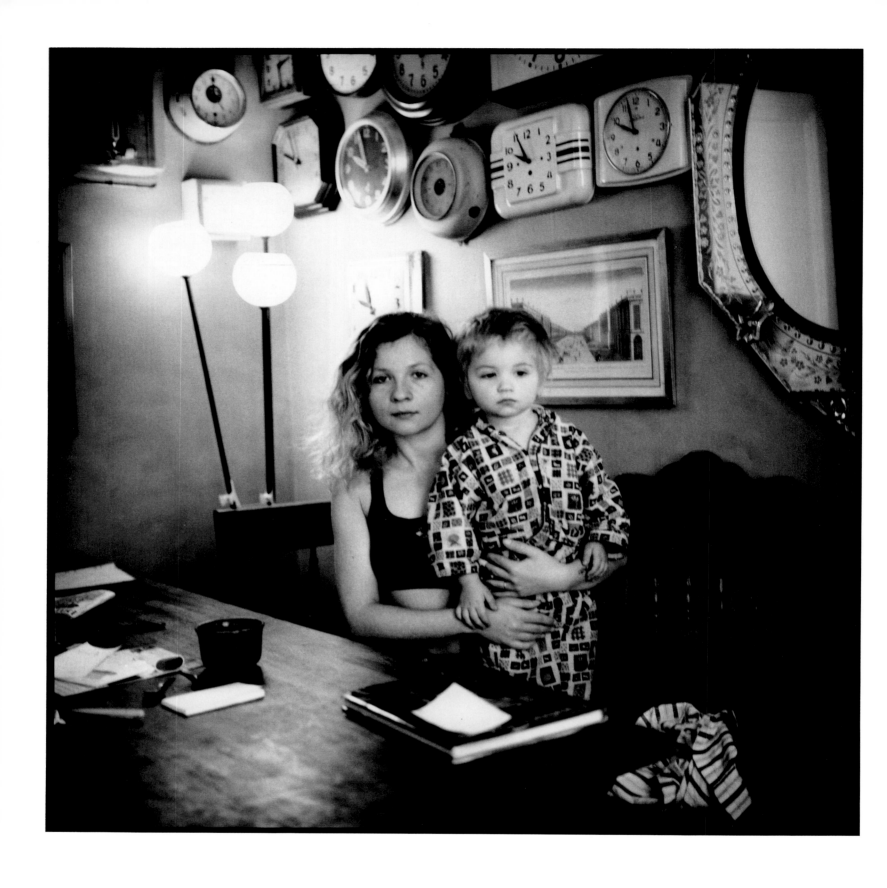

Eva Ionesco, 9.56 am

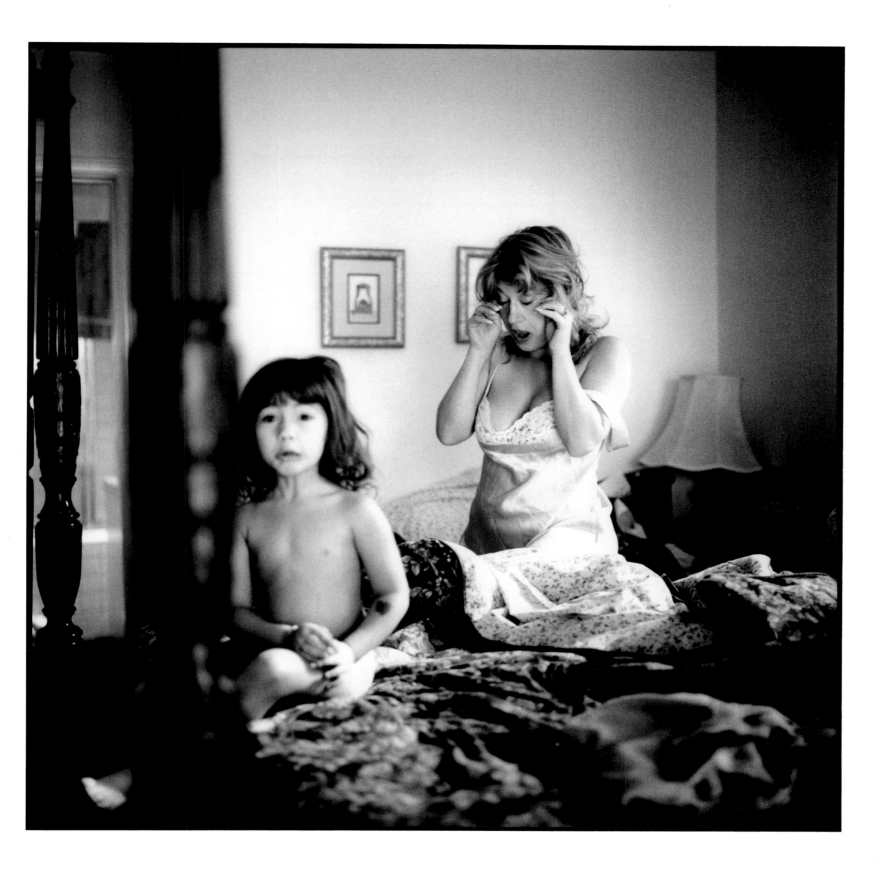

Lisa Ann Walter, 9.15 am

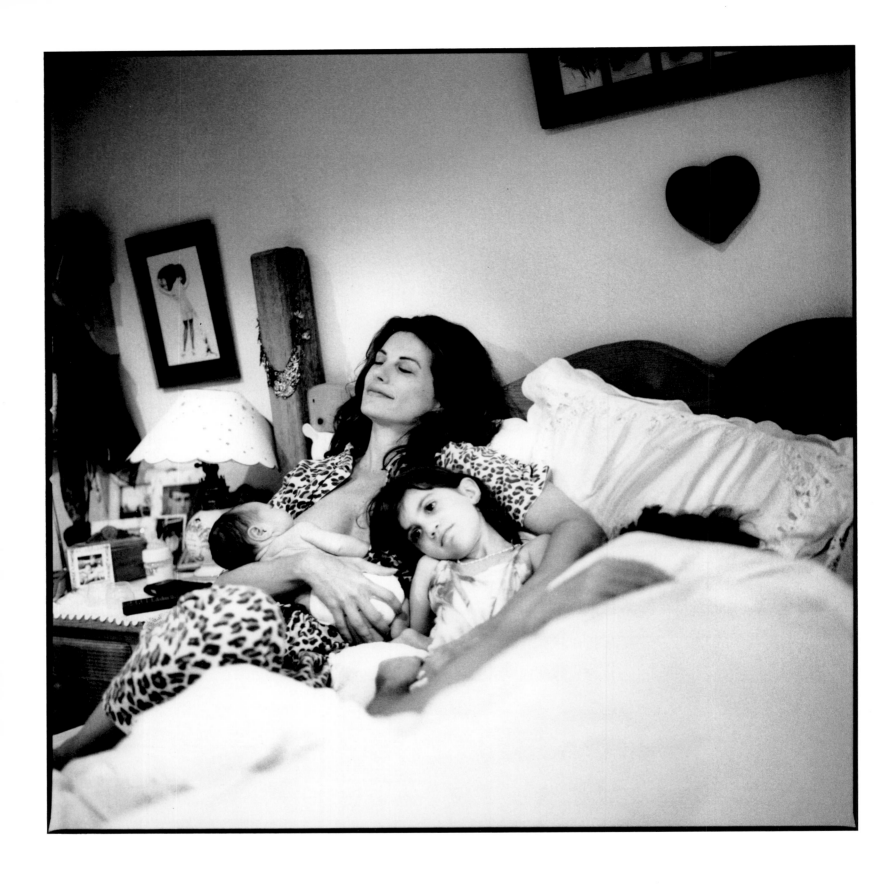

Hilary Shepard - Turner, 8.00 am

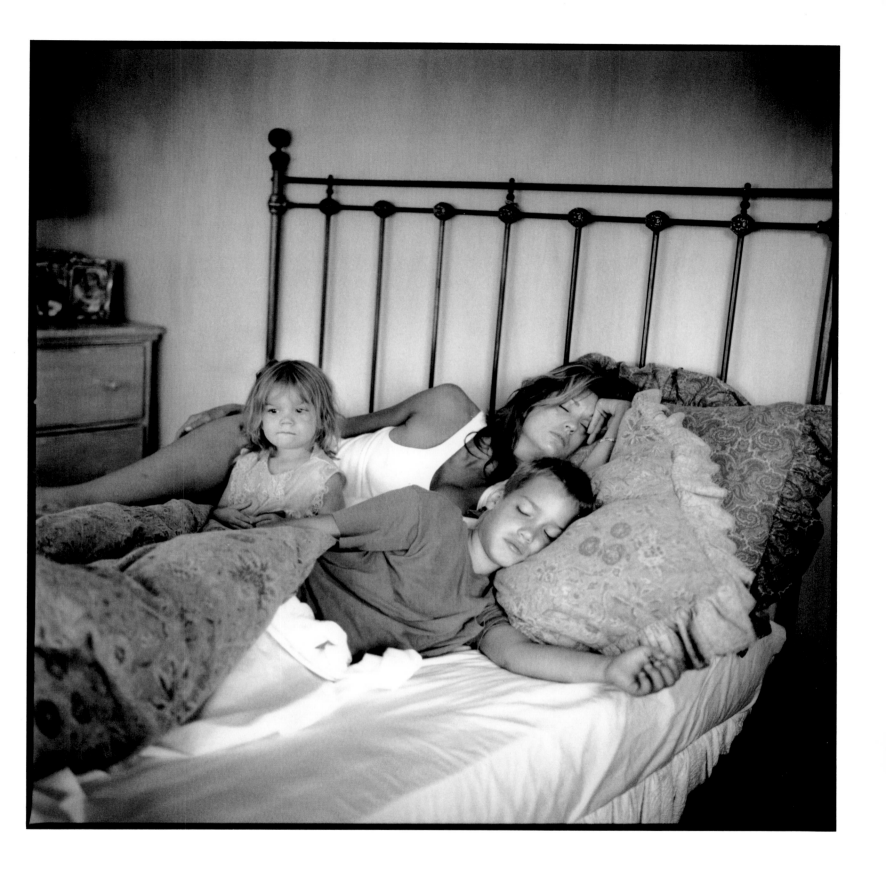

Janice Dickinson, 9.17 am

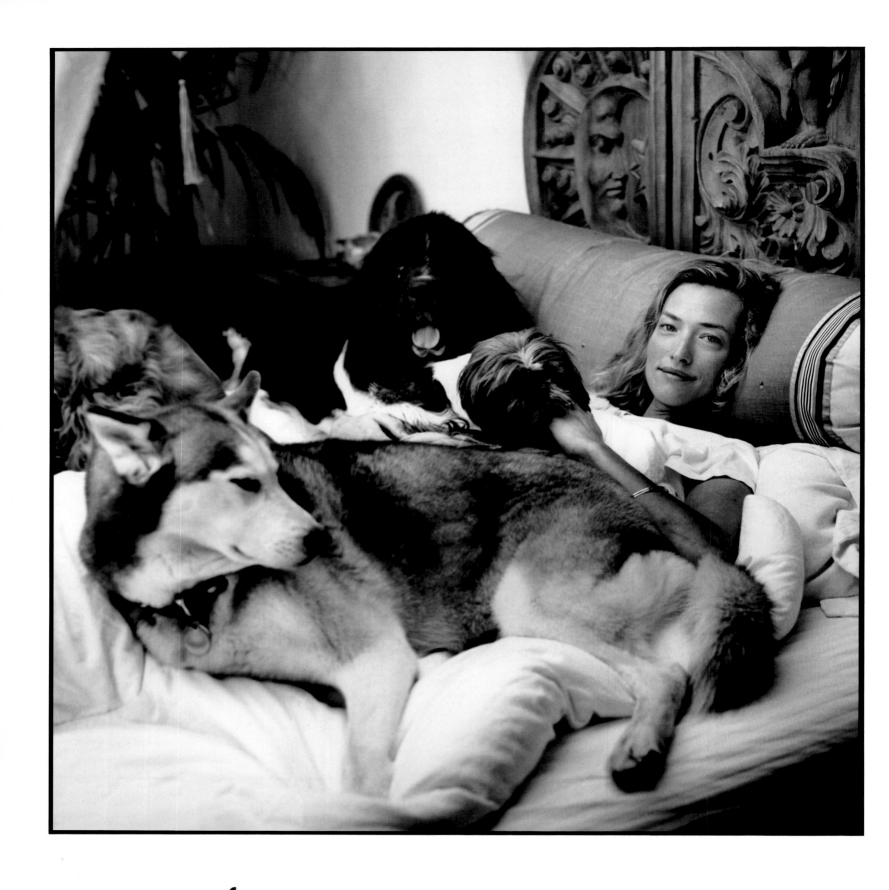

Tatjana Patitz, 9.33 am

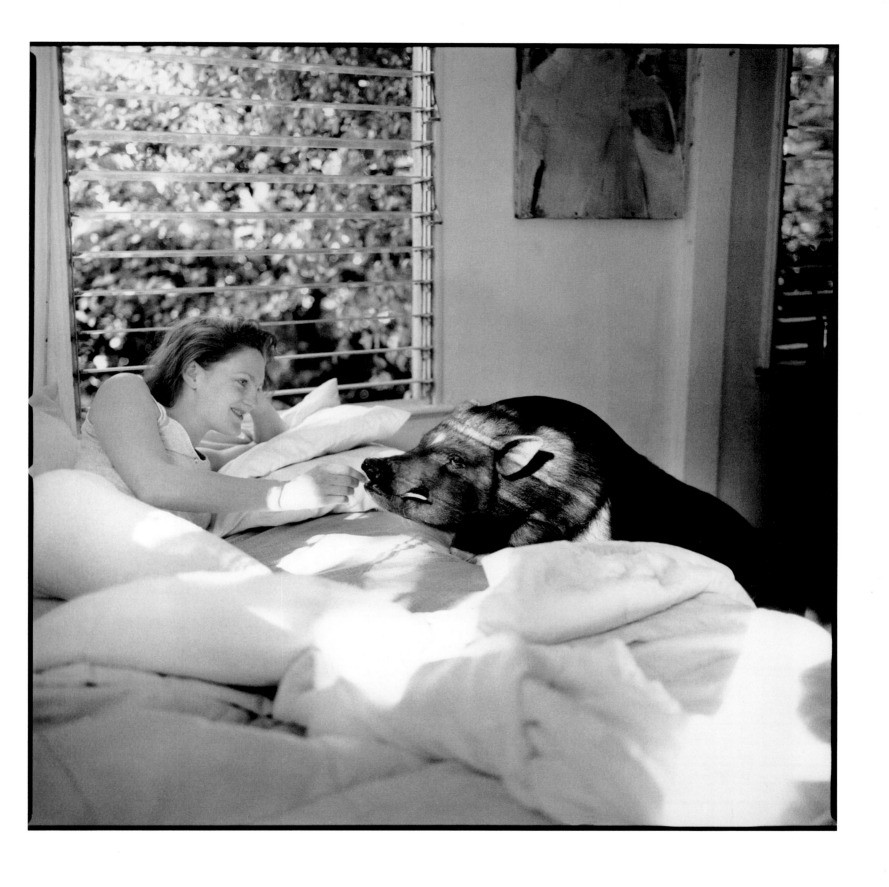

Courtney Reid and Epiphano, 8.30 am

Embeth Davidtz →

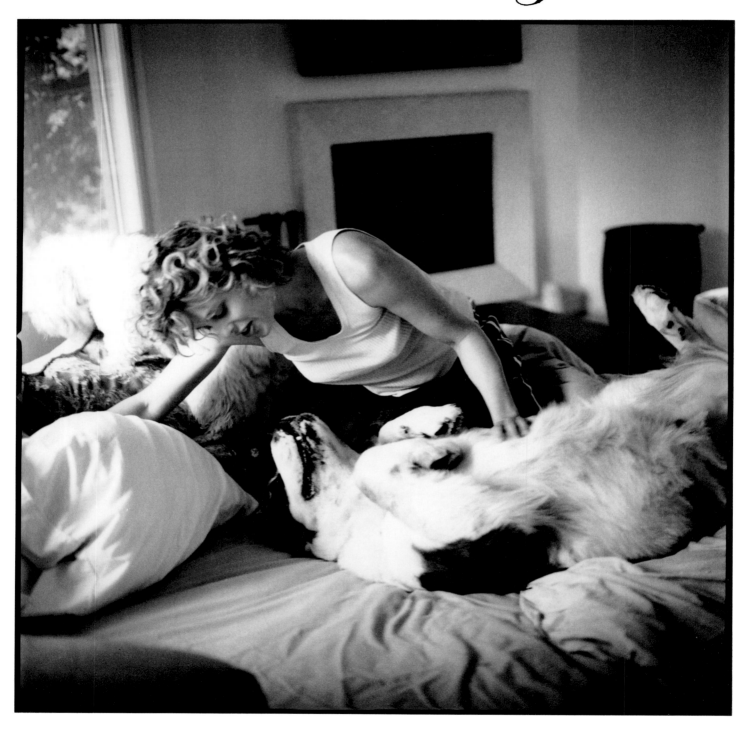

Rebecca Broussard, 8.16 am

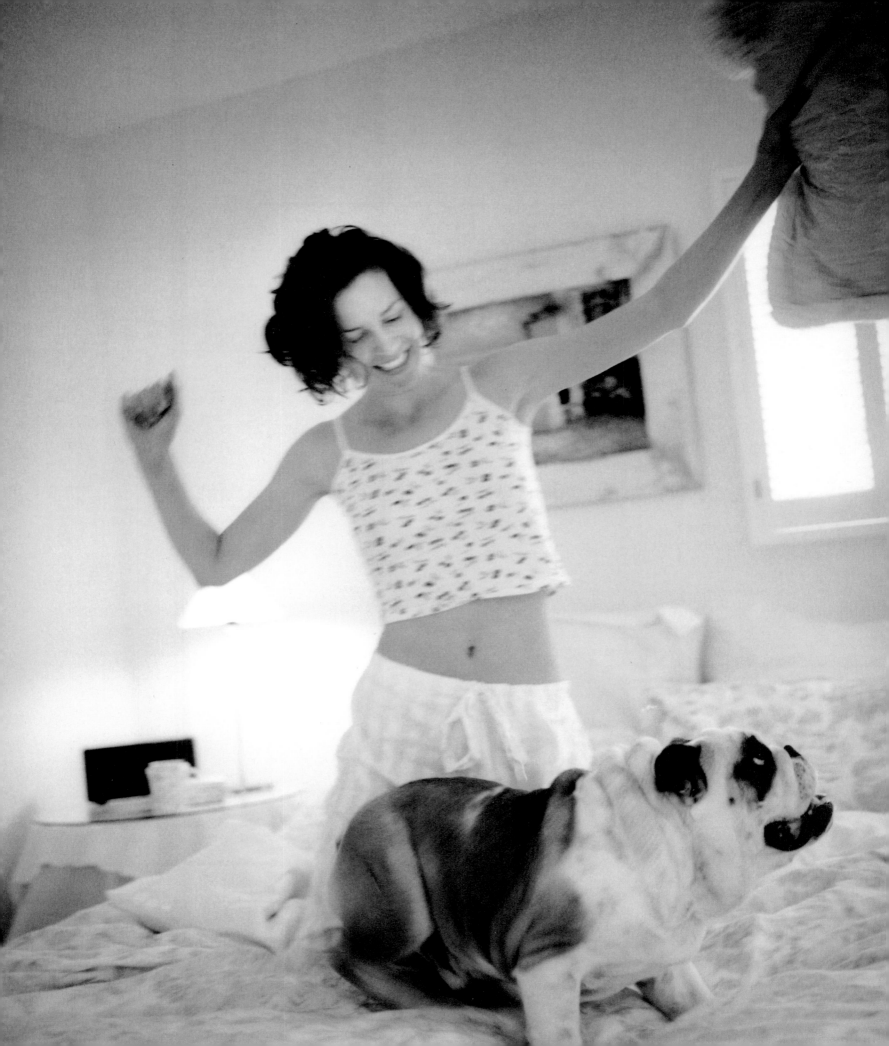

Mimi and her daughter were chasing invisible butterflies!

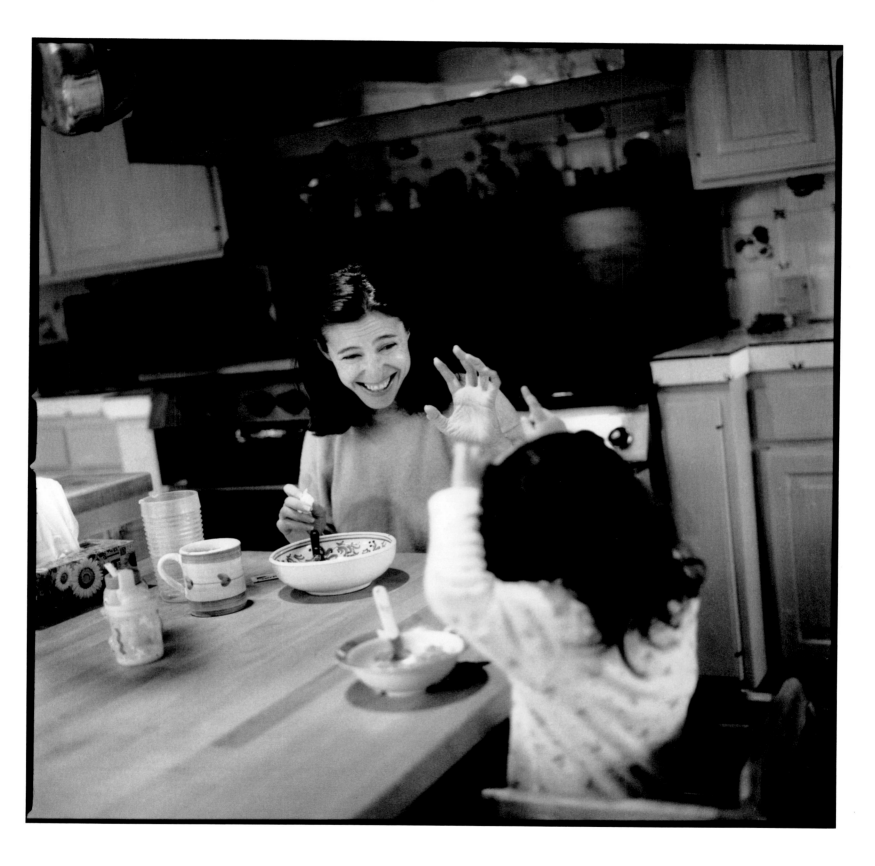

Mimi Rogers, 9,01 am

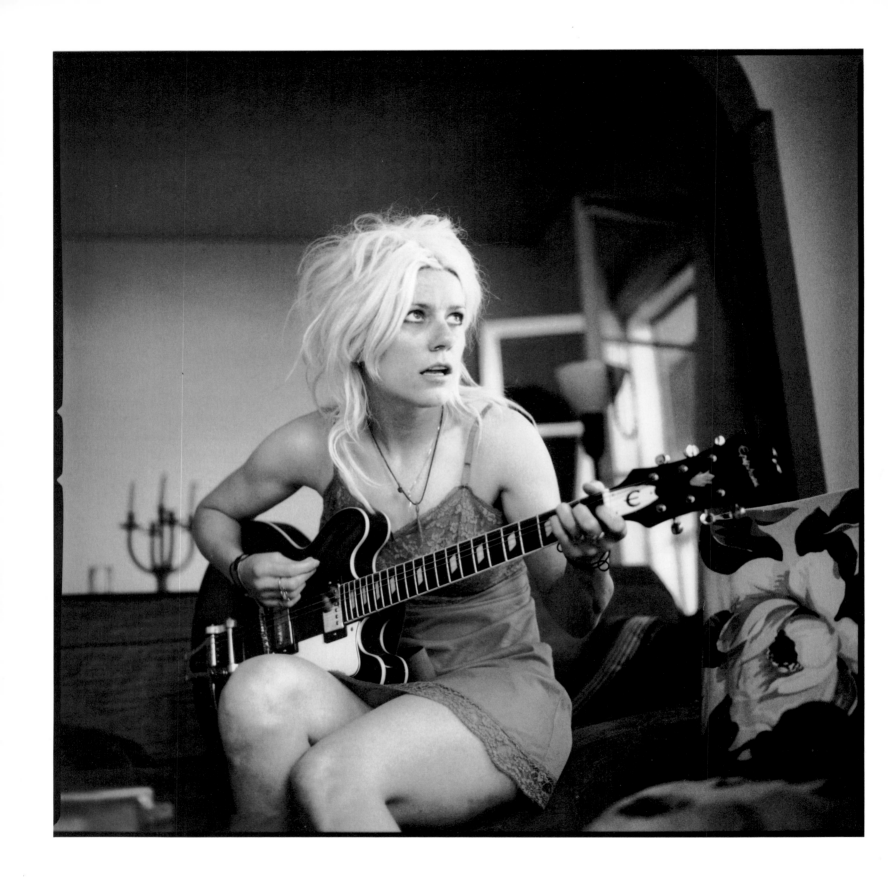

Donita Sparks, 8.49 am

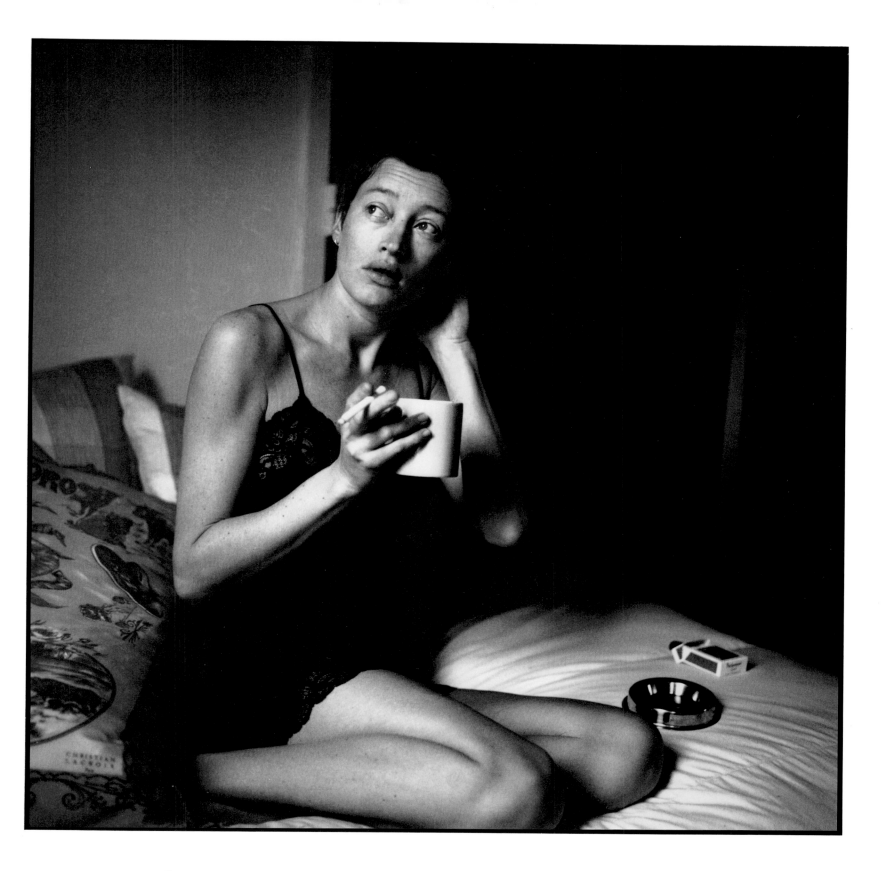

Marie Sophie Wilson, 9.05am

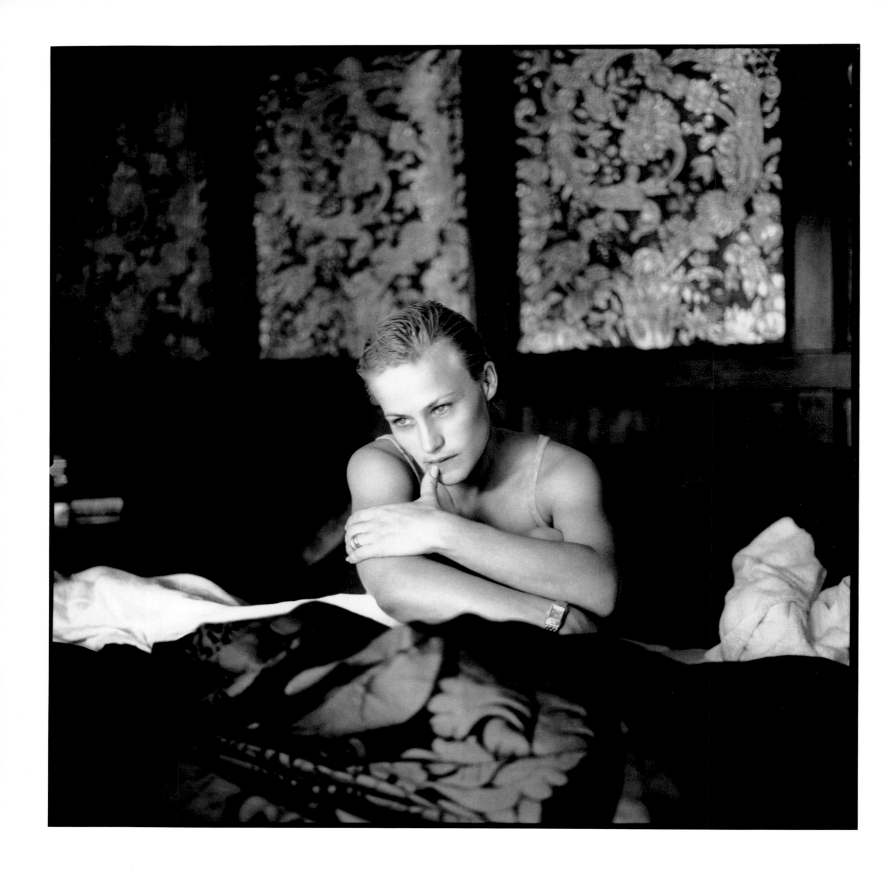

Patricia Arquette . . .

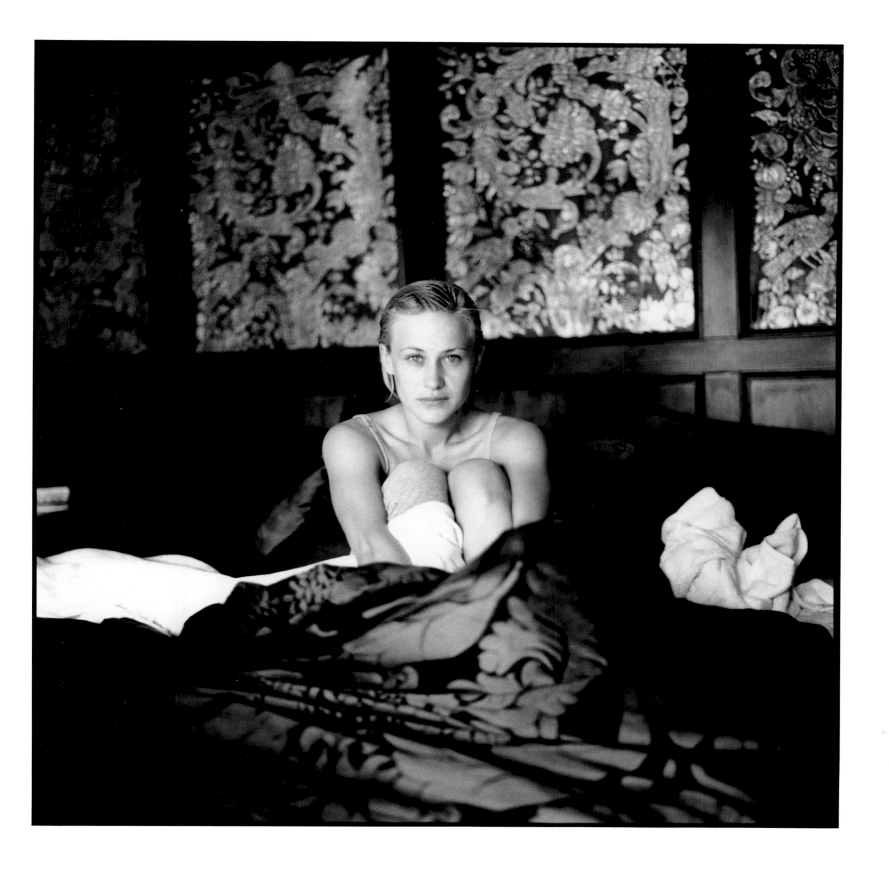

Los Angeles , 8. 33 am

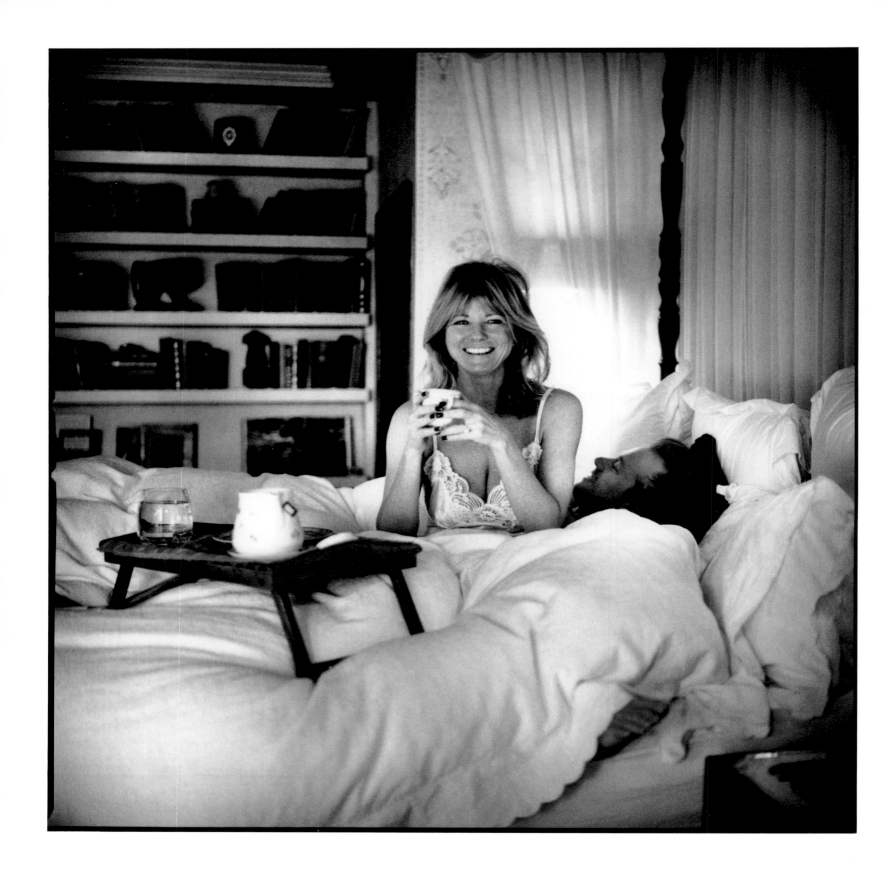

Cheryl Tiegs...

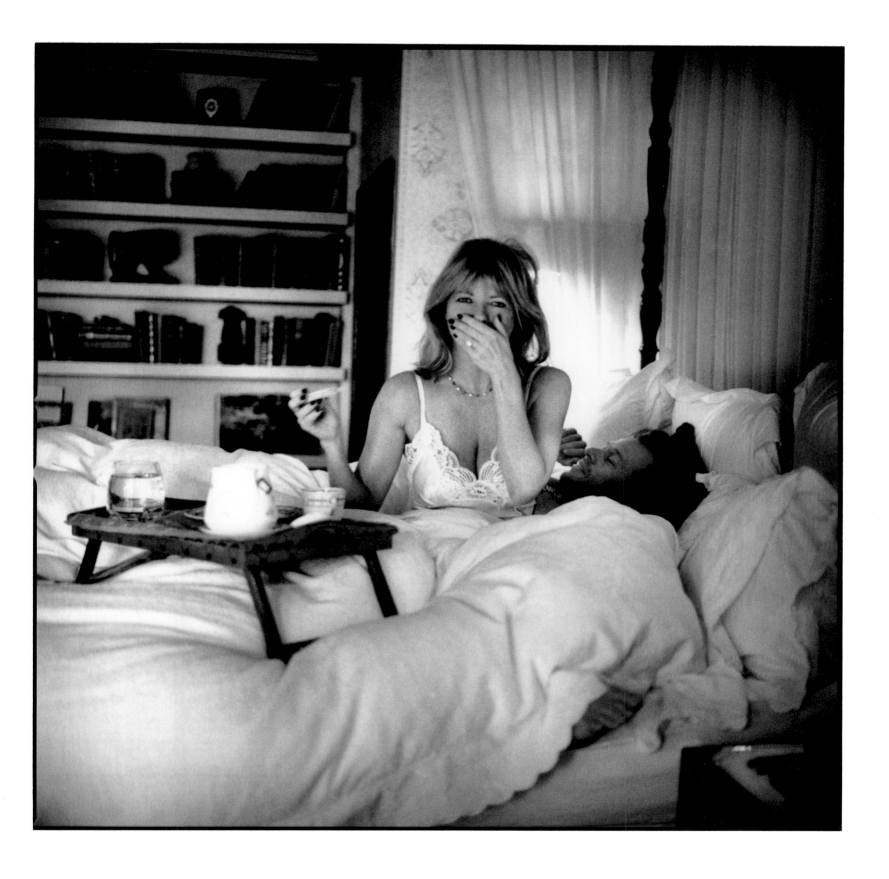

Bel Air, 9.10 am

Gina Gershon

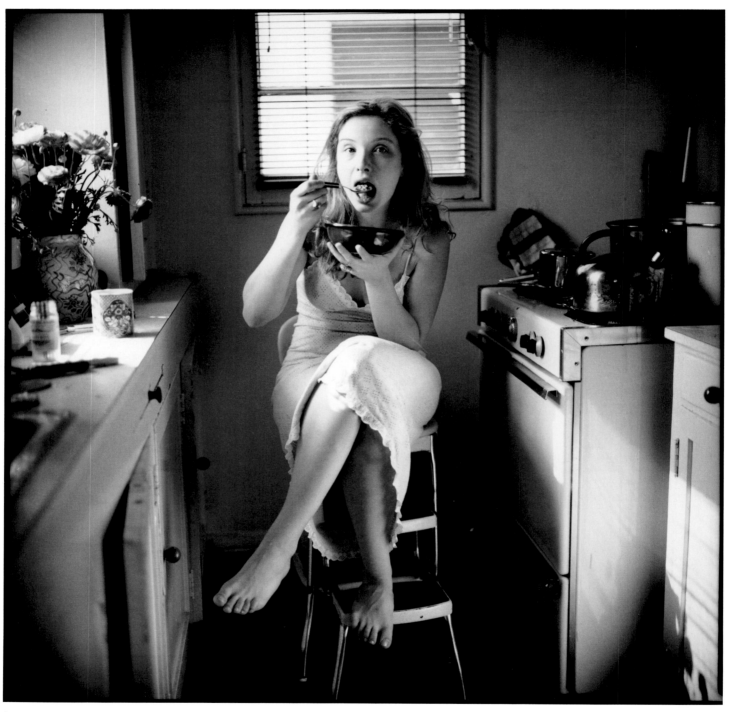

Julie Delpy, 9.25 am

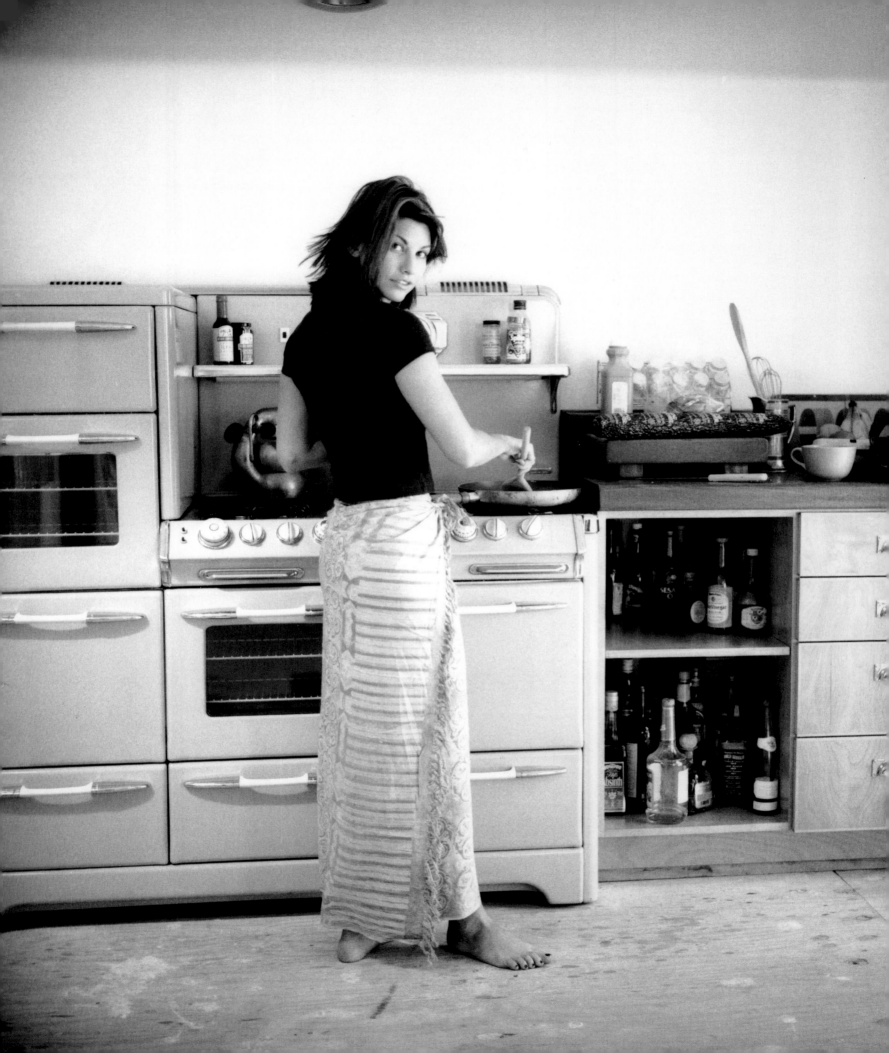

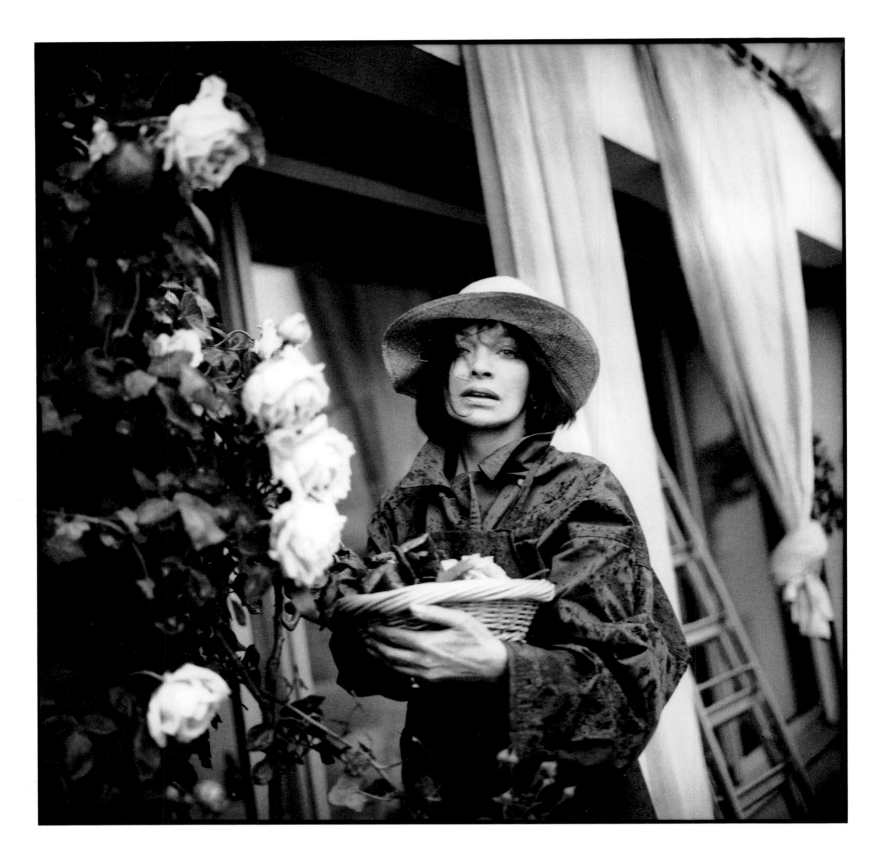

Marie Laforêt, 9.32 am

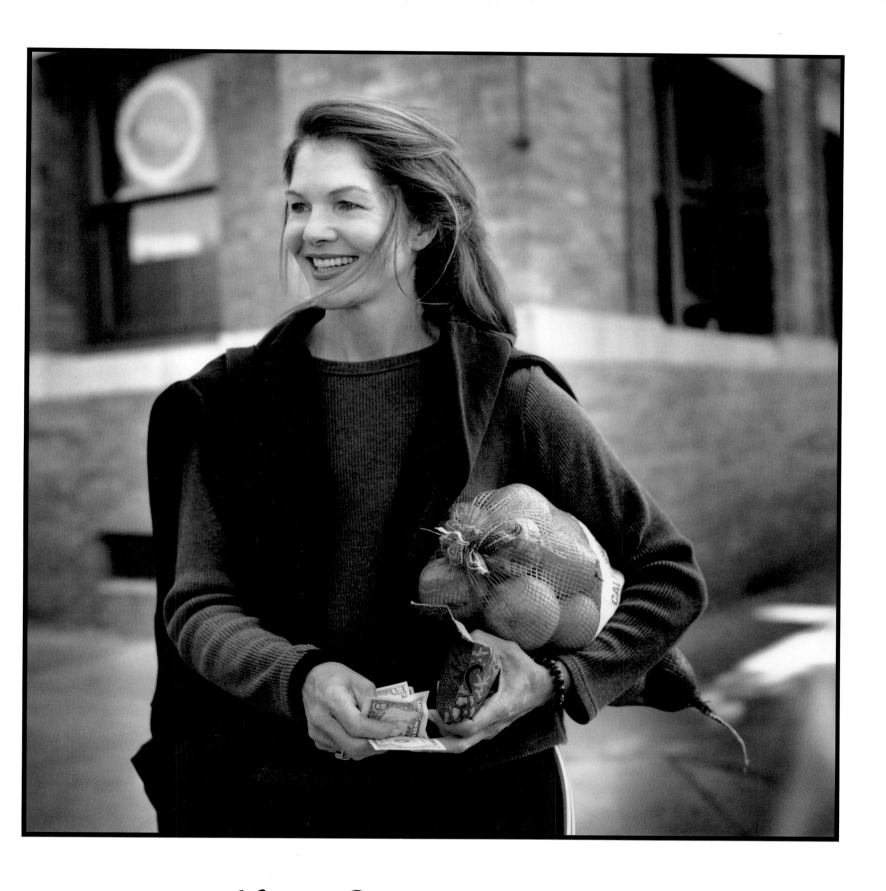

Lois Chiles, 9.02 am

Winona was shooting her big science fiction movie when I photographed her in her trailer dressed for the scene and waiting for her call. My 9-year-old niece – who had always dreamed of meeting her – was with me that day, visiting from Paris. Winona was so nice to her. She spoke a very cute broken French to us, and we all had a good laugh !!!

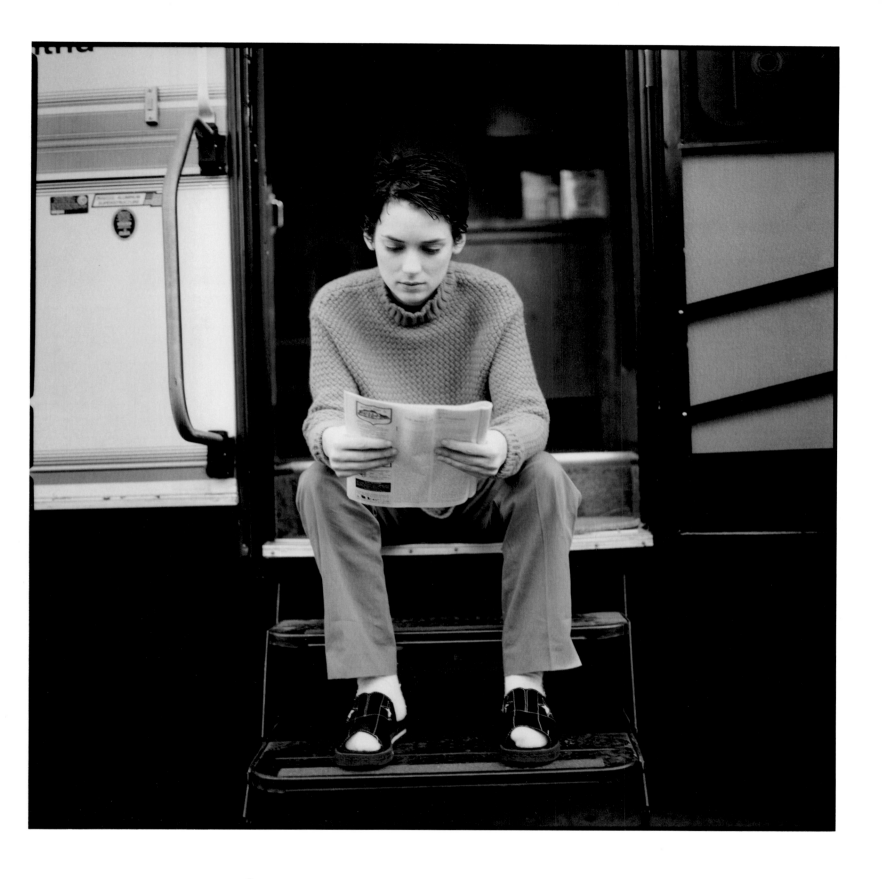

Winona Ryder, 8.54 am

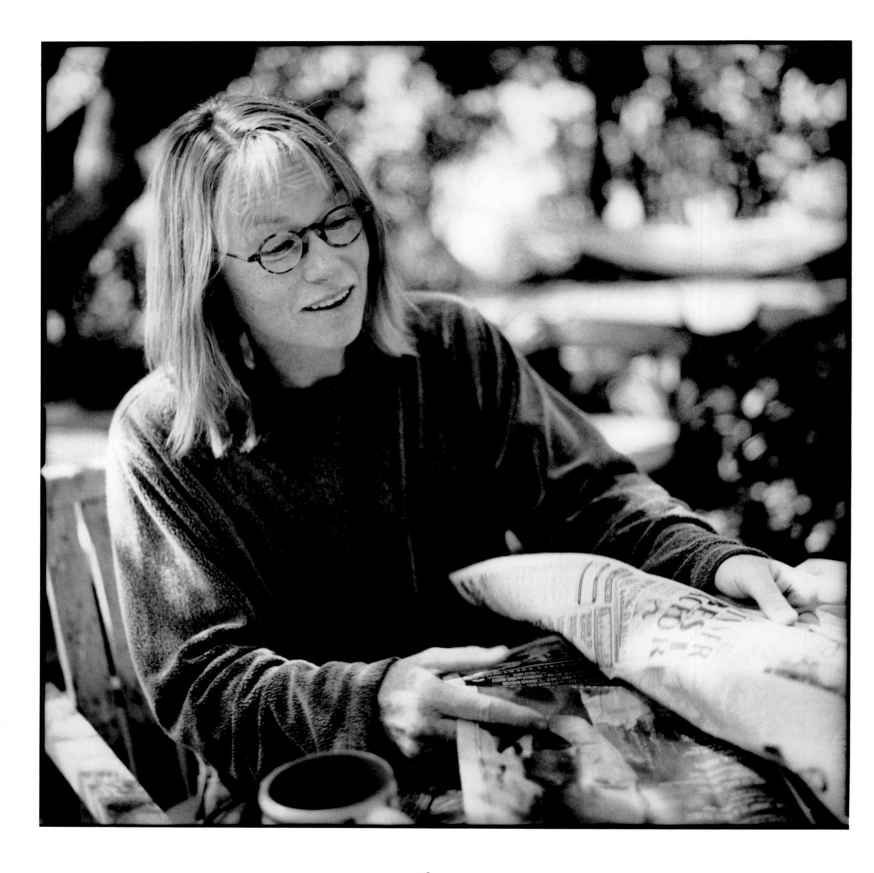

Amy Madigan, 9.26 am

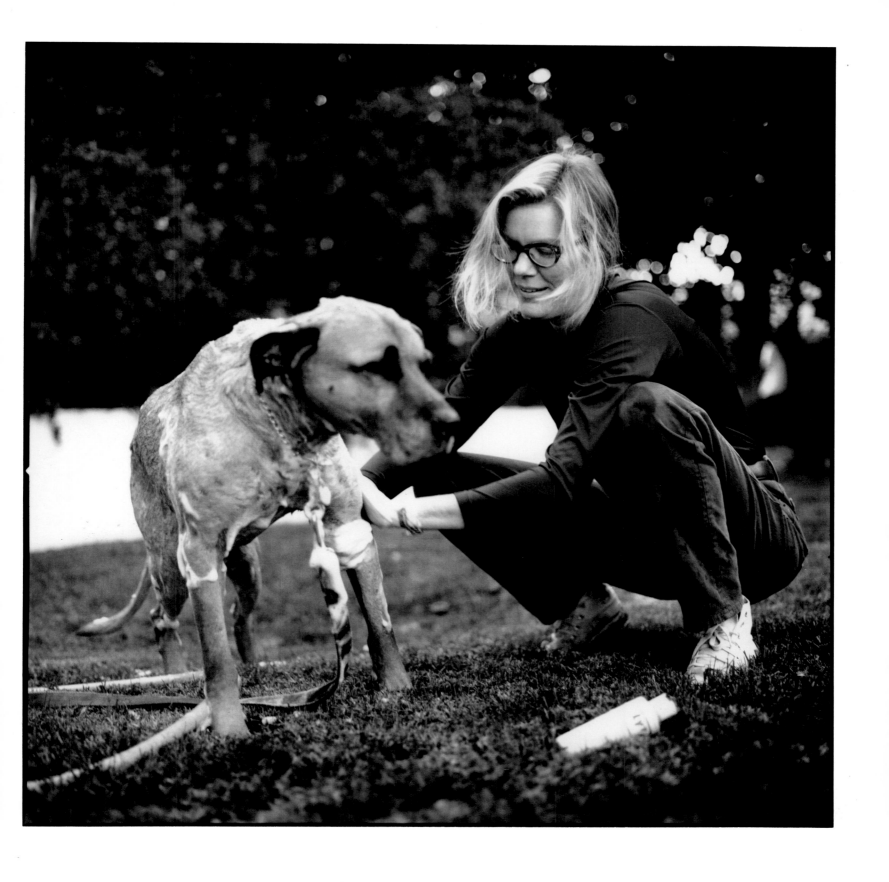

Becky Johnston, 9.10am

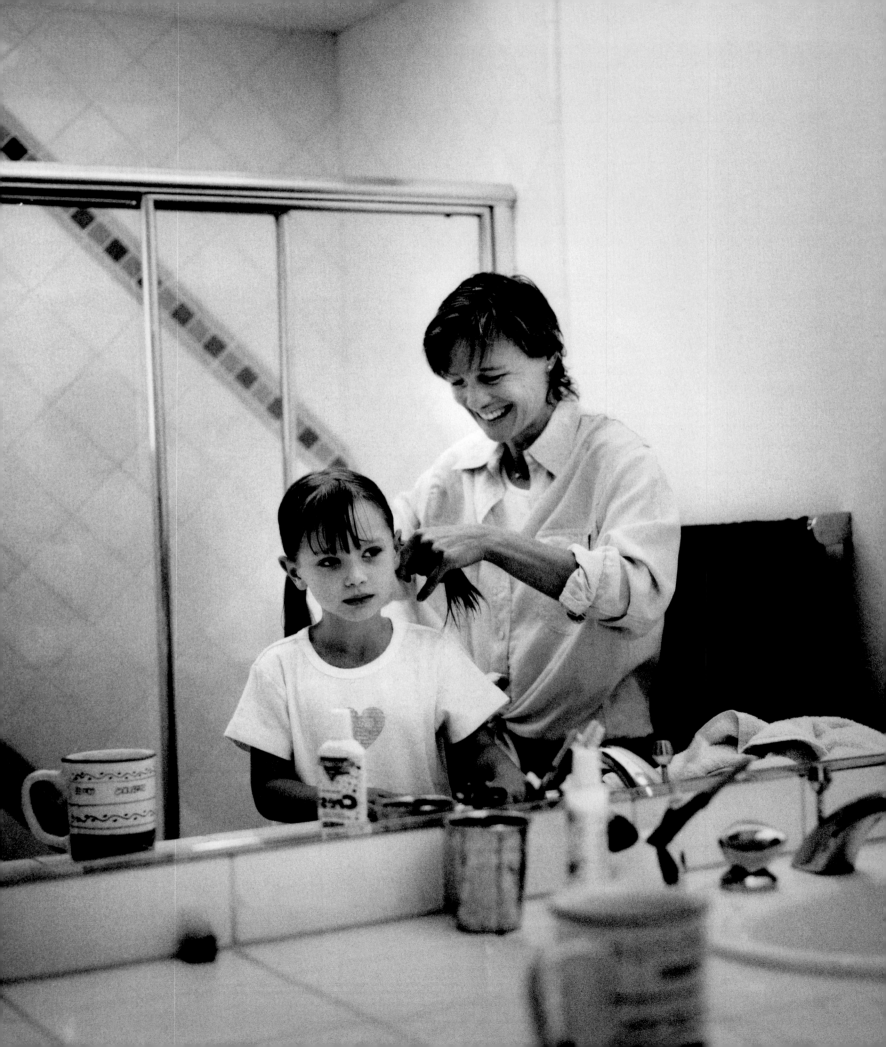

Pacific Palisades

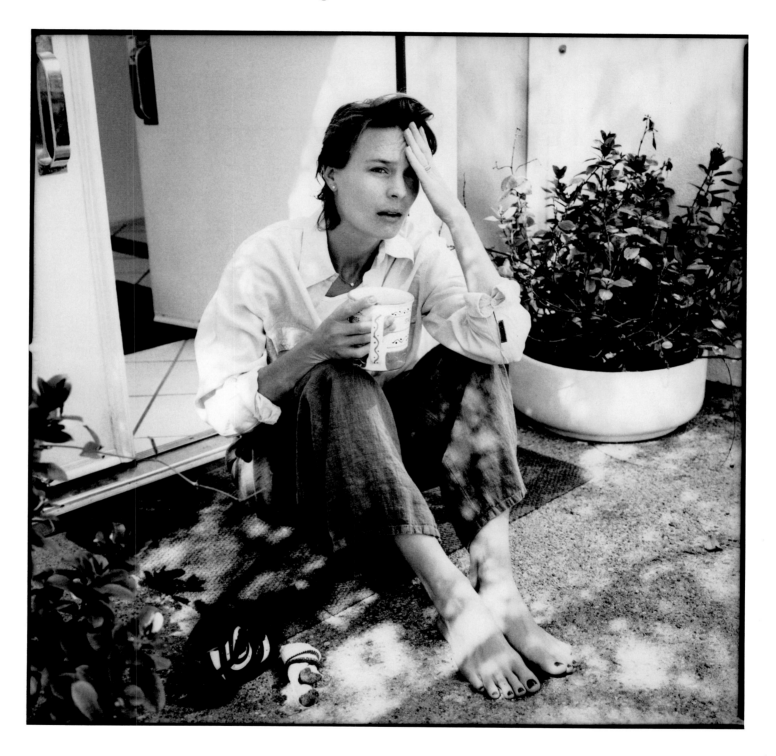

Robin Wright Penn, 9.48 am

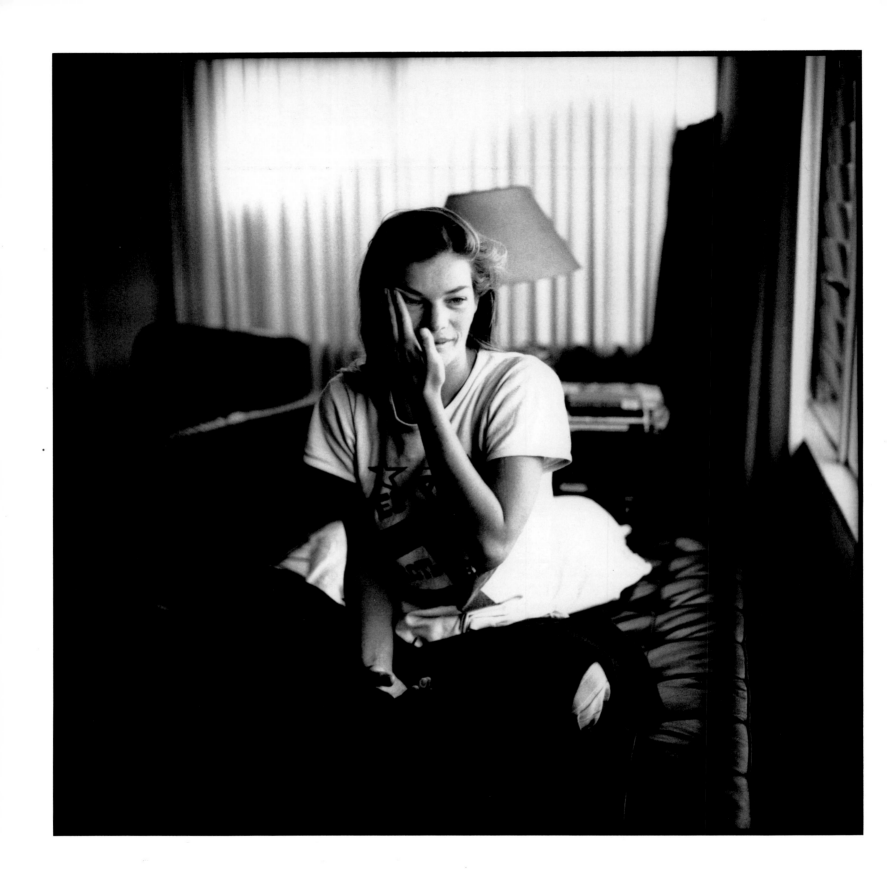

Cordula Reyer, 9.00am

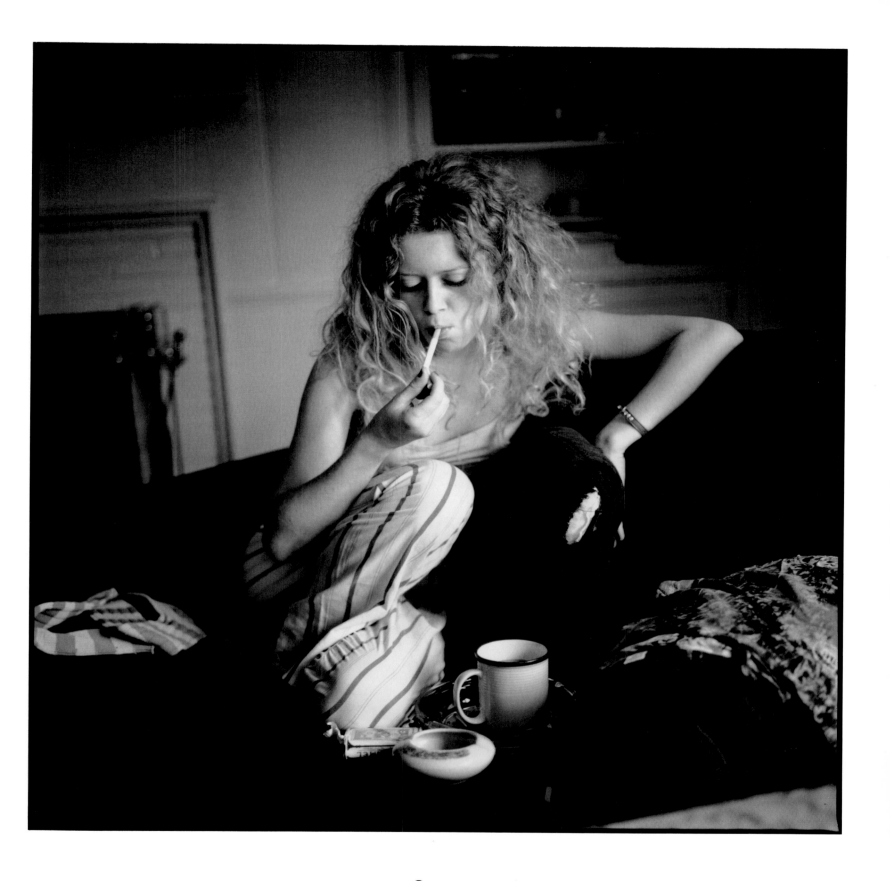

Natasha Lyonne, 9.00 am

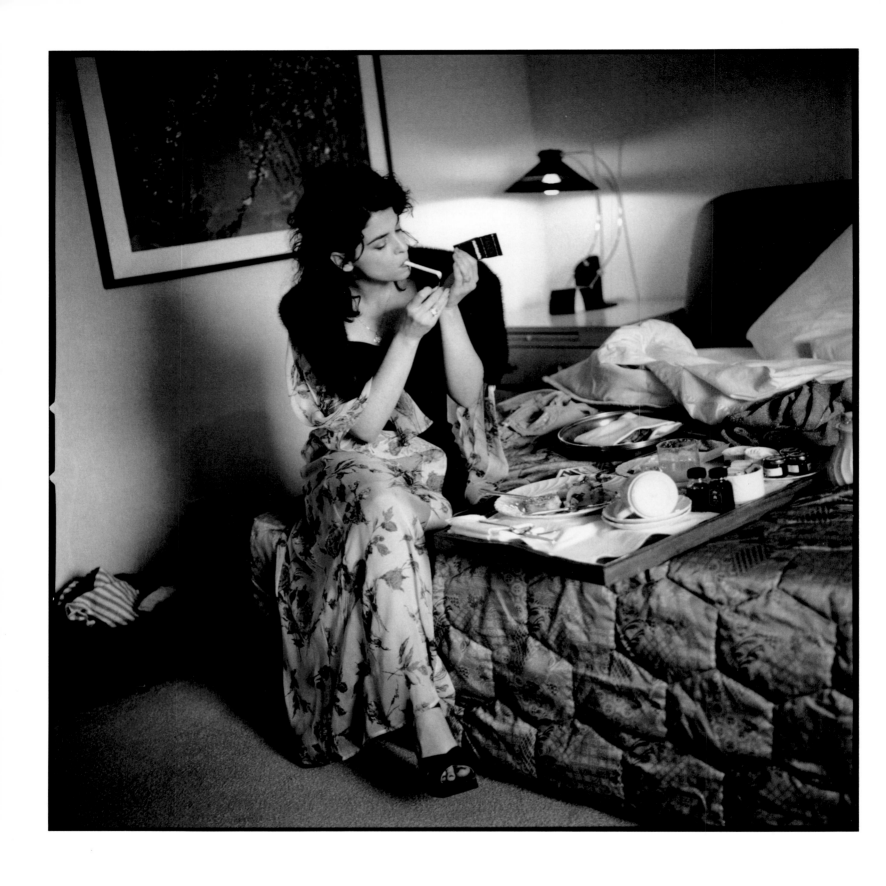

Annabella Sciorra, 9.05 am

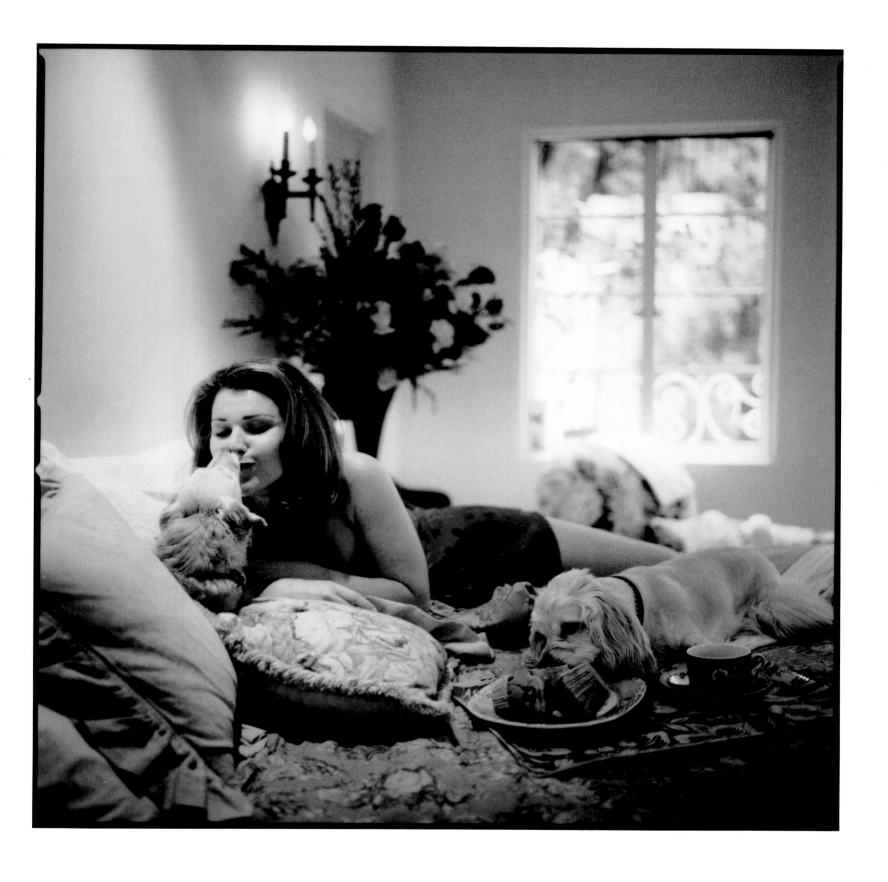

Peri Gilpin , 9.30 am

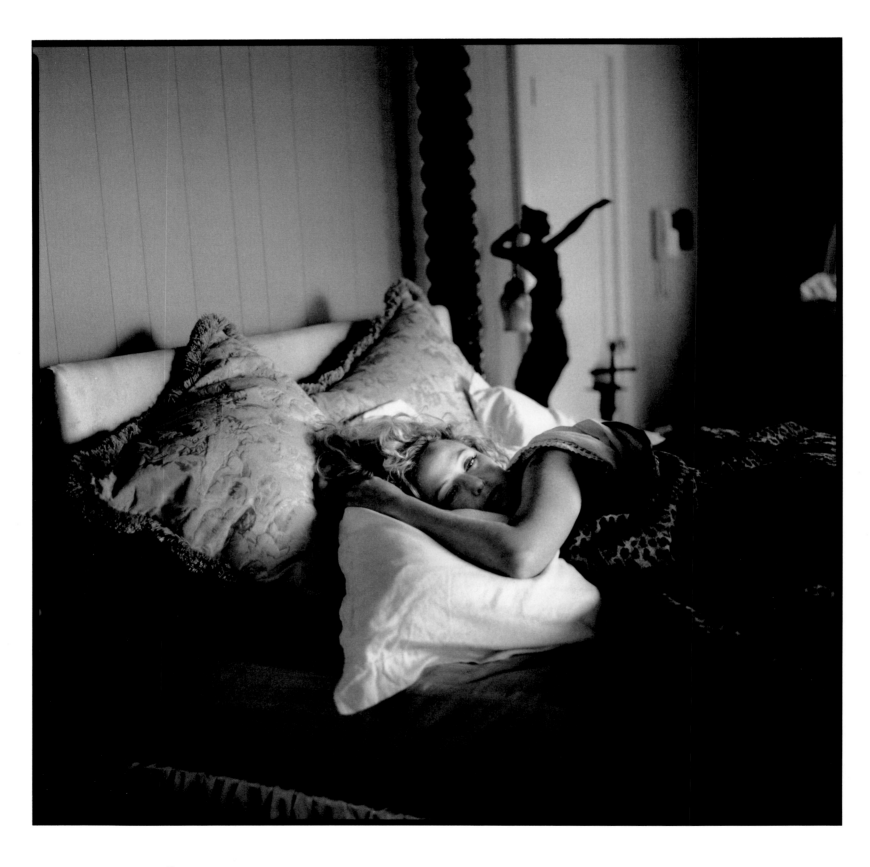

Virginia Madsen, 9.02 am

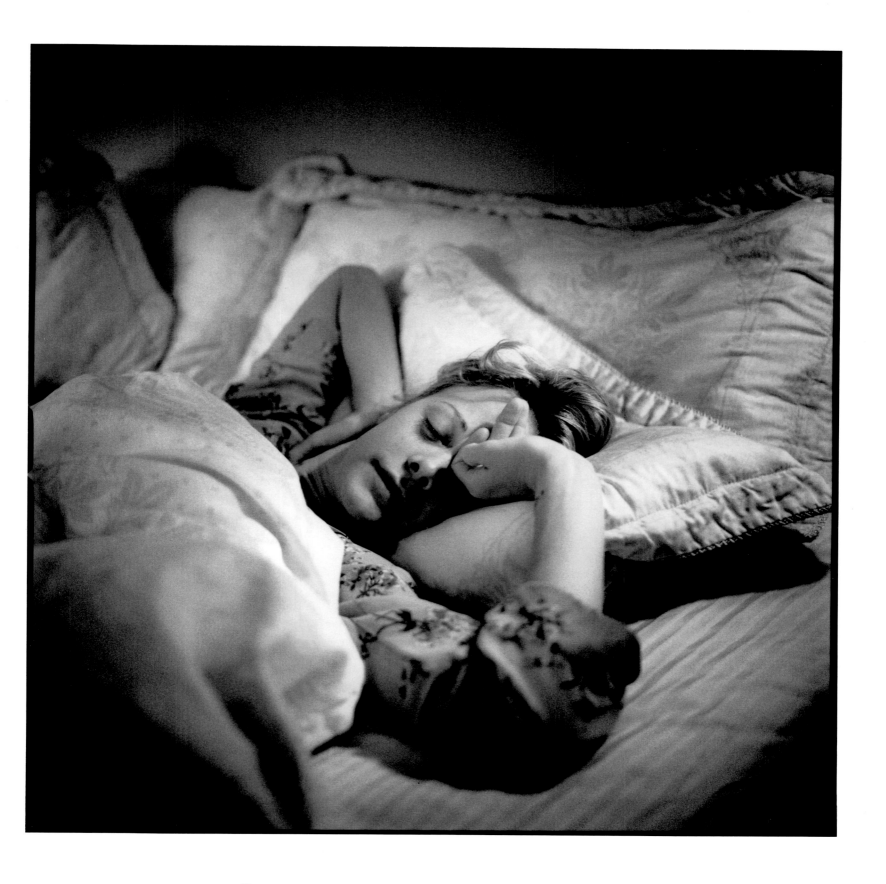

Alison Eastwood 8.48 am

Acknowledgements

This book would not have been possible without the help of some special people whom I would like to thank personally; I am very grateful to them:

- Geoff Katz and CPi for pushing me to do this book and supporting me all the way;
- Phillip Dixon for all of his constructive criticism on the project;
- Paris Photo Labs for their excelent work, especially Alain Labbé and David Healey for their superb printing;
- Sean Penn for sharing a few words with us;
- Carlos Rosario for doing the "dirty work" setting up the shoots;
- Fanny Pereire for sharing her home in New York;
- My publishers Daniel Power and Craig Cohen for being so enthusiastic;
- Robert Avellan for putting the pieces together;

and of course my cat, who still loves me after I deserted the house every morning before I even had time to feed him.

Finally, a big "Merci" to everyone who allowed me into their homes at those early hours, to wake them up and photograph them when I'm sure they would have preferred to be sleeping!

Véronique Vial July 1998

140

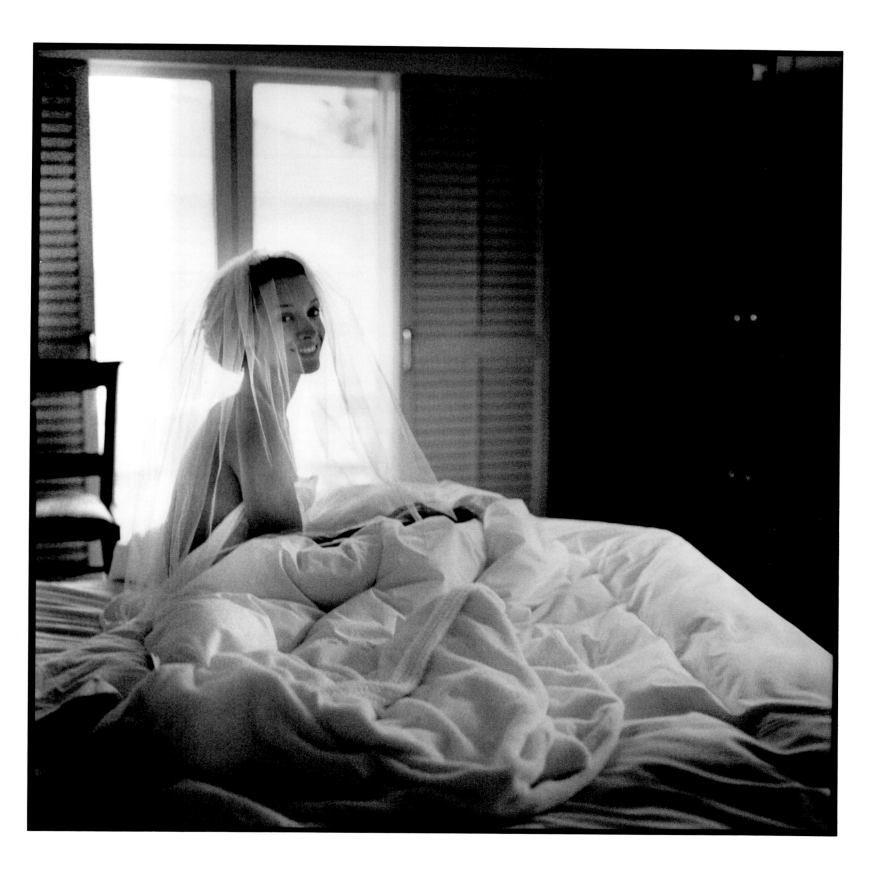

Jennifer Beals , 8.00 am

captions

Jacket cover Elle Macpherson (model) was the inspiration for this book. I went to a house to shoot a guy for my last book, *Men Before 10 a.m.*, and she opened the door! He was grumpy and still sleepy, but she was up and beautiful and so nice that I decided to shoot her too. She asked me, "Why don't you make a book on women?" So before I finished shooting that day I had started *Women Before 10 a.m.*

P. 1 Sylvia Plachy (photographer)

P. 3 & 9 Diana Barton (ex-model/actress)

P. 5 & 7 Milla Jovovich (model/actress) is funny, funny, funny! She is goofy too; she made me laugh a lot. I found her sleeping with her teddy bear in a tiny, dark loft bed in a big flat.

P. 11 Reese Witherspoon (actress) has a miniature staircase by her bed to help her squat little dog climb up at night!

P. 12 Naomi Campbell (model) was in a "princess suite" at the Bel Air Hotel when I shot her. Her plane from New York was delayed the night before, and she had only 4 hours of sleep.

P. 13 Gabrielle Reece (athlete/model) is a very good volleyball player _and_ very beautiful. I met her through her surfer boyfriend—now husband!—Laird Hamilton.

P. 14 & 15 Helena Christensen (model) was in bed with her boyfriend at the Chateau Marmont, and she made me feel like I should have arrived one hour later.

P. 16 Salma Hayek (actress) is a wild mixture of warmth, hospitality, and spiciness. Her Hollywood house is decorated with beautiful Mexican pieces.

P. 17 Daniela Rotelli (model) had a hard time erasing the ravages of the smoky Parisian nightclub from the night before.

P. 18 & 19 Emma Spöberg (model) was unconscious of her beauty; she woke up like a tomboy, ready to play.

P. 21 Jay Alexander (actor)

P. 22 Angelina Jolie (actress) moves like water, smokes like a truck driver, and laughs like a lover who knows more about you than you think!

P. 23 Jale Arikan (actress) is fire, but I got her during the rain!

P. 24 & 25 Jenny Shimizu (model/actress) was asleep with her girlfriend when I arrived; her dog showed me the way to their very luxurious and theatrical bedroom.

P. 26 Uschi Obermaier (model)

P. 27 Georgina Cates (actress) was a sexy, playful creature in her deserted house, which she visits only to pick up mail and pose in bed!

P. 28 Ione Skye (actress)

P. 29 Isabelle Pasco (actress)

P. 30 Julia Stiles (actress)

P. 31, 32 & 33 Laetitia Casta (model) cut holes in her hotel bed sheets for eyes, ran around like a ghost, and then stripped and jumped into the bath before running off to a photo shoot! She was playful like a little sister.

P. 34 Ingrid Seynhaeve (model) was taking her driving test that morning, and was studying between "takes." She was playful, and we laughed a lot. I don't think she passed that day!

P. 35 Emily Watson (actress) was trying to wake up, but her eyes wouldn't listen!

P. 36 & 37 Mia Kirshner (actress) was trying on several dresses for a press interview, so I had my own private fashion show!

P. 38 & 39 Daryl Hannah (actress) is a free bird surrounded by a horde of dogs and horses! She takes great care of them, and they give it back.

P. 40 Sophia Medina (model)

P. 41 Charlotte Flossaut (model/actress)

P. 42 & 43 Amanda De Cadenet (actress) has so much tenderness and love for her daughter that I could not shoot one without the other.

P. 44 & 45 Elisa Bonora (film editor) was ready to have her baby any minute! She lives in the wild with her three dogs and five black cats.

P. 47 Deborah Unger (actress)

P. 48 Laura Leighton (actress)

P. 49 & 51 Emma Thompson (actress)

P. 52 Dyan Cannon (actress) jumps on her trampoline for digestion and inspiration!

P. 53 Huguette Caland (artist)

P. 54 & 55 Holly Hunter (actress) had me come to her trailer on the film set where she was getting her makeup done. Her makeup artist is very famous!

P. 56 Rosemary McGrotha (model)

P. 57 Julianne Moore (actress)

P. 58 Clara Bellar (actress)

P. 59 Christina Ricci (actress)

P. 60, 61 & 63 Frédérique van der Wal (model/actress) feeds her cats naked, lucky cats!

P. 62 Claire Forlani (actress)

P. 64 Denise Crosby (filmmaker)

P. 65 Denise Richards (actress) did not want me to photograph her in the shower! But she was pretty relaxed getting dressed in front of me.

P. 66 Elpidia Carrillo (actress)

P. 67 Brenda Blethyn (actress) was rushing to catch a plane to London and asked me if the shoot would take long. She was in a hurry.

P. 68 Laura Harring Von Bismark (actress)

P. 69 Stephanie Smith (model)

P. 70 Rizia Morcira (ex-model)

P. 71 Yael Bergman (writer) and Rahda Mitchell (actress)

P. 72 & 73 Robin Tunney (actress) let me take photos of her in the bathroom doing very normal but private things!

P. 75 Arielle Dombasle (actress)

P. 76 Diane Warren (actress) has a fantastic 180° view of Los Angeles; her bird has a 360° view on top of her head!

P. 77 Eileen Ryan Penn (actress/artist) is a great mother of 3 wonderful boys, Christopher, Michael, and Sean. She kindly introduced me to Sean, and he wrote the foreword.

P. 78 Ann Cusack (actress) reads tarot cards in the morning, and plans her day with them. Some days she does puzzles to help her concentrate.

P. 79 Karina Lombard (actress)

P. 81 Alexandra Stewart (actress)

P. 82 Alfre Woodard (actress)

P. 83 Debbi Morgan (actress)

P. 84 Sofia Coppola (actress/filmmaker)

P. 85 Nim Kim (musician) is an amazing concert pianist. She couldn't stop licking the butter on her strong little fingers while we talked!

P. 86 & 87 Pamela Gidley (actress)

P. 88 & 89 Sigourney Weaver (actress) spoke perfect French, and danced to music to wake up and warm up before her karate exercises!

P. 90 Joely Fisher (actress)

P. 91 Lisa Marie (actress) impressed me with the strength of her hands and body.

P. 92 Lumi Cavazos (actress)

P. 93 Maxine Bahns (actress)

P. 94 Daphne Zuniga (actress) had her face in the shower because her dog scratched her while she was playing with him during our shoot!

P. 95 Sarah Jane Wylde (actress)

P. 96 Coralie Langston-Jones (publicist) has a beautiful Spanish bathroom, very old-style. I decided to shoot it, so she decided to take a shower!

P. 97 Charlotte Lewis (actress) is a graceful swimmer; I couldn't resist photographing her in the shower afterwards.

P. 98 Angie Everhart (actress/model) was totally hung over when I rang the doorbell, and her look-alike brother had to let me in. She ran a bath to help her wake up.

P. 99 Myrtille Blervaque (actress) is a very famous stunt woman because of her black belt in karate. She surfs every day.

P. 100 Trista Delamare (actress)

P. 101 Barbara Williams (singer/actress) is a great singer. I am glad I photographed her with her cat Olson, because a few weeks later he got run over by a car.

P. 103 Colleen Atwood (costume designer)

P. 105 & 106 Demi Moore (actress) and her mother Virginia.

P. 107 Rosanna Arquette (actress) has a daughter who kept coming in and out of the bedroom directing her mother's poses during our shoot. It was very sweet.

P. 108 Eva Ionesco (actress)

P. 109 Lisa Ann Walter (actress) was still sleeping when I arrived; her daughter was running around in her underwear and there were suitcases everywhere. It was a chaotic shoot!

P. 110 Hilary Shepard-Turner (actress)

P. 111 Janice Dickinson (model) had a black eye and a headache from eye surgery the day before; she was trying to sleep, but her daughter was watching cartoons at full volume!

P. 112 Tatjana Patitz (model) sleeps with all her animals: parrots, dogs, cats; only the horses can't make it up the curly staircase to her bedroom!

P. 113 Courtney Reid (artist) lives with her very smart pig Epiphaño, who loves to eat paint and knows where to look when she begins painting!

P. 114 Rebecca Broussard (actress) has a big couch in her bedroom, where she sleeps when her kids sneak into her bed and wet it at night. We had to shoot on the couch today!

P. 115 Embeth Davidtz (actress) has a small house like an arena; her dog was the bull, and she was the bullfighter!

P. 117 Mimi Rogers (actress)

P. 118 Donita Sparks (musician) lives with her dog and many guitars and suitcases, and lots of vases with dead roses!

P. 119 Marie Sophie Wilson (model)

P. 120 & 121 Patricia Arquette (actress)

P. 122 & 123 Cheryl Tiegs (ex-model)

P. 124 Julie Delpy (actress)

P. 125 Gina Gershon (actress) was trying to cook in her kitchen, which was being remodeled. Even when barefoot on a rough unfinished floor she makes a great omelette!

P. 126 Marie Laforêt (singer/actress) has such amazing rose bushes on her penthouse patio in Paris.

P. 127 Lois Chiles (actress) was already at the market, where I met her because I slept too late!

P. 129 Winona Ryder (actress)

P. 130 Amy Madigan (actress)

P. 131 Becky Johnston (writer)

P. 132 & 133 Robin Wright Penn (actress) opened the door when I arrived and whispered, "Sean is still sleeping; follow me, but be careful not to make any noise." We went outside, where she played with the kids. We didn't make any noise!

P. 134 Cordula Reyer (model) is the most beautiful woman I have ever met.

P. 135 Natasha Lyonne (actress) had beautiful blond hair that kept flirting with the cigarettes she kept lighting!

P. 136 Annabella Sciorra (actress) had not slept at all; she had been out all night visiting friends and having a ball! She made sure to get back so she could be in the book!

P. 137 Peri Gilpin (actress) had a glamorous negligee and professional makeup on, with flowers everywhere. I wanted more spontaneity when her dogs jumped on the bed and one started to eat her muffin! I don't think she even noticed!

P. 138 Virginia Madsen (actress)

P. 139 Alison Eastwood (actress) was being begged by her dog for breakfast before we started shooting, and her cat charmed her to the kitchen before we finished.

P. 141 Jennifer Beals (actress) was on her honeymoon with her new husband and her Siamese cat, which she takes everywhere. She did not sleep the night before the shoot because she was so nervous! She said it felt like the first day of school!

P. 143 Emmanuelle Sallet (actress) and her husband bought their house from Madonna. It was decorated very nicely; they kept the curtains and most of the original decoration.

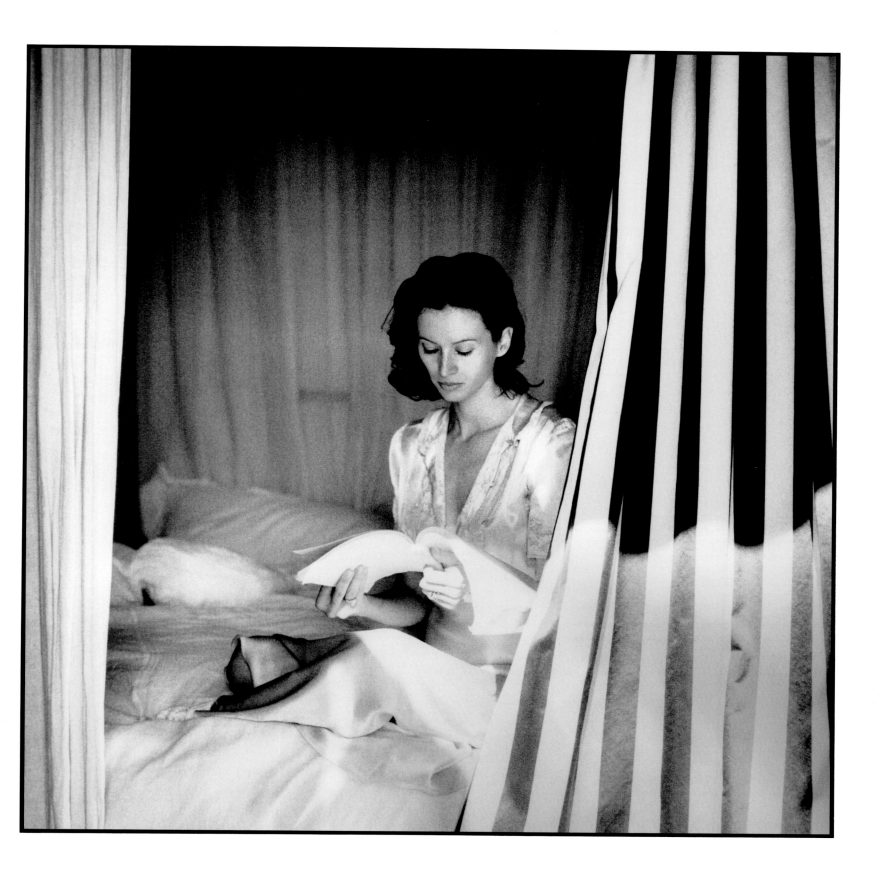

Emmanuelle Sallet, 9.35 am

Women Before 10 a.m.: Photographs by Véronique Vial

© 1998 powerHouse Cultural Entertainment, Inc.
Photographs © 1998 Véronique Vial
Foreword © 1998 Sean Penn

Published in the United States by powerHouse Books,
a division of powerHouse Cultural Entertainment, Inc.
180 Varick Street, Suite 1302, New York, NY 10014-4606
telephone 212 604 9074, fax 212 366 5247
e-mail: info@powerHouseBooks.com
web site: http://www.powerHouseBooks.com

First edition, 1998

Library of Congress Cataloging-in-Publication Data:

Vial, Veronique
 Women before ten A.M. / photographs by Véronique
Vial ; introduction by Sean Penn
 p. cm.
 ISBN 1-57687-039-1
 1. Portrait photography. 2. Celebrities--Portraits.
3. Photography of women. I. Title.
TR681.F3V49 1998
779'.24--dc21 98-30024
 CIP

Hardcover ISBN 1-57687-039-1
Limited Edition ISBN 1-57687-042-1

Duotone separations: Martin Senn
Printed and bound by: L.E.G.O./Eurografica, Vicenza

A complete catalog of powerHouse Books and Limited Editions is
available upon request; please call, write, or hit our web site.

10 9 8 7 6 5 4 3 2 1

Printed and bound in Italy

A slipcased, limited edition of this book with a signed and numbered gelatin-silver print by the artist
is available upon inquiry; please contact the publisher.

art Direction: robert Avellan_r + ave/la